D1530355

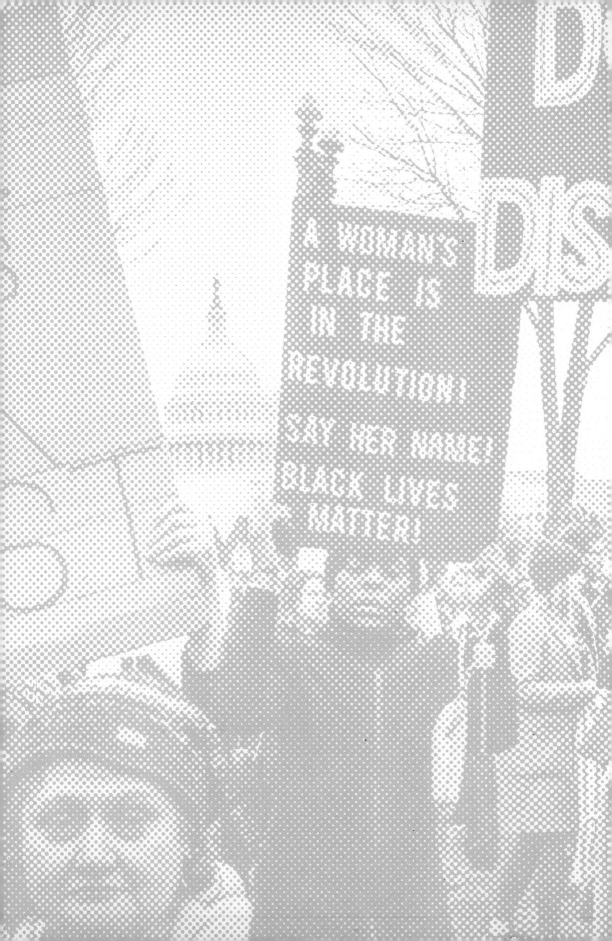

ACTIVIST

KK OTTESEN

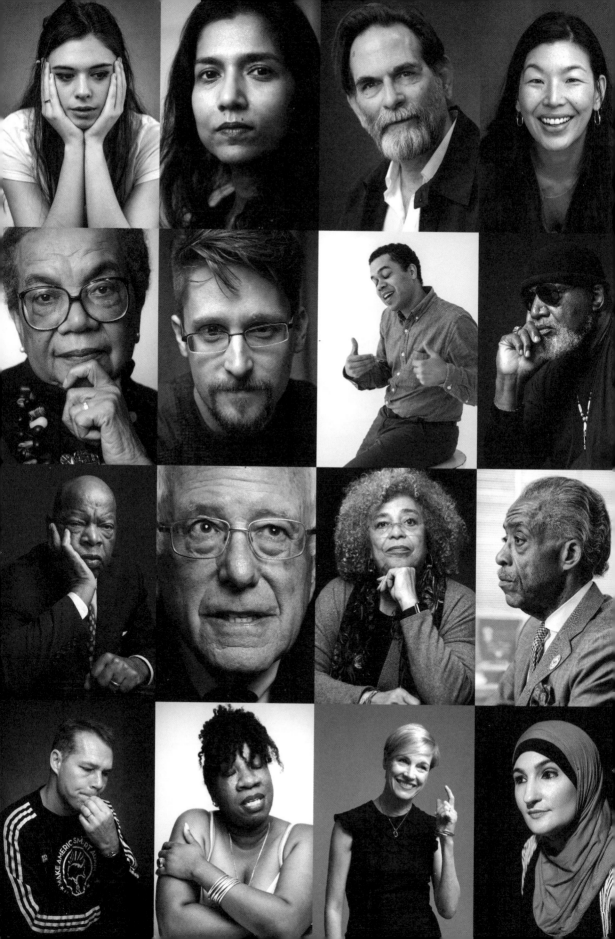

ACTIVIST

KK OTTESEN

CHRONICLE BOOKS

SAN FRANCISCO

in association with

Blackwell&Ruth.

"A time comes when silence is betrayal."

—Martin Luther King, Jr.

INTRODUCTION

There comes a time for each of us, when, in the words of Martin Luther King, Jr., we feel that "silence is betrayal." When we wrestle with the decision of whether and how to speak out against something that deeply offends our sense of right and wrong. Some of us speak out in quieter, more personal ways. Activists are those among us who, in such times, use their voices to challenge conversation or practice in public. They dissent, disrupt, and otherwise get in the way when compelled by conscience.

For John Lewis (page 128), that time came in 1955 when he was fifteen, growing up in the oppressive inequality of the Jim Crow South, and first heard Dr. King speak on the radio, calling on the community—and him specifically, it seemed—to get involved. For Bonnie Raines (page 54), the time was 1970, when a trusted colleague suggested that breaking into the FBI might be the only way to prove that the government was spying on and intimidating fellow antiwar protestors. For Nicole Maines (page 174), the time came as a fifth grader in 2007, when she was suddenly banned from using the school bathroom of the gender with which she identifies, as the school came under pressure from an outside group. These three people, like all the activists profiled in these pages, share the moments and decisions that launched their journeys. And while the circumstances giving rise to each journey vary tremendously, each individual chose to meet adversity with action rather than silence. Action fueled by the dictates of personal conscience, a sense of civic responsibility, and an abiding hope in a better future.

Many of the individuals in this book have been active for more than half a century—Harry Belafonte, Phyllis Lyon, Dolores Huerta, Ralph Nader, Marian Wright Edelman, John Lewis, Harry Edwards, Clyde Bellecourt, Angela Davis, Bernie Sanders, John Kerry, Billie Jean King, Al Sharpton. Others have only recently begun. But all have left their imprint on society through courageous actions, which, individually and collectively, have helped change the United States' laws, norms, and trajectory.

As much as we may celebrate certain activists now, it's important to remember that today's icons were yesterday's pariahs. It often takes years for the gains of once-unpopular protests, and the sacrifices made waging them, to be appreciated. Consider, for example, Dr. King's 75 percent disapproval rating in 1968, the year he was assassinated. Like Dr. King, many of the activists in this book have also faced the storms of public condemnation, and have experienced intimidation, surveillance, prison, exile, death threats, and violence by the mob and by the state. And yet these individuals—these activists—have persisted, rooted in a common sense of moral imperative and personal urgency—a feeling that, as John Lewis put it, you "cannot be at home with yourself" unless you act.

Compelled by the abusive working conditions in the fields of California, Dolores Huerta (page 84) left behind a comfortable middle-class life to advocate for farmworkers, even though doing so meant that she had to raise her eleven children in the poverty of the fields. Sister Megan Rice (page 166),

feeling a heavy responsibility to "expose and oppose" nuclear weapons, decided, at eighty-two years old, to break into a nuclear-arms facility—her first major action—knowing it would likely land her in jail (it did, for more than two years). Edward Snowden (page 286), compelled by top-secret knowledge that the US government was lying to the public about the extent of its mass surveillance, risked freedom to share that information, and now lives in exile in Russia. These courageous actions to hold power accountable call to mind the words of abolitionist and orator Frederick Douglass, "If there is no struggle there is no progress. Those who profess to favor freedom and yet deprecate agitation are men who want crops without plowing up the ground; they want rain without thunder and lightning . . . Power concedes nothing without a demand. It never did, and it never will."

We are in a contentious moment in our country's history, and it can be tempting to conclude that the level of conflict and division we are experiencing today is without precedent, that the battles over national identity and priorities, and even over facts themselves, are historical anomalies that spell irreversible demise. But as the stories in this volume testify, we've faced dark periods before. And from those dark moments have sprung activists—regular people, who have stepped up when the moment and their conscience demanded— to transform society for the better.

We see this happening today, with a powerful new wave of civic engagement, particularly among young people. Individuals from all over society, and in numbers not seen since the 1960s, are finding ways to use their voices, whether by protesting in the streets, walking out of classrooms, lobbying legislators, participating in town halls or social media campaigns, or finding other ways to creatively agitate for change. And they are getting results. Witness recent examples such as the impact of the student-led backlash against gun violence, or the election of the most female and diverse Congress in US history. In meeting the moment, activists are, once again, finding ways to confront power and demand change.

As I sought ways, myself, to understand and respond to the tumultuous times, I turned to my tools: Interviewing and photographing people to capture and share stories. For decades, I have documented people's lives with a keen interest in understanding both the unique characteristics that motivate and define individual journeys and, at the same time, the common and often more subtle threads that unite us. More recently, I became acutely interested in activists, and deeply curious about one specific question: What leads certain individuals, in the face of considerable personal, social, and political challenge, to choose action? I thought there must be wisdom to glean as well

as what felt like much-needed inspiration. So, I set out to talk with activists from across the generations about what motivated their journeys and about their perspectives on the current moment. The stories that follow are in each activist's own words, edited and condensed, with clarifying information judiciously added parenthetically.

And what a privilege the experience has been. Having initially interviewed ten of the activists featured in this book for the *Washington Post Magazine*, I realized that I wanted to—needed to—continue to share these powerful stories of civic engagement with the broader world. So I traversed the country, venturing from the halls of Congress to living rooms and humble cafés, speaking with people who were, to paraphrase Angela Davis (page 262), no longer accepting the things they cannot change, but changing the things they cannot accept. Time and again, I was inspired by the activists' determination and marveled at the sense of agency so many of them demonstrated even in their youth. And they reminded me that there are no permanent victories, but rather that every generation must continue to fight. Their courage has had a profound impact on me, leaving me both grateful for their sacrifices, and hopeful for our ability, together, to confront injustice.

Although many of the stories in this book bear witness to serious adversity, *ACTIVIST* is, ultimately, a hopeful book for those who dare to dream—and act— in divided times. Its stories of courage, determination, creativity, struggle, and triumphs, small and large, remind us of the transcendent power of individual and collective action to help society—in the past, present, and future—overcome seemingly intractable obstacles. They highlight the shared humanity, optimism, and courage required to heed the call of conscience, regardless of one's specific beliefs or path. I hope these stories resonate across ideological lines and help rekindle the understanding and empathy—critical ingredients for constructive dialogue—that come from listening closely and fully to others' stories.

It is a great privilege to share the stories of this magnificent group who represent but an infinitesimal fraction of the struggles, past and present, that have shaped our country and our world. They remind us that activism comes in countless forms and from every segment of society, and that courage and conviction reside in each of us, along with the potential to stand up for what we believe is right. It is my great hope that these stories inspire others, as they have me, to be ready to speak up when the time comes, and to act on our own calls of conscience in our own individual ways. Today, tomorrow, and forever.

—KK Ottesen

"Every acti

n matters."

—Shepard Fairey

Harry Belafonte is an award-winning singer, songwriter, and actor, and became active early in the civil rights movement, helping finance the Student Nonviolent Coordinating Committee (SNCC), the Freedom Rides, and voter-registration drives. He served as a confidante to Reverend Martin Luther King, Jr., and helped organize the March on Washington in 1963.

HARRY BELAFONTE

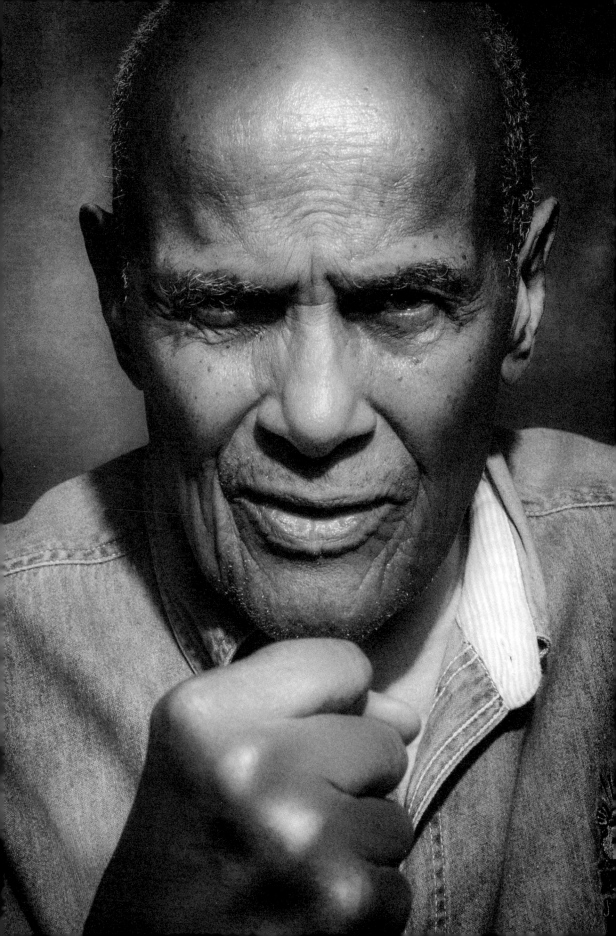

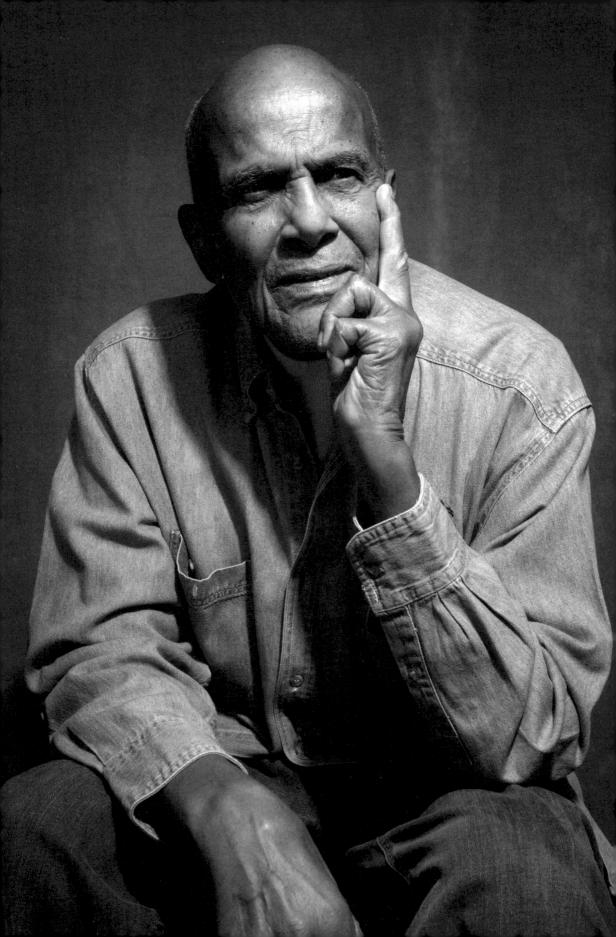

I became an activist because I was born into poverty. And the experiences of poverty and the cruel way in which it treated my family and the members of my community and the members of my race constantly imposed itself on my sense of, *What do I do about it?* The indignities that were heaped upon my mother. Her valiant struggle against being undereducated and being unskilled and being a woman of color and being an immigrant was a cruel burden. And as a child growing up, there was always the suggestion that there was a life to be aspired to that was better than the ones we were experiencing. And I never could quite understand why it was denied us. Watching my mother's melancholy, her anxiety about food and a place to sleep, and how long we would have to be somewhat nomadic, constantly on the move to the Caribbean, to Harlem, to different places, seeking to escape the wrath of hunger.

Those who capitulated to it, I found no glory in that. And those who resisted, I saw some fear because of the penalty you pay for resisting. I used to wonder, when I saw movies with James Cagney and stories about the great Irish Rebellion, the struggle of the Irish against British domination, that those who valiantly resisted the British occupation were heroes, and statues were built of them. Yet, when we did exactly the same things, we were considered malcontents and criminals and unpatriotic and worthy of prison. So, these disparities bombarded a child growing up in a system that held so many contradictions. Why us and not they? Why they and not us?

I think that what to do about it was nurtured by my mother's tenaciousness, her dignity, her courage, her wit—and her instruction. I remember once she came home from an unrewarding day trying to find work, very despondent and just sitting down and staring at the wall in our one-room apartment. After a fairly lengthy silence, I asked her what was the matter. She stared at me for a while, and all she said was, "Harry, boy, just promise me one thing. That as you're growing up and you see injustice, never fail to stop and do something about it." And, though that was a rather confusing and daunting instruction for a seven-year-old, it lingered. The thought rooted itself. And wherever I went, I would find zero tolerance for injustice.

After serving my term in the Second World War, after the great victory against Hitler and fascism, I came back and found that there were no rewards for black people. Those of us who fought the same battle and died the same death, were denied the right to vote, denied access to schools, to places to live. And one day, working as a janitor's assistant in an apartment building, I was given a gratuity for doing a repair: two tickets to the American Negro Theater. The lights went down, this curtain opened up, and the whole evening was an epiphany. There were black forces on stage reciting remarkable poetry and using language in a way that I'd never heard before. I thought: *I like this place! I think I'll hang around and see if I can dust off the furniture and set up the chairs for the next performance.* They gladly gave me the broom and told me to clean up. And in the process of listening to them and doing my tasks, I gravitated toward the magnificence of the art, of the performance. I found that in this platform, people were saying things that needed to be said, defiantly and poetically and with reward.

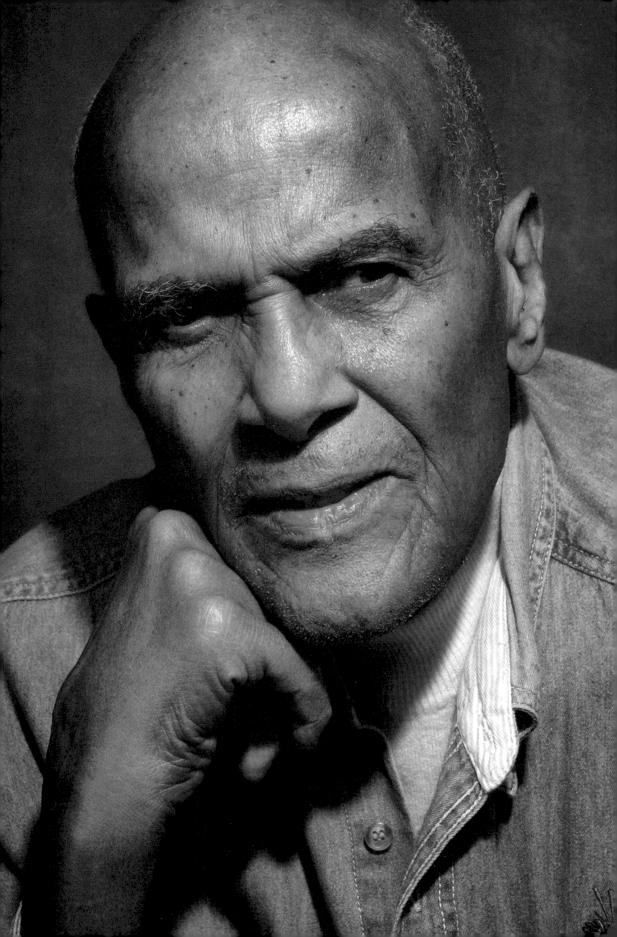

So, I went to an acting program created by a German Jew by the name of Erwin Piscator, who fled the Nazis and came to America. Piscator was quite a guy. He was fierce on the subject of using the theater and art as an instrument of social commentary. And, fortunately for me, I had classmates like Marlon Brando, Walter Matthau, Bea Arthur, Rod Steiger, and Tony Curtis, and began to do things I had never done before. I was a high school dropout, had a great deal of difficulty reading. All sorts of emotional and psychological obstacles were constantly challenging me. But good fortune came my way, with Paul Robeson coming in one day. He loved what we did, and sat with us afterwards. He said, "It's a wonderful thing that you've chosen this profession, because we are the gatekeepers of truth. We not only show life as it is, but our responsibility is to show life as it should be." I heard phrases like, "Art is the moral compass of civilization." And, "We're the 'radical voice of humanity.'"

I went down and heard Lead Belly and Woody Guthrie—songs of social content. Just talking about it excites me. And through the instruction of people like Paul Robeson, Dr. [W.E.B.] Du Bois, Eleanor Roosevelt, Martin Luther King, and others, I began to understand the power of art. I could do something, say something, about oppression. And I could use my voice in the service of their social agendas.

So I did my "Banana Boat," my "Day-O," because these songs, while they entertain, were songs of the peasants in Jamaica working on the banana plantation. I found all the songs I could that were filled with social content. And my tickets became sought-after for an audience that was deeply curious about where I would lead them. I knew I could express points of view that would either rattle them or put a smile on their faces. It was a really incredible power. What do you say? What do you do? Some of the protest material was so influencing, so commanding. Although there were those who denounced me for bringing politics into art, there were those who rewarded me handsomely. And when the blacklist really energized itself to destroy careers, my audience stayed fiercely loyal. So, any television show or sponsor that didn't want me: Fine. If the [Joseph] McCarthy forces came after me and shut me down in theaters, I could just say, *Fuck you*, you know. *I'll see you in Paris. Or London or Germany.*

And what do we get as a result of that struggle, at least at the moment? Trump and everybody on a campaign to dismantle everything we gained. But it's not Trump that bothers me. There's always a Trump somewhere. A McCarthy. You know. It's that we let the moment get away. But, giving up? How do you do that? You've got to believe in life, you've got to have a good slice of hope, and a sense of future. We got to go back to the drawing board and say, *What did we miss? Let's put that in the cake for the next time around.*

Like my early days with SNCC in the early civil rights movement, I'm working now with a lot of young people, artists, and activists from all over the country. I see rich activists and poor activists and black activists and women activists and youth activists—we're in abundance. And the truth of the matter is that, with all the angers and pain that we may still feel, you measure each cycle, the progression, and we do make a change. We do get better. There is the human progress.

"Why us and not they?

Why they and not us?"

—**Harry Belafonte**

Ai-jen Poo is a labor organizer and social activist with a focus on domestic-worker rights. She is the director of the National Domestic Workers Alliance (NDWA) and co-director of Caring Across Generations. She was named one of *Time* magazine's "100 Most Influential People" in 2012 and published her first book, *The Age of Dignity: Preparing for the Elder Boom in a Changing America*, in 2015.

AI-JEN POO

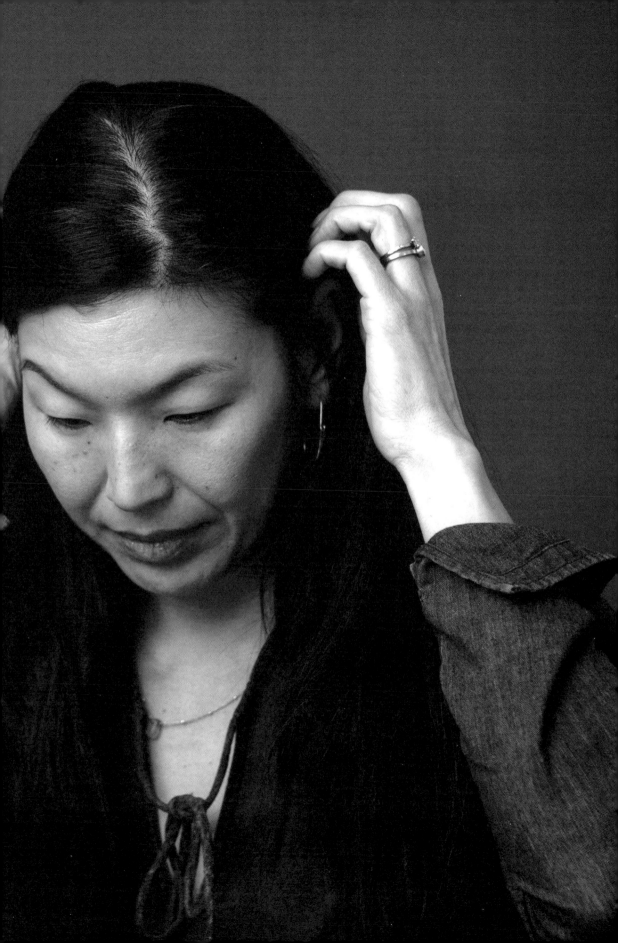

"I hear stories of abuse, of r wages; you d grounded in t in order to do stay focused

—Ai-jen Poo

all the time
onpayment of
need to be
at suffering
what I do and
nd anchored."

I grew up with books, [my father's] books. Writers like Noam Chomsky, Edward Said, and people like that. And all these books about China. With him really thinking critically, and asking critical questions about why things are the way that they are. That was definitely an influence. Also, my mom's a physician because she wanted to take care of people. So, the combination of having political analysis and being surrounded by this ethic of really wanting to take care of people was really important to me.

I feel like my high school years were defined by early learning about feminism and reproductive rights, Rodney King in Los Angeles, and the first Gulf War. Those big, defining social issues and moments really caught our attention and made me want to be much more aware of what was happening in the world and get involved in whatever was available to me. In high school, there was infrastructure for that kind of activity, so I was involved in the Women's Forum, the Earth Friends group, in community service and student government, and the gay–straight alliance. My first protest was maybe tenth grade. George Bush visited campus and a bunch of us protested for reproductive rights. It was, like, *This is happening, and we should do something. What can we do?* I don't think I even knew how to assess if it was the right thing.

Also, I had a teacher who focused on literature from the Vietnam War. So we learned a lot about the social movements and the different people that shaped that time in history through the stories of soldiers, of women in Vietnam, and of people in government. That was really influential to me because I think I got a sense of how movements have shaped history and politics. And I felt there was something important about the fact that all these young people, especially students, were able to combine with veterans and others to stop the war—at least, that's what I thought happened at that time.

When I moved to New York for college, I was a women's studies major. I was actually looking to major in ethnic studies, but we didn't have ethnic studies. There were only a couple of Asian American–studies classes available to undergrads. I took them all, of course. And that's why, in my senior year, we formed a multiracial student coalition to fight for ethnic studies on campus. Our goal was to win an ethnic studies department so that students, particularly students of color, could study the history of social movements that have fought for justice and equity in this country. We had this really vibrant campaign and it involved a fourteen-day hunger strike and building takeovers and lots of civil disobedience and arrests. A whole bunch of really dramatic actions that got the attention of the administration and forced them to the table. It yielded the establishment of the Center for the Study of Ethnicity and Race at Columbia. So, now there's the opportunity for students.

Many of us were volunteering off campus in community organizations. It was during the Giuliani era, and police brutality and police violence were a huge issue. So I was very involved off campus on racial justice issues in particular. It was also in those early years that I was volunteering, working the hotline at a domestic violence shelter for Asian immigrant women. And I was just

struck by the stories of women who were struggling to leave their abusers and figure out how they were going to take care of their kids. A big issue was the complete lack of economic security on the part of women who were working in low-wage jobs. It was impossible to figure out how these women could support themselves and their children on their own, doing the jobs they were doing. That's what got me interested in economic justice for women and figuring out how we make jobs for women better in this economy. Especially immigrant women and women of color. That's what put me on a path to organizing domestic workers.

We have a thousand everyday heroes who are the backbone of our movement. Women like Juana Flores, a former domestic worker and a survivor of domestic violence. She speaks a little more English now, but she's a monolingual Spanish speaker. She's the executive director of Mujeres Unidas, one of our founding affiliates. And she's been a leader in our movement since the beginning. She is a real anchor for me; knowing that I have this elite education—Andover and Columbia—and that I find it incredibly hard and have to summon every ounce of privilege to try to position our work in what feels like a philanthropic and political environment dominated by a culture that overvalues white men and undervalues everybody else. Yet she's been at it for much longer, just making it happen with so little, you know? That's the thing that makes me, like, *Okay. I can deal with whatever.*

I hear stories all the time of abuse, of nonpayment of wages; you do need to be grounded in that suffering in order to do what I do and stay focused and anchored. But truthfully, from a survival standpoint, I tend to not focus on them too much. Because I think the role that I have in this work at this point is to be able to stay optimistic, creative, and generative, and to be able to see ways forward that are otherwise really hard to see if you are wrapped inside of the suffering.

Activists are a motley crew. We're as diverse as people themselves. I think people in general are at their best when they're connected to a sense of purpose. And activists connect to their sense of purpose more than your average person—purpose beyond our individual goals. And the best activists are always learning and are good listeners. And good collaborators. Because it's really all connected in the end. I think it's a golden moment for activism right now. And really critical that we channel that energy in the right ways. Because these kinds of moments don't come around very often.

Bernie Sanders is a US senator from Vermont
and the longest-serving independent in
Congress. He ran a transformative, upstart
campaign for the Democratic nomination for
the presidency in 2016. Sanders subsequently
decided to run again as candidate for
the Democratic nomination in the 2020
presidential race. Previously, he served as
mayor of Burlington, Vermont.

BERNIE SANDERS

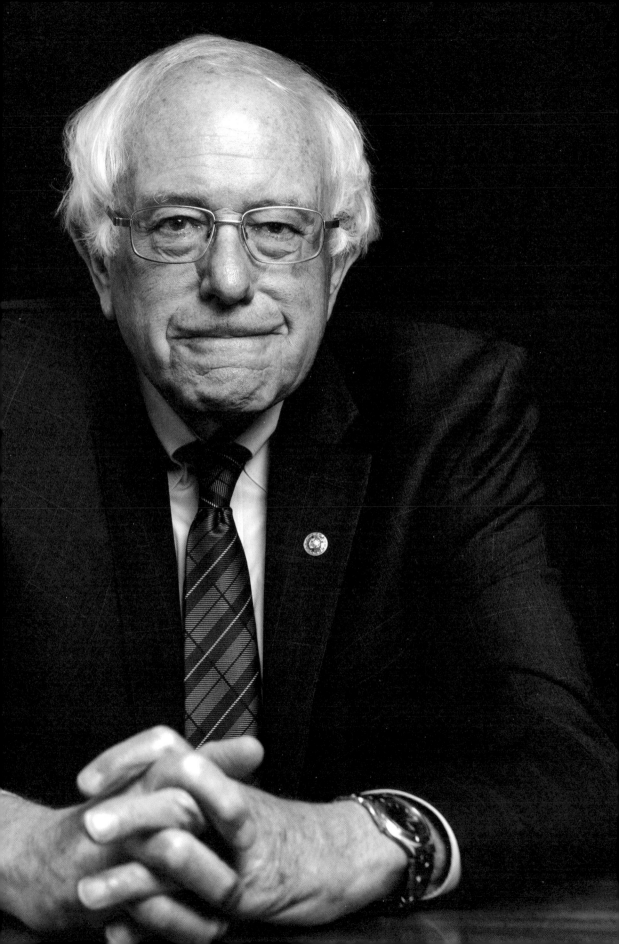

A couple of years ago, my brother and I and our wives went to the small town in Poland where my father was raised. And what we learned is—above and beyond anti-Semitism—it was an incredibly poor community where people were really struggling to eat. So, at the age of seventeen, he left there and came to America. It blows you away to think of the courage to do that. So the idea that I would be a United States senator, let alone a candidate for president of the United States, would have been absolutely unthinkable in the house that I grew up in. A three-and-a-half-room, rent-controlled apartment in Brooklyn, New York.

Coming from a family that did not have a lot of money, and being Jewish, and understanding what racism was about because some of my father's family were killed in Poland, the issue of social justice is something that I have felt my entire life. And, I'm not the first to make this point, but [the Dodgers leaving Brooklyn] was a major sociological event for New York City, too. The Dodgers were a team that the whole community—whether you were black or white or whatever—kind of rallied around. As a kid, those ballplayers were not abstract names to us. They were like family. Gil Hodges, the first baseman, lived about a mile away from us, and we used to ride our bicycle past his house. And, honest to God, probably half of our math skills were developed by [looking] if somebody was batting .283, and they went three for four in the game . . . We knew everything. So, when you're a kid and somebody says "Brooklyn Dodgers," you assume it's Brooklyn, not a private entity. It's Brooklyn, you know, how can you sell Brooklyn? That was a very enlightening moment for me about the power of money over the needs of the community.

I went to Brooklyn College for one year—it was virtually tuition-free then, I should tell you. But my mom had died during that year, died at the age of forty-six, and I didn't want to hang around the neighborhood anymore; I wanted to get out of the city. Decided to go to University of Chicago.

Chicago was very important for me. Less, I think, from what I learned in the classroom than what I learned all around. It was a very politically active city. I got involved in the civil rights movement there. We had a chapter of what was then the Congress of Racial Equality, CORE, where I was active. Got involved in the peace movement. Did a lot of reading about history, economics, sociology. Got involved in the Young People's Socialist League (YPSL). And that exposed me to ideas. And, you know, you start asking: *Why, why, why?*

You understand that power—and who has the power—is the great influencer, obviously, of what happens. In politics today, many don't want to ask those fundamental questions: How does it happen that you have incredible levels of income and wealth inequality? Are we allowed to talk about the fact that three people own more wealth than the bottom half of America? Or that the top one-tenth of 1 percent owns more wealth than the bottom 90 percent?

I found that before the campaign in 2016—I mean, you tell me—there was almost no discussion of income and wealth inequality. Where it was such a glaring obscenity in American society. And it's still not discussed very much. People feel, you know, wealthy people make contributions, you don't want to offend them, so you don't talk about those issues. But if we're talking about creating a democratic society, you have got to address the glaring wealth and income inequality. Not just from the perspective of economic inequality, but what it means politically. Because you have the Koch brothers and a handful of other billionaires spending enormous sums of money to elect candidates who represent their interests. So, it is an issue that has to be dealt with.

But I think political consciousness in this country is not very high. And I think it has a lot to do with the fact that we don't have the kind of vigorous debate that we should be having between the parties. And that the media does not allow us to focus on the most important issues facing the American people. I just came back from running all over the country. You meet people who are making eight bucks an hour. Why, in America, in the wealthiest country in history, should people be making eight dollars an hour? Why should thirty million people not have any health insurance? How in God's name has there never been a town meeting or a serious discussion about Medicare for all? CBS didn't do it. ABC, NBC didn't do it. So, we did.

When I first got involved in electoral politics in Vermont in 1971, I got 2 percent of the vote. One year later, I ran for governor; went down to 1 percent. And then two years later, I got 4 percent, and then 6 percent in '76. Which, by the way, back then, was not bad for a third-party candidate with no money. But 2 percent, so what? I got out on the street and talked to tens of thousands of people. I got on radio stations, talked to newspapers, did interviews. And played a good role, I think, in raising political consciousness. Look, none of your ideas matter unless you get involved. You can have the greatest ideas in the world, but if there is not an activism at the grassroots level fighting for those ideas, fighting to elect candidates who will implement those ideas, you're not going to go anyplace. You know, electoral politics, done the right way, is activism. And I have always felt that if you could explain your ideas to people, to working people, great things can happen.

I remember at a rally a guy comes up to me, he says, "Bernie, you know why I like you?" *Why?* "Because you treat us like we're intelligent human beings." Now, that was after a speech that was probably an hour and fifteen minutes about the issues facing the American people, which bored the media completely. They didn't really write about the speech. "Oh, God, Bernie Sanders is giving the same: Rich are getting richer, da da da da da." But you had 10,000 people there, paying attention, listening. There is a hunger in this country for people to tell the truth about what's going on. Not just in cheap rhetoric or 140-word tweets. People want to know why we are where we are. People appreciate that. Young people, maybe, especially.

"Are we allowed to talk about the fact that three people own more wealth than the bottom half of America?

Or that the top one-tenth of 1 percent owns more wealth than the bottom 90 percent?"

—Bernie Sanders

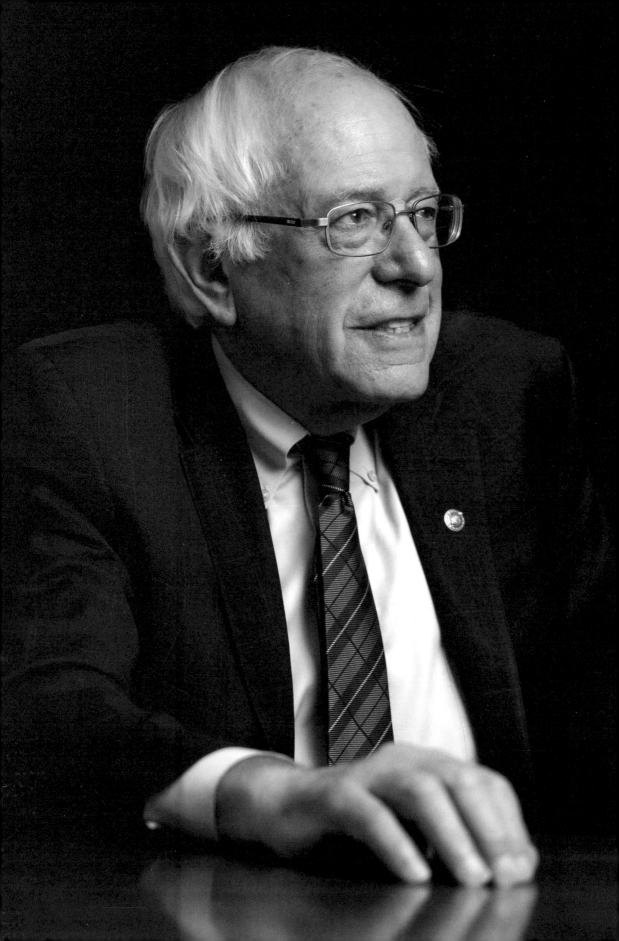

I was just in Arizona at a small meeting with mostly Latino kids—activists. And some kid asked me, "What advice would you give people who are going to be out canvassing, knocking on doors?" I said, *Look, you're going to be very nervous. But just keep pushing.* In Vermont, we have mayoral elections in March. So that means you got to campaign in January and February. Pretty cold. I would literally knock on doors and be sweating. Because it's scary. You know, "Who is this guy knocking on the door?" But it becomes easier. And it often turns out to be a good experience. You get blown away by the intelligence of people. Where you would least expect it. Like, many years ago, I was at a county fair. People come in from the sticks—very, very rural. And this guy, who hadn't shaved in a week, came up to me— very rednecky-type guy. He says, "You one of those guys that supports gay marriage?" I thought, *Oh, God, here we go . . .* I said, *Yeah, I do.* And he said, "Good! My sister's gay."

Three years ago, when we started talking about an agenda that worked for working families and not just the 1 percent, time and again, we were attacked. Not just by Hillary Clinton, but by editorial writers all over this country, that we were way, way out of touch with where the American people are, that our ideas are extreme, radical, fringe ideas. I think the word "socialism" gets people a little bit nervous.

But if you look at the polling today, virtually every idea that we campaigned on has strong majority support. So, I'm very proud that taking those ideas all over this country made people aware that these ideas are not radical, but the direction that we should be going. I think the American people are far less divided on what they want to see for the future of this country than many perceive. The reason that people like Trump can win elections is they understand there's a lot of pain out there. People are hurting. Five blocks away, there are moms who cannot afford to find decent-quality childcare in the city of Burlington. Just a fact. Okay? And we have to talk about those issues.

Anybody in politics will tell you, especially in this moment, it's a tough life. I have some good friends who said, "Okay, we've done it thirty, forty years, and that's enough." And I understand that. As my wife will tell you, it's been a long time since we've had a vacation, which is not a good thing. But, you know, I have seven beautiful grandchildren, four kids, and I do feel a moral necessity to do what I can to make this a world in which they can live good lives. And I'm in a position where I have some influence. And, at this moment, I just cannot walk away from that.

Reverend Al Sharpton is a Baptist minister, longtime social justice activist, and founder and president of the National Action Network (NAN), a nonprofit civil rights organization based in Harlem, New York. He hosts his own radio show, *Keepin' It Real*, and is the host of MSNBC's *PoliticsNation*.

REVEREND AL SHARPTON

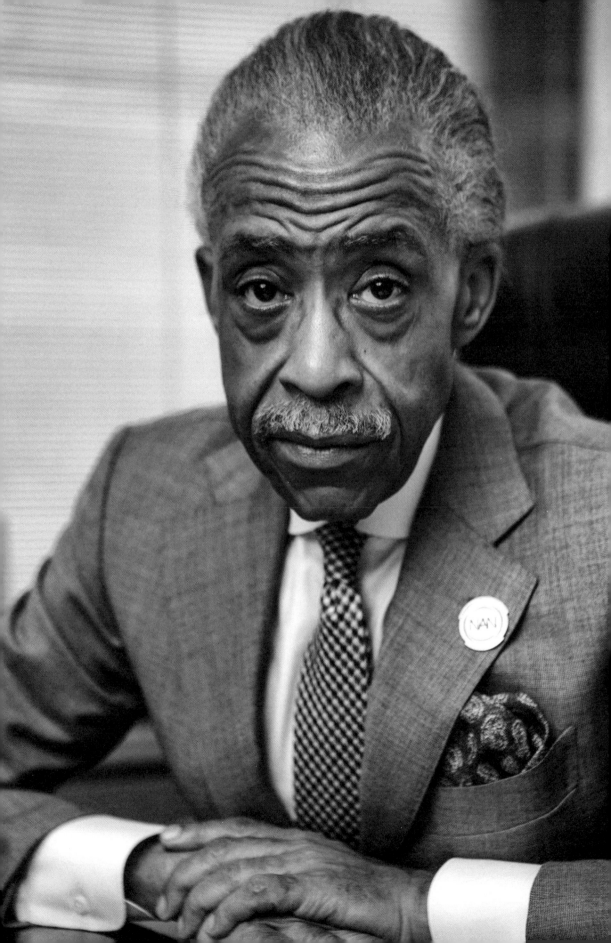

"Anytime I get discouraged, I think about how I felt sitting on that stage watching this brown-handed Barack Obama going by with the King James Bible to get sworn in. And think about all the people that died and never got to see that day. I owe it to them to keep fighting. Because they died. I'm still here."

—Reverend Al Sharpton

I was a boy preacher. Licensed when I was ten, and probably would have been a middle-class bourgeoisie black preacher. But God took me in another direction. My father was a business guy, and he abandoned us after he and my stepsister had an affair and had a kid. So, we went from middle-class, nice house in Queens, to living in the projects. That gave me the sense of knowing the other side. In the projects, the garbage was all stacked up; the city was not picking it up. I was outraged. I said, *They pick up the garbage every day in Queens where I lived.* So I organized a little picket line—I was all of ten years old. It was all kids. We didn't win. But I felt this energy around activism; it resonated with me.

I became mesmerized by Adam Clayton Powell [Jr.], who was the congressman and activist here in New York. So, I finally convinced my mother to let me start going to little rallies. But she became concerned that I was going to leave the church and went to my bishop who had licensed me, and said, "I don't want him out there with the militants." Because New York was dominated by black nationalist self-defense groups—the Black Panthers and others. And most of them were secular. He said, "There's a group of ministers under Dr. King that are in civil rights, let me take him to them." Reverend William Jones was the head of Dr. King's economic arm in New York, Operation Breadbasket, headed nationally by Jesse Jackson. They started mentoring me from when I was twelve, thirteen.

I'd be around the pillars of the movement—Reverend Ralph Abernathy, Reverend Jones, all two- and three-generation ministers—who had that lineage, had gone to the best schools. I didn't have that lineage. I think the reason I was attracted to Reverend Jackson was because he was the only one of that crowd that didn't have that. You know, he was born out of wedlock, just like I came out of Brooklyn when my father had abandoned us. I said, *I can't make up my father and granddaddy, why go to seminary and get the degree?*

So, I went the Jesse route: I opted not to have a church. My ministry was going to be doing social justice worldwide. I made that decision at thirteen. Sometimes in life you don't know what you're looking for, but you know when you find it. And when it connects it's like putting the password in your laptop: It just turns on, bing! Mine came on early. And it felt like home.

I felt my calling was to try and bring that movement into the northern urban setting. Because the country never understood that there was northern intrinsic racism. People don't see it because it's in pinstripes and it's on Wall Street, but it's just as bad. Then, when Bernhard Goetz happened, the subway shooter, and then Howard Beach, I said, *We're gonna march. We're going to go out there, doing King kind of stuff here.*

The reaction was different from the mass media. It's a lot harder when somebody's dramatizing against you or your cousin than it is [when it's against] somebody down South, because you can say, "Look at them, they're uncouth." But how do you say that about the neighborhood that you grew up in?

And every step of the way, from Howard Beach to Trayvon to Eric Garner, I've had to fight the northeast establishment media. So, of course, the attacks came in, because I'm pulling the veil off. People would say, "Oh, Sharpton just wants publicity." Exactly. Nobody calls me to keep their issue silent. Or, "You're a publicity seeker." You're doggone right! They used to call Dr. King that. I'm not comparing myself to Dr. King, but the public attention and publicity—that's a tactic. I have never been involved in a case, whether it was thirty-some years ago with Howard Beach, all the way to Trayvon Martin and Eric Garner, where the family didn't call me.

For years, you would have thought that I caused World War I, II, III, and the Korean War—all in one night. But they don't talk about how I got stabbed leading a march in Bensonhurst. I've been arrested at demonstrations maybe thirty times. Twice, I had to do thirty days in jail. Once, I had to do ninety days, for leading the sit-in in Vieques. So, when they come with all this "opportunism," who can pay you to take a knife in your chest? What they gonna pay you? Who can pay you to take three months in jail, away from your kids? So, yeah, you're going to be called an ambulance chaser. Yeah, you're going to be called an opportunist. That comes with the territory. But, at the end of the journey, I want people to say, "You know, he had flaws, he did right, he did wrong. Sometimes was too abrasive. But he did make the country deal with criminal justice. And he did bring the veil off of northern racism." The rest of the stuff, I'll accept. I can handle it.

I think you've got to be built a certain way to take the discomfort. You've just got to make a decision about what you're committed to and the tactics you really believe will get you there. And know that there's going to be an upside and a downside. But you just keep going. I tell all the young activists that make a good speech, do a great interview: *I may even put you on my show, but I want to see if you can take a punch. I want to see when you look at a front page, and they're lying on you, can you take that? I want to see when people you care about say*, "I can't be seen with you." *Can you take that? Can you take nights in jail when you don't know if anybody's outside?*

I got to know Muhammad Ali when I was a kid. And I remember I was down in Deer Lake, Pennsylvania. He had a training camp there. And I went into the gym one day and there was a guy in the ring that looked good to me. I said, *Champ, that guy's good. That guy'll be a champ one day.* And I'll never forget it. Ali said, "Well, he's good, fast, good left jab, but let's see if he can take a punch." Because real leaders have got to learn how to take blows, not just throw them.

You know, a lot of young activists today have to understand that, just like I come out of a King–Jackson tradition, they're not the first ones to do decentralized. That's what SNCC (Student Nonviolent Coordinating Committee) was. That's what Freedom Riders was. Dr. King never rode one bus with the Freedom Riders. Dr. King was not a member of SNCC. They used to call him "old guard." Out of Trayvon, Black Lives Matter (BLM) started, these

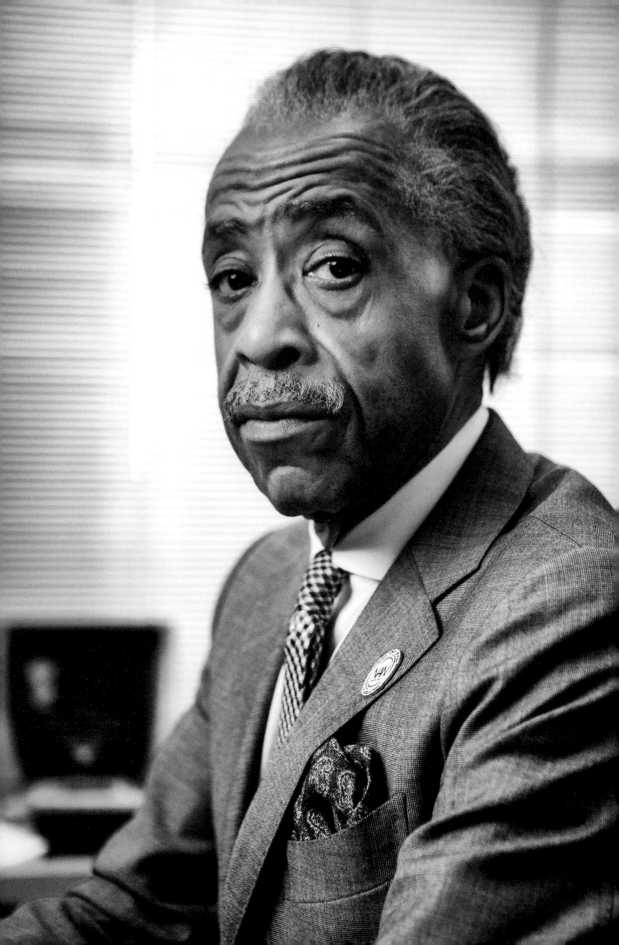

three very brilliant young ladies. And others picked up on it and there was the whole friction with them and traditional groups. And then we all calmed down and started saying, *Well, wait a minute, we may have different tactics but let's talk.* I would tell them: *This ain't new.* Martin Luther King didn't call the March on Washington—A. Philip Randolph did, who was in his seventies. Largest gathering of blacks in the history of the country, Million Man March in '95, Louis Farrakhan was sixty-two when he called it. So where do you all get this age stuff from? You all are not the first young activists questioning the old guard. We questioned the old guard. And there are young people in NAN, in the NAACP (National Association for the Advancement of Colored People), in the National Urban League (NUL), who disagree with you all—who believe in the tradition. Just like Julian Bond and John Lewis and Jesse disagreed with SNCC. So, don't act like you represent a whole generation. You don't. Stokely Carmichael, Jesse Jackson, John Lewis—all the same age. Don't fight. Don't argue. If we are sincere, we'll find a way to come together.

I always knew it was going to be a long struggle. I mean, they had the Montgomery [Bus] Boycott in '55. Didn't get the Civil Rights Act until '64. Took nine years. Ten years to get the Voting Rights Act. So, whether it's been racial-profiling laws that we eventually got, or stop-and-frisk, which we stopped in New York, they were all long and hard. But anytime I get discouraged, I think about how I felt sitting on that stage watching this brown-handed Barack Obama going by with the King James Bible to get sworn in. And think about all the people that died and never got to see that day. I owe it to them to keep fighting. Because they died. I'm still here.

Alicia Garza is an advocate on issues of
reproductive health, rights for domestic
workers, police brutality, racism, and violence
against trans and gender-nonconforming
people of color. Garza cofounded Black
Lives Matter (BLM) with Patrisse Cullors and
Opal Tometi in 2013, and is the director of
special projects for the National Domestic
Workers Alliance (NDWA).

ALICIA GARZA

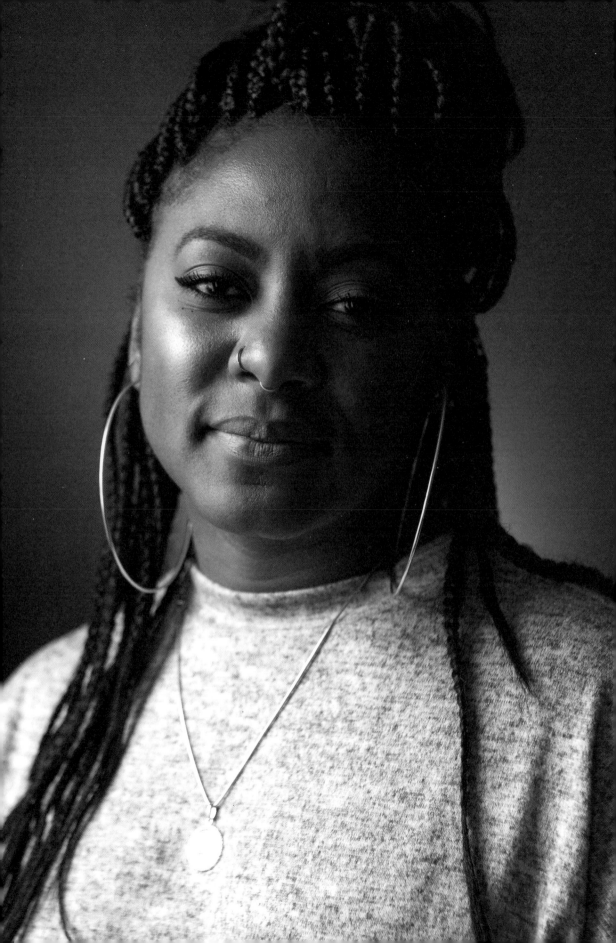

"More changes a
more suffering i
under any illusic
But what I am h
people won't ta

e coming, and
coming. I'm not
ns about that.
peful for is that
e it lying down."

—Alicia Garza

My mom has this thing where she doesn't sugarcoat stuff. She would tell me growing up that it used to drive her crazy how we use code words to talk about things. She was like, "The impacts of that are really serious." There's no "stork," for example. "Sex makes babies, and babies are expensive." That was her regular refrain to me. So, when I was twelve and there was a debate happening in my school district over whether or not to allow school nurses to provide condoms, I had strong feelings about it. Bush—the first one—had just instituted a global gag rule, cracking down on any public institution that had any kind of honest conversation about sex and the effects and impacts. So, I got involved. I did sex health education counseling with my peers and wrote op-eds in our local paper.

When seemingly unexplainable things happen in the world, like the murder of a child in the case of Trayvon Martin, we look for community. Black Lives Matter started from a post that I put on Facebook after the acquittal of George Zimmerman. I woke up in the middle of the night sobbing, just trying to process what had happened and wanting to find community around being in a lot of grief and having a lot of rage. I woke up the next morning to see that the post had been shared and liked and all these different things. And my sister Patrisse put a hashtag in front of it—I didn't even really know what hashtags were—which certainly helped to put the conversation out there much farther. I think it was shocking under the administration of the first black president of the United States, where everybody thought that electing Barack Obama marked this significant shift away from being a racist society. And I think what caught people's gut and heartstrings was that this could happen even if a black person was president. Right? People were moved in a way that inspired them to want to organize. People were contacting us, saying things like, "How can we be a part of this? We want to start a chapter. We want to be a part of this thing called Black Lives Matter."

Patrisse and myself and Opal were all organizers and had to figure out what our next step was going to be, because there was so much response. For us, building this project was both a reaction and a response to the murders of black people that happen every single day at the hands of people who have some kind of power, whether it be social, political, institutional. But we also wanted to create a space for black people to dream about the world that we deserve to live in. To come together to try to achieve that world together. And we don't pretend that we were the first people to come along to give a shit about violence against black people. I mean, people have been organizing around this for a really long time.

I'm often surprised at how many people care and want to get involved, and they've just never been asked. Like, I've been in conversations with family and colleagues where I say to myself, *Wow, I assumed that that wouldn't be something that you cared about*. And silly me for assuming that. But the best advice I ever got as an organizer was that, if you can organize your family, you're a good organizer. Because it's not just rhetoric then. These are the people we care for most. The people who changed your diaper,

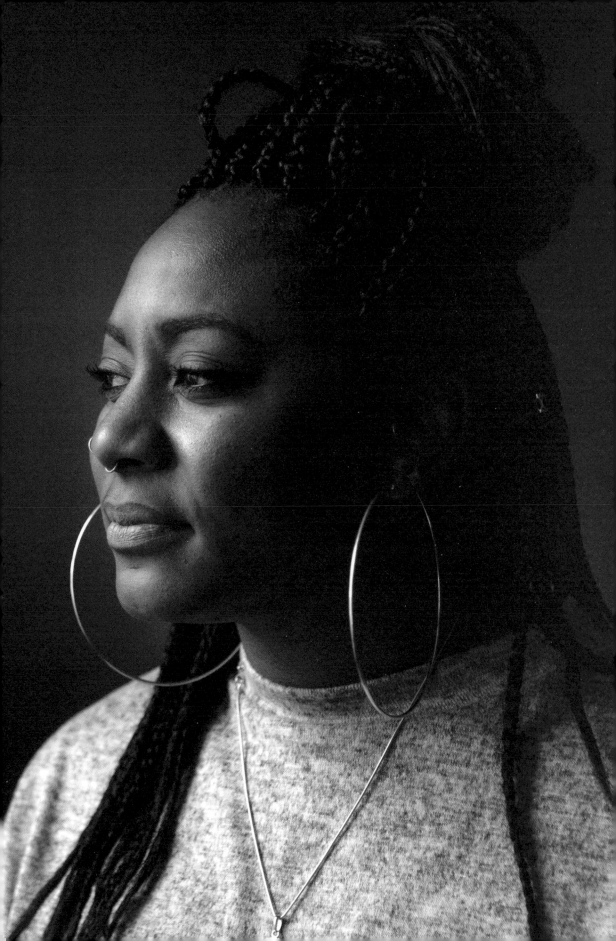

the people who loved you at your ninth birthday party. And if they know that there's something that's really important to you, it does have the potential to change—not just minds, but the way that people act politically. So, when people say, "Well, I don't talk to my family because they're all conservatives" or "I don't talk to my family because they're racist," I'm like, *No, no, no; that's exactly who you need to be talking to.* Because the only person who's going to stop them from sending me death threats is you.

These things happening now at the federal level are literally impacting whether or not people live or die. But it makes me incredibly hopeful that people taking care of their own lives, trying to make ends meet, are now suddenly like, "How can I be involved?" I think that's important. And I feel optimistic—it makes me feel weird, but I do. Maybe it's the thing that kind of keeps me going. You know, my mom would say denial is not just a river in Egypt, right? More changes are coming, and more suffering is coming. I'm not under any illusions about that. But what I am hopeful for is that people won't take it lying down.

"People were contacting us, saying, 'How can we be a part of this? We want to start a chapter. We want to be a part of this thing called Black Lives Matter.'"

—Alicia Garza

Dubbing themselves the Citizens' Commission
to Investigate the FBI, Bonnie Raines and
her late husband, John Raines, along with
six others, broke into an FBI office in Media,
Pennsylvania, in 1971. The group stole its files
in order to expose illegal activity and abuses
of power, including COINTELPRO, which
targeted political activists. They were never
caught and remained silent for forty-two years
before their involvement was inadvertently
disclosed—long after the statute of limitations
had expired. Their actions are chronicled
in the book *The Burglary: The Discovery
of J. Edgar Hoover's Secret FBI* and the
documentary film *1971*.

BONNIE RAINES

I met John when I was a junior in college. He was eight years older and had been a Freedom Rider. We found we had so many values in common. And ideas about what we wanted to do with our lives. A year after we met, we were married and went to New York, because he was going back to Union Theological Seminary to finish a Ph.D. It was in New York that John and I began to really find some very specific ways together to be activists. Activism around apartheid and, of course, the civil rights movement and passing the Voting Rights Act.

John took a job at Temple University here in Philadelphia in 1967. Philadelphia was a good place to live at that time as an activist, because there was a lot going on—the combination of the Quakers, the so-called Catholic left, and all the universities and colleges in the area. There was just an expectation that, unless you were brain-dead, you would see things that needed to be addressed and jump in.

Draft resistance [to the Vietnam War], was very much centered in Philadelphia. One of the people most involved was one of John's graduate students, and she invited us to come to a meeting with other folks in the movement who were planning an action to break into a draft board in the middle of the night, remove draft files, and destroy them—it was just a paper system at that time. It seemed a good way to disrupt the draft. We both agreed to participate. And it was successful.

But, of course, then the war just continued and worsened, and none of the peaceful protests that we were involved in—rallies in Washington, petitions— none of that was making any difference. It was getting worse. We'd learn how much we were being lied to about the war. And also realized that, here in Philadelphia, the FBI had a massive surveillance operation to infiltrate and intimidate the peace movement. They had agents sitting in professors' classes. They were opening people's mail. Just a massive system of intimidation and surveillance. You knew that that was happening. But there wasn't any way to substantiate or stop it.

And then this brilliant colleague, Bill Davidon, who was a physics professor at Haverford College, and had been very active in the disarmament movement and then in the civil rights and anti-war movements, called a few of us together who had been active in the draft-resistance movement, and invited us to his house. He posed an idea that perhaps the only way we could show what the FBI was doing was to get documentation. And the only way to do that was to get documents. And the only way to do *that* was to break into an FBI office and remove files and documents.

Well, if it had been anybody but Bill, I would have said, *That's impossible.* But he was such a brilliant strategist. And he was not reckless. So, we really did think about it seriously. There would be no way we could get into the FBI office in downtown Philadelphia, because it was in a government federal building. But, we found that there were field offices scattered around. And one of them was in Media (Pennsylvania).

We did a lot of casing. But we needed to know whether there were security systems inside the FBI office, and about the layout of the offices. That part of the plan was my piece, which was to call the office and say that I was a Swarthmore College student doing research on opportunities for women in the FBI, and could I come in and interview the head of the office about that.

They were very cordial, and they gave me an appointment, and I went in. I had this long hippie hair and I tucked it all up inside of a big winter hat. I wore glasses that didn't belong to me, so I could hardly see. And I never took my gloves off while I was taking notes in my little notebook. It gave me a chance to look around, to see if there were any security devices and what kind of locks were on the doors. There were no locks on the file cabinets. I mean, it was just like a business office. So we said, *Okay, we can probably move ahead.*

John and I talked at length about it. We had three children under ten at the time. But we felt pretty confident about the feasibility of it, and about the people that Bill select[ed]—that we could trust them. When the film is shown, or the book is discussed, people always ask, "How could you have put those children at that kind of risk?" We were anxious. I mean, we had to think about the worst-case scenario. We talked to John's brother and his wife about the children. We said, *We're going to be doing something with a lot of jeopardy—* we didn't tell them what it was because if they were called before a grand jury, they could just say, "Well, we didn't know." But, we said, *If we should be arrested and sent to prison, could you take care of the children?* And they said they would. But we felt compelled to do it—and we weren't going to be reckless. We weren't going to be martyrs. Once we accomplished what we wanted, we could just go back to our regular lives. But you need whistleblowers in a democracy. And we felt that that was part of our role as citizens.

One of the reasons they didn't find us after the burglary was that we had left no physical evidence in the office at all. People who went in to remove the documents were wearing gloves. Then we went to a Quaker retreat center about an hour outside of the city to sort the files—wearing gloves. Pretty quickly, we realized what we had. Only about 40 percent of the documents had anything to do with legitimate crime. And 60 percent were political in nature. So we picked the most shocking, incriminating documents and we photocopied them and sent them to the *New York Times*, the *Washington Post*, the *Los Angeles Times*, and two politicians. Everyone except the *Post* sent them to the FBI. Although, we learned later that the reporter at the *Los Angeles Times* never even received the documents; someone in the mail room never gave them to him.

In one document, agents were instructed to increase the paranoia among left groups to have them think that there's an FBI agent behind every mailbox. That was stunning. We learned about a switchboard operator at Swarthmore listening in on professors' calls, and mail being opened. There was a couple at some college who were active, and the FBI circulated a rumor that one of them was unfaithful and broke up the marriage. They were proud of that.

"We were very fortunate that we could always locate ourselves within a community of people who were serious about their roles as citizens—a community of resistance."

—Bonnie Raines

Those were the kinds of dirty, dirty tricks that they were doing. Other documents were strategies of massive surveillance of black communities, simply because they were black. They had agents everywhere—in churches, schools, libraries, barbershops—watching and spying on black communities.

And then there was also the horrible example of Hoover urging Martin Luther King to commit suicide. It came out. And one more thing that was learned when reporters finally began to look seriously at FBI abuses was that not only did the FBI want to destroy the Black Panther Party, but they arranged for the head of the Black Panther Party in Chicago, Fred Hampton, to be assassinated. It doesn't get much worse than those kinds of examples.

Ultimately, one of the best results was the congressional committee that held hearings on the need for oversight of the FBI and the CIA. And there were new regulations that were approved that we desperately needed. That's when the whole story of COINTELPRO came out. We didn't know what that word meant until an investigative journalist found out what COINTELPRO was and how terrible it was.

I don't think I was cut out to be on the sidelines when something is very disturbing. I suppose I would have been content to effect change in smaller ways, which is just fine. But we were very fortunate that we could always locate ourselves within a community of people who were serious about their roles as citizens—a community of resistance. I do think that average citizens need to think of themselves as protectors of our democracy. Sometimes there are laws, such as segregation in the South, that you have to break in order to change the system.

We told [our children] about the burglary when they were older teenagers—and we told each of them individually—because we thought, by then, they could sort of put it in perspective. And they understood that they weren't to tell anybody about it. They were pretty surprised, and also very proud. I think they saw it as an example of what a difference an ordinary citizen can make. That was, in so many ways, the message that we wanted to get across. That since no one in Washington was going to hold Hoover accountable, then it was up to ordinary citizens to do that.

"They had agents everywhere— in churches, schools, libraries, barbershops— watching and spying on black communities."

—Bonnie Raines

Bill McKibben is an author and
environmentalist who cofounded 350.org,
the first planet-wide grassroots climate
change movement. He spearheaded
resistance to the Keystone Pipeline (KXL)
and helped launch the fossil fuel divestment
movement. He is the author of several books,
including the recently published *Falter: Has
the Human Game Begun to Play Itself Out?*
McKibben is the Schumann Distinguished
Scholar at Middlebury College in Vermont,
where he teaches environmental studies.
He has received numerous awards, including
the Right Livelihood Award in 2014.

BILL MCKIBBEN

"We should try so
a movement on t
occasionally in A
or world history,
been able to coi
lack of money ai

mehow to build
e theory that
nerican history
movements have
pensate for the
d political power."

—Bill McKibben

My first job out of college was at the *New Yorker*. I was mostly interested in the issues of the city—homelessness above all. So, I was not really an environmentalist. But I wrote my first long piece for the *New Yorker* about where everything in my apartment came from. I followed all the lines. You know, Con Ed[ison] was getting oil from Brazil, so I went down to Brazil, and up to the Arctic, [where] they were getting hydropower. Along the New York City water system, and out on the garbage barges, in the sewer systems, and so on. And it had the interesting effect of making me realize, for the first time, I think, that we lived in a physical world. I had grown up in the suburbs. Suburbs are kind of a machine for hiding the operation of the physical world from you.

Somehow, doing that reporting impressed on me not only the physicalness of the planet, but the fact that these were somewhat vulnerable systems, more fragile than I had assumed. That set me reading the early science on climate change. I was also reading Wendell Berry and Ed Abbey. And thinking a lot about what environmentalism meant, and didn't, and so on. And so that hot summer of 1988—at the time, the hottest in American history—it all very quickly came together. And, within a matter of months, I wrote *The End of Nature*, the first book about this subject for a nonscientific audience.

I guess I thought that that was my contribution to this purpose. And I kept writing about it. But, at a certain point, it became clear to me that writing another book was not going to move the needle on this—that what had started out as an argument no longer was. The argument was over. The science of this was entirely clear by the mid-1990s, really. But people like me—writers and academics—were still treating it as an argument, because that's what we knew how to do. You know, the answer to all questions is another symposium, another article, another book, another speech, whatever. It took me a while to figure out that there was another side here—and that it was winning. And it was not arguing; it was fighting. The fossil fuel industry, which is the richest industry in human history, the most powerful, having lost the argument was easily winning the fight. Because the fight was about money and power.

So, I thought that we should try somehow to build a movement on the theory that occasionally in American history or world history, movements have been able to compensate for the lack of money and political power. I knew that what we called the "environmental movement" really wasn't a movement anymore. That it had sort of coalesced into a series of organizations, all of them fine, but none of them set up for [this] kind of mass persuasion.

The first iteration came after a trip to Bangladesh that really sort of shook me in a lot of ways. I contracted dengue while there—their first outbreak. But I didn't die, because I was plenty healthy going in. A lot of other people did. And what was shocking about it, of course, was the thing that's always most shocking about climate change—that people who have done the least to cause it suffer the most. You can't even really get a number for how much carbon Bangladesh [produces]—I mean, it's just a rounding error on the global tables. But the country's going to essentially be wiped out.

So, I just asked people to come on a march. We walked for five days, and by the time we got to Burlington, there were 1,000 people marching, which is a lot of people in Vermont. But I knew that there were lots of people in lots of different places. So I said, *Maybe we should try and do really dispersed actions all around the world.* We tried it first in this country in '07. And it worked. And so, with beginner's luck, and being highly irrational, we said: *Let's do this around the whole world.* And that's when we formed 350.org. In the fall of '09, we had 5,200 simultaneous demonstrations in 181 countries. We were telling everybody, *As soon as you do your demonstration, upload a picture of it.* The images were amazing. But the problem with climate change as an issue is it's the first issue with a time limit that we've come up against. And so, we felt very strongly the need to keep kind of upping the ante. So we moved from rallies into more direct confrontation with some speed.

We helped start the national fight over the Keystone Pipeline. The First Nations Indigenous people in Canada and some of the farmers and ranchers in Nebraska had been working hard on [stopping] this pipeline. But it hadn't become a national issue. Because the odds of beating it seemed incredibly small. The oil industry had never not gotten to build something they wanted to build. Literally, ever.

My instinct was that we might be at the place where there were people concerned enough about this for civil disobedience. And the minute we all had been tossed in jail, the number of other people who showed up to do this went through the roof. Over the next two weeks I think 1,253 people went to jail, which may have been the biggest civil disobedience action in those terms in a very long time. And it was moving to see people willing to do that. Within a few months, we had 20,000 people circling the White House, and then 50,000 in a rally outside. It demonstrated that you actually could fight these guys. And pretty soon everything was getting fought by everyone. So now, not a pipeline, not a coal port, not a frac well gets built pretty much anywhere in the world where you don't get shot for this kind of stuff, without people opposing it, and hard. And what amazes me is, often when you fight, you win. Which hadn't occurred to me.

So, the irony of all of this is, this is not my work; I mean, I'm a writer, which means I'm an introvert by nature. I got pretty good at giving a speech. But left to their druthers, writers are people who would like to sit in a room and type; it's a strange affliction. For certain kinds of people, it's just the opposite, you know? If you watch real politicians walk into a room, if they shake a hundred hands, somehow a small quanta of energy goes from each hand into them. But with me, if I shake a hundred hands, I'm pretty worn out, like: *Time to go sit and read.* So, I've spent a lot of the last five years trying to put the spotlight on other people. And now, happily, there's a ton of new activists. And they're all younger and more interesting, very diverse. One of the things that's been really fun is that, because 350 is truly global, I end up most years doing some organizing in other places—often places earlier on the kind of organizing curve. So I can still be useful.

"We'll continue to work very hard. But we're not going to get out of this anywhere near unscathed."

—Bill McKibben

It's been fascinating to be a tiny, little part of the movement. It would be a big overstatement, however, to say that it's winning. There's been really great reporting recently about the history of the fossil fuel industry. It turns out that they had all the science. Their product was carbon, they knew it, they understood it. And they decided to mount an absolutely full-fledged, full-throttle effort to make sure that nobody came to understand what was going on. The amount of money, time, and effort they invested in obfuscation and denial turns out to be staggering. And successful. They delayed, by a generation, action on this. And I think it's entirely plausible that that may have been the last generation we really had to deal with this.

We'll continue to work very hard. But we're not going to get out of this anywhere near unscathed. And the sad truth is that Mother Nature is a very powerful educator. Last fall, some combination of reports from the UN (United Nations), the ongoing idiocy of Trump, and those California wildfires combined to change something. And we're at a moment—some kind of new inflection point. Let's see what we can make of it.

Cecile Richards is a pro-choice advocate who retired in 2018 after twelve years as president of Planned Parenthood. Previously, she was deputy chief of staff to Congresswoman Nancy Pelosi (D-CA), founded and served as president of America Votes, and was a labor organizer. She is the daughter of the late Texas governor Ann Richards. She is the author of *Make Trouble: Standing Up, Speaking Out, and Finding the Courage to Lead.*

CECILE RICHARDS

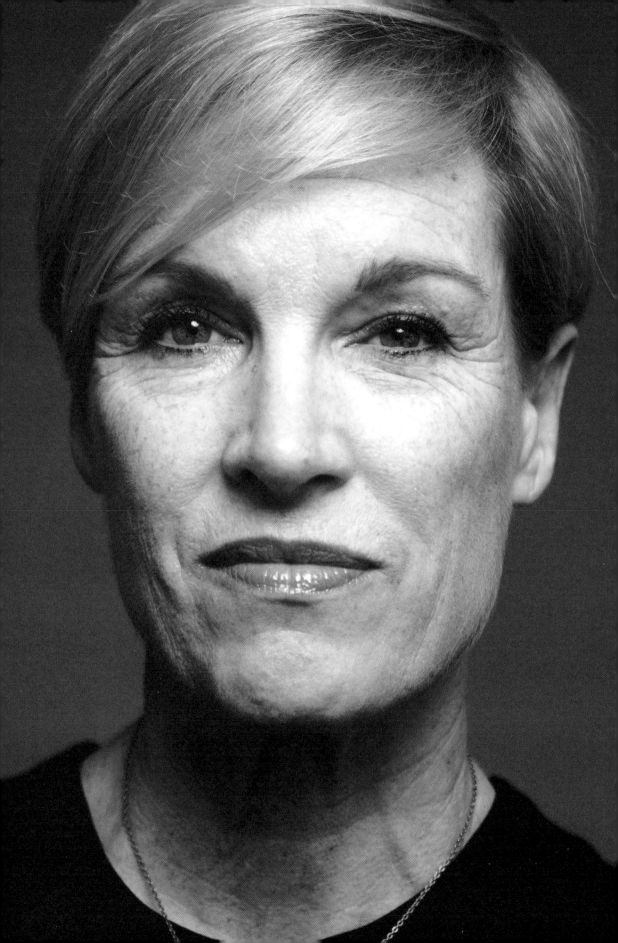

"People in this c
the very least a
and I think that
of lessons from

untry who have

e so courageous,

e can learn a lot

hem."

—Cecile Richards

I grew up in Dallas at a time [when] it was very conservative, and my parents were liberals and beginning to get into progressive politics, the labor movement, the civil rights movement. So, I did learn from an early age that it was okay to be against what was happening. Fitting in was never a priority. Like, usually you go to the grocery store, you don't want to be noticed. But that was not my mother's MO. When the farmworkers were organizing, my mother would march into the grocery store demanding to see the UFW (United Farm Workers) label on the lettuce—and refuse to buy anything that didn't have it. I think that did give me the ability, when I didn't agree with things later on in life, to be able to say something. Because I saw there was a path.

We were living in Dallas when President Kennedy was shot and that, I think, changed everything for my parents. It didn't seem like an isolated, freak occurrence. There was so much animosity, hatred toward the Kennedys, just racist, right-wing hysteria. So, when the president was assassinated and then when [Lee Harvey] Oswald was killed by [Jack] Ruby, it felt like the world was just coming apart. That made a big impression on me. But my parents didn't then retire and go and open a dairy farm somewhere; they just sort of got back into it. And I think that's another theme that, thank goodness, I also learned: You're going to lose a lot more than you're going to win, but it is really important to stay in the fight, because that's really why we're on this earth. That gave me this sense of purpose about my life, for which I'm eternally grateful.

My own first activism was seventh grade. The Vietnam War was going on. And I had learned there was going to be this big moratorium against the war and folks were going to wear black armbands in opposition. I remember getting on the school bus—I feel like it was yesterday—and thinking, *What are people going to think?* I was new there and didn't know anyone. I got to school and right off the bat, the principal stops me and says, "Do your parents know what you're doing? I'm going to call your mother and talk to her." Of course, I still think that was his biggest break, that Ann Richards wasn't there when he tried to call. But I remember feeling like, *That's kind of scary, because I'm not used to being in trouble.* It was also exhilarating. I thought: *This guy's paid attention to me now, just by the simple act of me wearing this armband.* And over the years, whenever I've poked my head up or raised my hand to say*, I think this isn't right*, I have always been amazed by the people who come up and say, "You know, I was thinking the same thing."

For many years, I worked with women in the labor movement who had no options. Their pay was terrible, benefits were nonexistent, and the treatment—you talk about sexual harassment! Yet, these women found it within themselves to somehow make time between taking care of their kids, their mother, and everybody else, to try to organize to make something better. To me, people in this country who have the very least are so courageous, and I think that we can learn a lot of lessons from them. It's why I'm not the best at some of the millennial issues of, you know, work–life balance. It's like, I'll tell you what work–life balance is: It's working two shifts every day and somehow managing to take care of three kids. That's work–life balance.

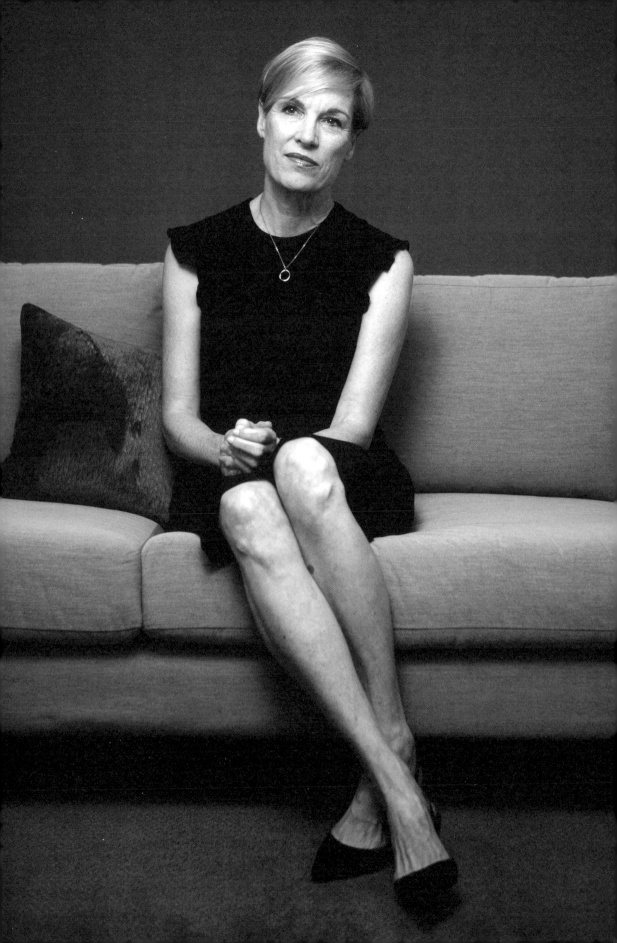

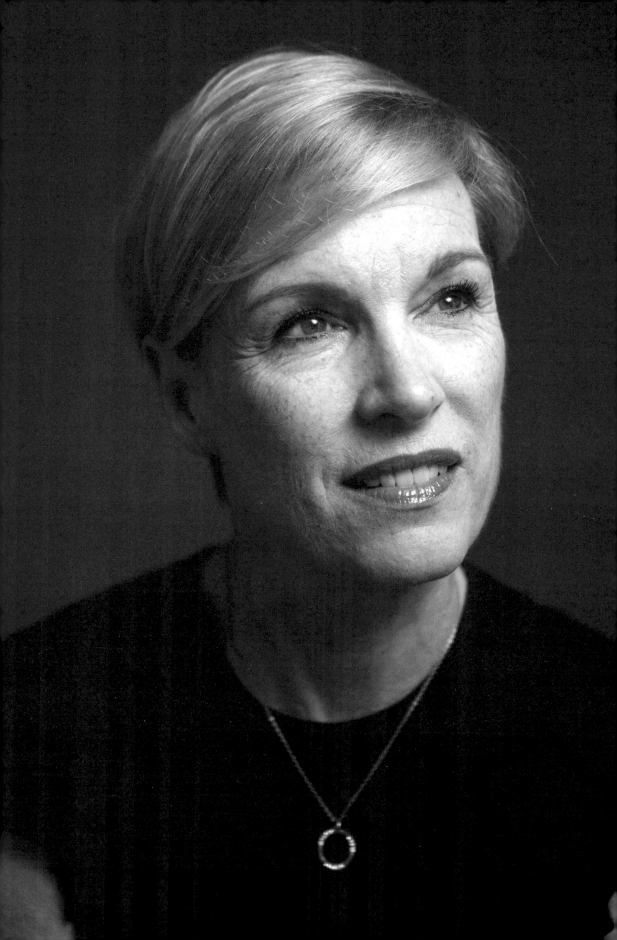

You know, people ask all the time, "Isn't it hard to be always the center of controversy?" But one thing I try to dispel is: I'm not pro-abortion or anti-abortion. I just believe that this should be a decision that people get to make. Some groups don't believe abortion should be an option. They don't believe in birth control, in large part; don't believe in sex education. So, where's the common ground? Common ground in this country could be reducing teenage pregnancy. We're now at a historic all-time low. And that didn't happen because teenagers just quit being interested in sex. It's because we started a more intentional effort—collectively. Yet, now this government is trying to dismantle sex education and teen-pregnancy prevention programs. So, if I have twenty-four hours in a day, my time is better spent bringing together people who aren't engaged in voting and having their voices heard than trying to convince people who just fundamentally disagree with pretty basic precepts about fundamental rights.

I mean, look, I talk to people in office who don't agree with me—not to folks probably on the far edge—but I talk to members of Congress, and I try to listen to them, try to educate them. But right now, the vast majority of this country needs basic things, including access to affordable health care. And I think that's probably where I'd rather spend my energy and where it would be, frankly, more effective.

To me, this moment is about a lot more than simply, *Can we just all get back to normal?* This is the moment for women to say, "Actually, what we're pushing for is true equity." And that's going to be a lot more than the next election. But I think it's why it's an exciting time. Instead of just nibbling around the edges, like, "Can we get another ten cents an hour?" I think women are now disrupting—economically and politically and culturally—in a way that I've never seen. Saying, "We're better than this. This is not the country we want to raise our kids in." And I hope we don't settle for half a loaf.

I hope to take all the learnings and relationships we've built over these years to get people doing things together. So people don't feel so siloed and isolated. And I think it's important for people doing even harder work than abortion rights—which is pretty hard—people dealing with criminal justice issues in the black community. Or transgender rights. We all need to be doing that. So, if you're a Planned Parenthood activist, go to a Black Lives Matter meeting. Or go to a local church that's dealing with incarceration. Or volunteer with the LGBTQ community to do a phone bank. Something. Because the way this is going to change is not just because we're going to say, *These issues all line up together.* It's going to be because we say, *We're all the same people.*

Cecile Richards

77

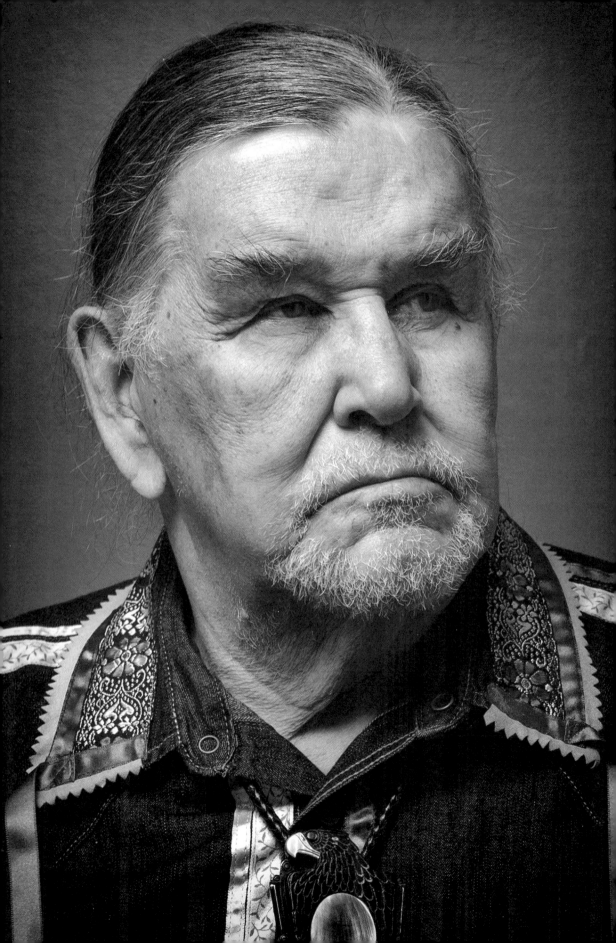

Born on the White Earth Reservation, Clyde Bellecourt is a member of the Mississippi Band of the Great Anishinaabe Nation and a cofounder of AIM, the American Indian Movement. His spirit name is *Neegawnwaywidung*, meaning "the thunder before the storm." He has worked to promote Indian rights for decades and lives in Minneapolis, Minnesota.

CLYDE BELLECOURT

I had dreams when I was in prison. About being electrocuted, guillotined, and all that kind of stuff. One day, I was in solitary confinement. It's total darkness. There's a little peek hole where they could come and look at you when they're doing a count and stuff. And I heard a guy whistling. He was whistling, "You Are My Sunshine." I was [thinking]: *What the hell is wrong with this guy*, you know? *Who the hell does he think he is?* I went and peeked out the hole, and it was a full-blooded Indian guy. Eddie Benton-Banai. And he was asking, "Is there a Clyde Bellecourt here?" I didn't want to talk to nobody. I wouldn't talk to him.

So, next day, he came again. Started calling my name. I got irritated. I said, *I'm right over here.* Next thing I knew, we were looking at one another's eye. I said, *What do you want?* He told me about a caseworker named James Donahue who had almost all the Indian cases in there—for some reason he really liked Indian people. So him and Eddie got together, they did a study, and found out that every single Indian in this institution was a repeat offender. They did the most time. They would go there for the lower crime. For alcoholic-related crimes. Runaways like myself. So they decided they were going to start an Indian studies program. They figured if they could get them into a class and start studying their culture, tradition, contributions to modern-day society, that we'd want to get out and do something about our alcoholism and skills and technical trade.

I knew it was the right thing to do, and I knew that Eddie knew what he said. But I said, *I don't know anything about being Indian.* If somebody said something bad about Indians, they got to fight me over it, you know? But I was never taught anything. Absolutely nothing. My mom spoke the Ojibwe language fluently. I'd hear the old people come to the house at night, you know? Big Bear and Mrs. Smith and all my mother's friends. I'd be awake listening. I could hear them greet one another in a

strange language. They'd start telling stories in Ojibwe. And they would laugh so hard, they'd be crying, falling right off the damn chair. My mother was in the boarding schools for nine years. She went in when she was a little girl and came out [when] she was nineteen years old. They tried to take her language. And one of the ways they did it—not just her, but hundreds and thousands like her—they would give them a little pail of soapy water and a toothbrush. They had to clean out the urinals and the toilets every time they got caught speaking Indian. Toward the end, they tied socks of marbles on their knees. She had arthritis from the punishment that she went through, but she never gave up her language. I asked my mom why she never taught us. The reason was because she didn't want us to be punished.

But no matter who you are, if you don't know anything about your culture or tradition or where you come from, you don't know the truth, you don't really enjoy it. So, I said to Eddie, *I'll help you do all that.* They knew they couldn't do it without me because I knew all the Indian inmates from Red Wing State Training School, St. Cloud Reformatory, and Stillwater State Prison. Same Indian people over and over doing time. I knew every single one of them after fifteen years of my life in correctional institutions. They wouldn't listen to Eddie or this Irish caseworker, so they would send them to me. I would start organizing them, getting them into skill[s] and technical trade, dental technicians and taking correspondence courses. Find out why they're there and how they could change.

You know, Indian people face a lot of discrimination in the prison systems in America, but we started making change. Started learning about the whole Midewiwin way of life, the heart way of life for the Anishinaabe people. We started the practice of looking out for one another and helping one another. So, I co-chiefed that effort. And now at every prison in America, federal and state, they've got Indian

folklore groups. And all these people that were doing prison terms, they weren't coming back anymore. All of a sudden, I started feeling good. I knew what I was fighting for then. And it was worth the fight.

We formed the American Indian Movement (AIM) in '68. People start talking about, "Well, how were we going to [make] change?" Martin Luther King's got millions marching all over the world. Who have we got? You know, a pitiful thirty, forty people? And I don't know where it came from. Must have been the creator. I [said], *We'll do it through confrontation politics.*

I didn't even know what the hell I was saying. This elderly lady said, "Well, what does that mean?" I said, *It means when there's somebody that gets shot by the police in our community, we go down and deal with the police chief and the city council and all that. And you knock on the door. And if they don't hear you, you [knock louder]—if they don't hear you then, you push the damn door down. And when you go in, you got to have it together with what treaties and agreements are made between two nations and all that—you got to quote that.* And when I told them that, half of them ran out the damn door. They wanted nothing to do with me. They were so scared of the things I was saying. You know, because they didn't ever confront the police or anybody. But that's what we're going to do.

I had a press conference the next day, and that's when I told them, you know, *We're going to do it through confrontation politics and we will stand on our treaties.* Elliott Abrams was secretary of state, and Tricky Dick [Richard Nixon] was president, and J. Edgar Hoover was the head of the FBI. And I told them, *We're not going to get down on our knees anymore and beg nobody for nothing.*

So, we formed AIM patrol, and people started coming. Almost every county and town here, somebody—some member or relative or family—was either shot or beat-up or in jail. So the first program I put together was

the Legal Rights Center. It was a joint effort between us and the black community. We would have attorneys on hand at all times. It's still there today. We'd stand up for our hunting and fishing rights, make the government live up to them. We started making our mark. We took over the BIA (Bureau of Indian Affairs) in Littleton, Colorado, and eight more BIA offices [in] Washington, DC. And then, of course, we took over Wounded Knee. It was supposed to be a peaceful occupation. But the very next morning, I counted twenty-eight armored personnel carriers. And then two jets come flying right over us. Buildings and everything were shaking. They had all these law enforcement agencies, and these right-wing groups. They gave us until five o'clock the next day to get the women and children and traders [out].

We called a big meeting and we asked for the women and all them to leave. And this old lady, whose name was Gladys Bissonette, she got up and went over to the head of our security and jerked the rifle out of his hand. She said, "All right, Mr. Bellecourt, I called you [to Wounded Knee] because there was no one else I could call. You did what I asked you to do. And us women, we're not going to leave here. I'm going to stay here and the other women here with me, they're going to stay. We're never again going to look the federal government in the eye and beg them for anything. We're going to get it on right here." Seventy-eight, eighty years old. Not one person left. And that's when we started to arm ourselves, because we knew what we were up against. And we started digging bunkers all the way around. Luckily for us, all three branches of the news media, ABC, NBC, CBS, went into Wounded Knee with us and were caught inside when they surrounded us. Which was a blessing in disguise: it would be on the news all over the world.

It turned out to be a seventy-one-day occupation. I left on the fifty-first day to go out and set up the Wounded Knee Defense Committee. I said, *It has to be called the*

"No matter who you are, if you don't know anything about your culture or tradition or where you come from, you don't know the truth."

—Clyde Bellecourt

Wounded Knee Defense/Offense Committee. We're going to put them on trial. Not us. They're the guilty ones. They never did anywhere in America what they did to us—they had snipers and Green Berets and everybody. They wanted to get rid of us. That's why they lost: Illegal use of federal forces. They can't just take [out] anybody, anywhere, without congressional or presidential approval.

They wanted to use me as an example. "What's going to happen when you die?" and all that crap. When I was laying in a ditch in Wounded Knee, they knew I was there. It was a hot day, and if I moved anywhere, they were going to kill me. So I just laid there until it got dark.

And, when them bullets were hitting in the gravel road, that gravel was flying all over my head. I thought I'd never walk out of there. They thought they could kill the chiefs and things were going to stop. They still got that old thinking, you know. They don't know about all the young people. Women leaders. Thousands of people who can take over. I don't worry about it at all. I knew I was doing the right thing. And once you make up your mind, you got to do it. You got to put your life and your body on the line. People were saying, "It's a good day to die." I wasn't saying that. I said, *What are you talking about? That's what they want us to think—that it's a good day to die. Bullshit. It's a good day to live.*

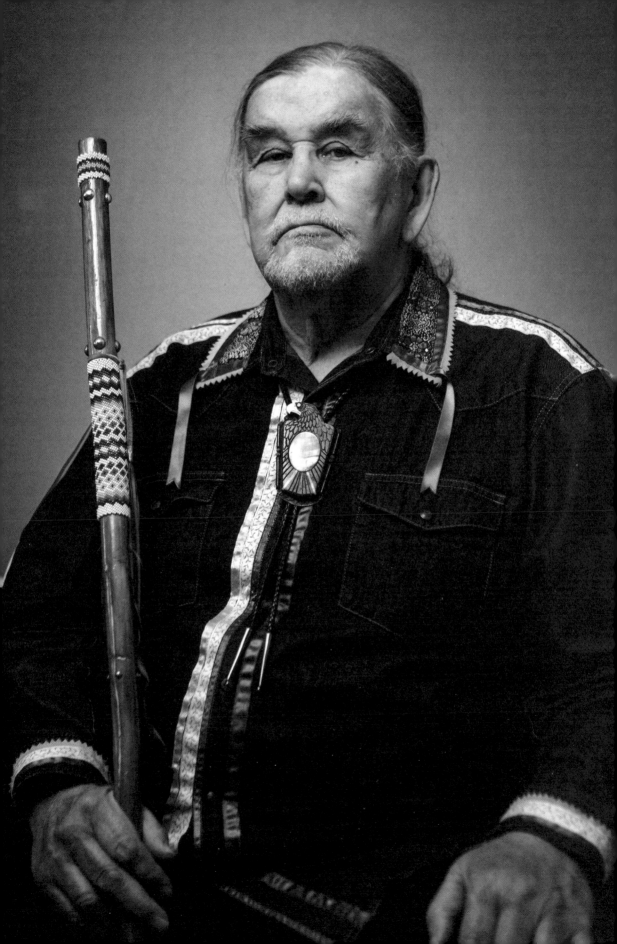

Dolores Huerta rose to prominence as an organizer, labor leader, and civil rights activist in California. In 1962, she and Cesar Chavez founded the National Farm Workers Association (now United Farm Workers, UFW), through which they led boycotts and negotiated better conditions and pay for farmworkers. Her famous call to action, *"Sí, se puede"* or "Yes, we can" (used by Barack Obama in his run for president), is often misattributed to Chavez. Huerta received the Presidential Medal of Freedom in 2012.

DOLORES HUERTA

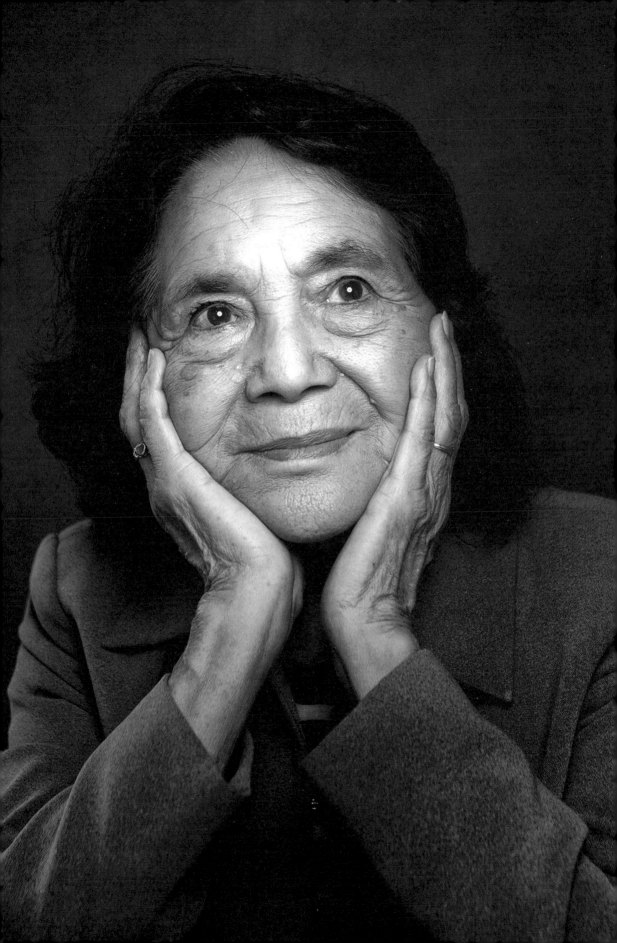

I was actually very shy as a child, but my mother was always pushing me to get out there and be active. So I got involved in a lot of organizations in our community—the Girl Scouts, a church club called the Teresitas after St. Teresa, a club called Azul y Oro. We would sing at the hospital, do dances and raise money, and then give out Christmas and Thanksgiving baskets. In high school, I organized a teen center. A lot of my friends were poor and didn't really have money to go places. We brought in a jukebox, table tennis, just trying to create a space where kids could come together and socialize. But the police shut us down. They didn't want the interracial [associating]—we were a very multiethnic group. We had white kids, African American friends and Asians, Filipinos, and Mexicans, all together.

All the time I'd been doing the social organizing and never been able to do anything that I thought really changed things. But in college, one of my professors invited me to this house meeting with a man named Fred Ross. Mr. Ross was organizing the Community Service Organization (CSO). He showed us how they had brought street lights and clinics into East Los Angeles, how they had organized to get a Latino elected to the City Council, and showed a picture of how they had sent these police to prison for beating up Mexican Americans. That meeting really transformed my life—I had to belong to that organization, you know?

Pretty soon I was volunteering with CSO every single day. I set up house meetings, would register voters, went to Sacramento to lobby. I became the legislative advocate and then political director. We passed a lot of amazing pieces of legislation: driver's licenses in Spanish, the right to vote in Spanish, being able to do door-to-door registration, that you did not have to be a citizen to get public assistance, aid to the blind and disabled, aid to needy children. We took on all different issues with CSO, but the farmworker issue was the one that really got me. The fact that ordinary people—poor people, farmworkers—have that power to make changes in the community. Both Cesar Chavez and I wanted to organize a farmworkers' union and CSO didn't support us on that, so Cesar and I resigned.

Talk about a big moment: I'm going through a divorce—my second husband was not very supportive of the work I was doing—I had seven kids by then. And I make a decision to go to Delano (California), leaving a job with stable income and not knowing literally where our next meal was coming from. It was a big risk, a big decision. But I did it. And Cesar and I, we started the union. The only thing that worried me was my kids: Was I doing the right thing by them? Because I had a wonderful middle-class upbringing—music lessons, dance lessons, able to go to movies and all that. And my kids, we had really come down to the poverty level of the farmworkers. Cesar's wife, her sister would go down to the food bank and get the beans and rice, oatmeal and cornmeal so that we could eat. But the end result is what inspires you. When you're organizing people, and convincing them that they have power, that they can actually make changes in their own lives, you see leaders develop—that payoff is just incredible.

Dolores Huerta

"When you're organizing people, and convincing them that they have power, that they can actually make changes in their own lives, you see leaders develop—that payoff is just incredible."

—Dolores Huerta

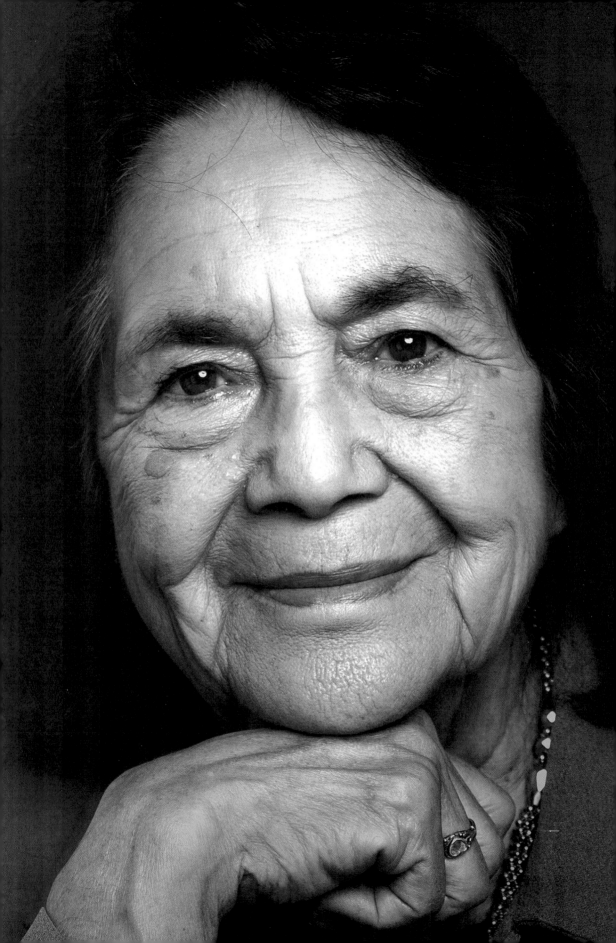

Everybody, all citizens, I think, have to take a responsibility to become involved at all levels. I think we find ourselves now in kind of a quandary, because we have such ignorance in our society. I mean, when I lecture, and I say to people, *How many of you know who your state representative is, or your assemblyperson, or your state senator?* Five or six people will raise their hands. They might know who their US senator is or who the president is, but otherwise, they don't know. But people are finally starting to pay attention now. And when I'm going around speaking, I'm asking people to please run for office. Run for your school board. Run for your city council. They say leaders are born; I think they're made. People choose to be activists, choose to be leaders. Anybody can do it, but you have to make the decision. And you have to sacrifice your most precious resource that you have, which is your time.

The road to justice is a journey. And even if it's a long one, you're organizing along the way, developing people who will be leaders. So, you can't get discouraged even if sometimes it looks pretty bleak. There's nothing more important that you can do with your life than empower and organize other people. I'm [eighty-nine] years old. People say, "Why don't you retire?" Well, if I can reach more people, and get them to get involved in organizing to make a change in their lives, I think that's worth every single additional year that I can live.

Jenny Beth Martin became active in the Tea
Party movement at its inception, first locally
in Georgia, and then as cofounder and now
president of Tea Party Patriots (TPP), which
focuses on issues of fiscal responsibility,
free markets, and limited government.
In 2010, Martin was named one of *Time*
magazine's "100 Most Influential Leaders."
She is coauthor of *Tea Party Patriots:
The Second American Revolution*.

JENNY BETH MARTIN

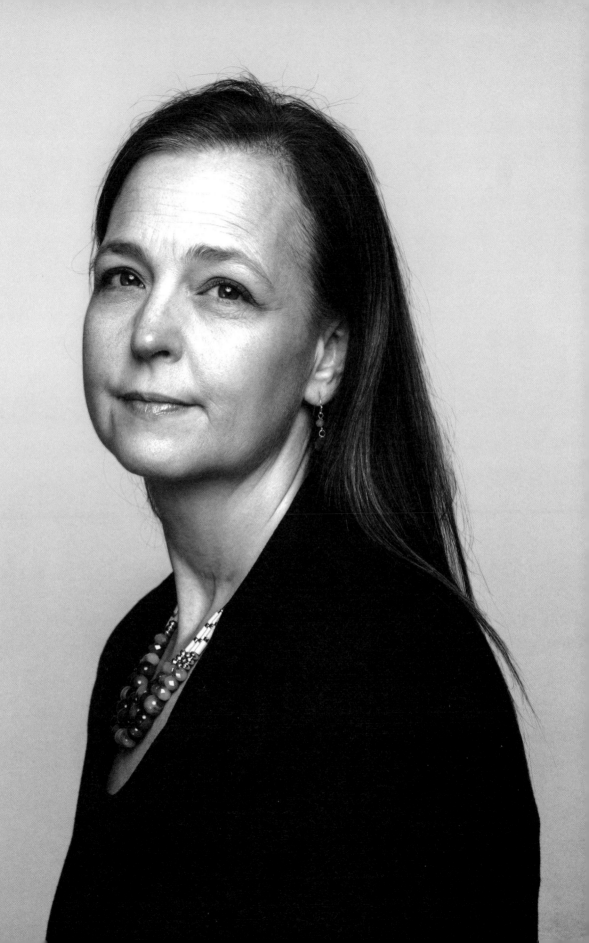

"I want to r
that we're
something
making ou
better for
and their c

ake sure
doing
that's
country
y children
hildren."

—Jenny Beth Martin

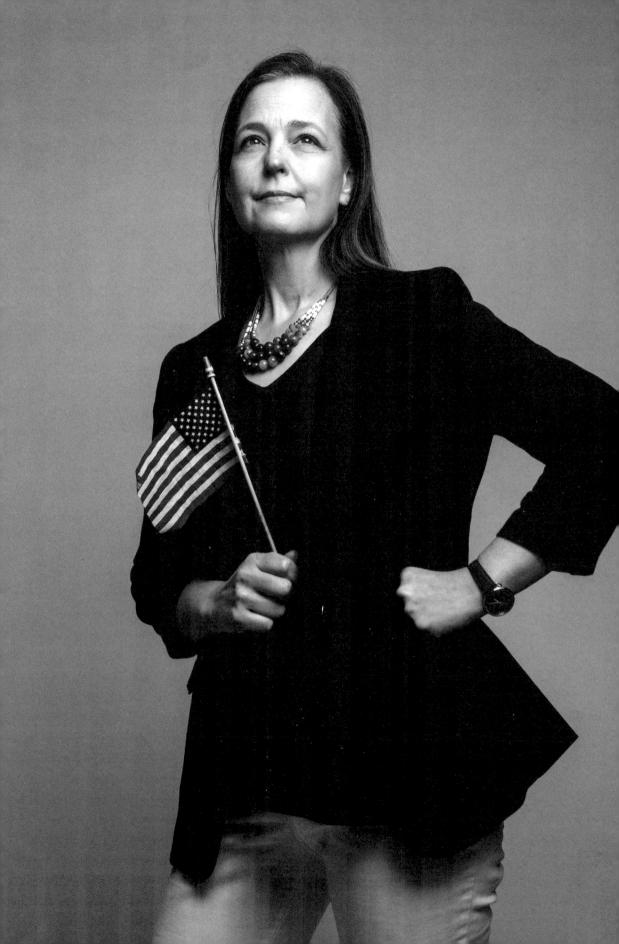

I've lived through financial crisis. And it puts things in perspective. In 2007 and 2008, my husband at the time, his business went through trouble. He wound up having to close his business, and we ultimately filed personal bankruptcy. We had little kids at the time. We lost everything. We lost our house. We lost our cars. We were cleaning our neighbors' homes and cleaning their bathrooms. Selling stuff at garage sales, just to get cash to be able to survive.

So that fall, when the TARP (Troubled Asset Relief Program) bill passed, the bank bailouts, we sat there watching and going: *Wait a minute, this is wrong. Businesses fail. Our business failed. And as much as life sucks right now, we're rolling up our sleeves and finding a way to rebuild. I don't want the government taking care of me, and I sure don't want the government taking care of these other businesses.* So, fast-forward a couple months. President Obama becomes president, and the stimulus bill passes. Rick Santelli has this rant on CNBC: "The stimulus bill is awful. Our Founding Fathers would be turning over in their graves. Who here wants to pay for your neighbor's home who has more bathrooms than you, and they can't even afford it? We should have a Tea Party just like our Founding Fathers." I heard that on the radio and knew I had to be involved. I started tweeting about it using #TCOT and #SGP. Smart Girl Politics and Top Conservatives on Twitter.

The next day, we got on a conference call, about twenty-two of us, and decided we're going to have a Tea Party. Seven days later, we had forty-eight Tea Parties across the country with 35,000 people in attendance. I had never even been to a protest before. I didn't even know to bring a bullhorn. Initially, the protests were focused toward Democrats, because they were in control, but when Republicans began to have control of the House our focus wound up being on Republicans as much as Democrats. But it wasn't about elections.

It was about issues and legislation and how it affects our lives. I'm very concerned about the debt that our country faces. I know what a real problem it can be. And I want to make sure that we're doing something that's making our country better for my children and their children.

I've always been active and interested in politics. I paid attention to the Iran hostage crisis when I was nine or ten. And when I asked my dad questions about it, he answered those questions not like I was a little kid, and not like I knew everything, but he talked through the issues in a way that showed that he respected the fact that I was asking important questions. And that kept me interested and wanting to learn more. So, during all of my career, and the whole time I was a stay-at-home mom, I volunteered—in the Republican Party, on campaigns, going door-to-door, learning how to write letters to the editor.

But I think one moment when I really did stop and just go, *I can't believe that I'm doing this—this is not what I ever pictured my life to be*, was when Obamacare was being argued in front of the Supreme Court in 2012. I was out there for all three days. I just remember thinking: *I'm one of those people who protest outside of the Supreme Court. Wait: I'm one of those people who organized a protest outside the Supreme Court.*

There is always a struggle between people who have power and people who want to be free. This isn't new. But the desire to be free is such a strong, innate desire in all of us that I am optimistic. So, as difficult as things are in our country, we're not in the middle of a revolution, we're not in the middle of a civil war, and we're not in the middle of World War II. We have repealed constitutional amendments. We ended slavery. We stopped segregation. And the problems that face us today—we're going to be able to overcome them.

Former US congresswoman Gabrielle
Giffords, a Democrat from Arizona, retired
from Congress after she was shot in the head
at point-blank range during a congressional
event in her district in 2011. Six people died
and twelve others were injured. She and her
husband, astronaut Mark Kelly, founded the
organization Giffords (formally Americans for
Responsible Solutions) to fight gun violence
and support gun-sense candidates for office.

GABRIELLE GIFFORDS

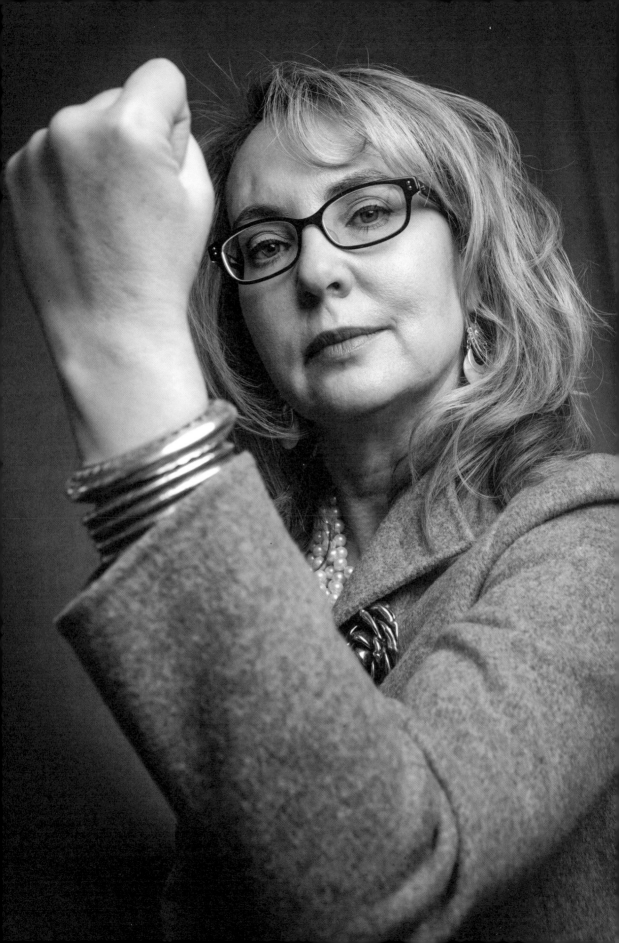

"I lost good friends. Six people died, and twelve others were injured. And it left me with a long road to recovery. Not many people realize that speaking is still hard for me. My eyesight isn't great, and despite hours and hours of

physical therapy, my right arm and right leg remain mostly paralyzed. But instead of focusing on the things that I cannot do, I've tried to focus on the things that I can do—and live without limits."

—Gabrielle Giffords

After college, I took a job in New York City working for Pricewaterhouse-Coopers. I was in my twenties, and moving to the city was thrilling. But that particular adventure didn't last long. After a few short months, I moved back home to Tucson (Arizona) and took over for my father as the president and CEO of El Campo Tire Warehouses. I wasn't very excited about entering the tire business. But my dad needed help, and when your family needs you, you show up. I had to learn the tire business from the ground up. That first year was such a whirlwind, but it was an experience I now realize forever changed my life.

While I learned about the tire business, I also learned a lot about my community and the people who live there. I began thinking differently about the issues that matter most to them, like access to jobs and affordable health care, and the real impact policy decisions have on their daily lives. When I took over the tire company, I noticed women weren't given the same opportunities as men, and I worked to change that, and made sure that all of our employees got treated with respect. Three years later, after careful consideration, including negotiations for all our employees' jobs, I sold the company and decided to pursue public service. When I first ran, I did what I've always done: Listen to the stories of people. I took meetings with as many people as possible and knocked on as many doors [as] I could. What I heard gave me inspiration to keep running.

After the shooting in Tucson, my life changed in many ways. I lost good friends. Six people died, and twelve others were injured. And it left me with a long road to recovery. Not many people realize that speaking is still hard for me. My eyesight isn't great, and despite hours and hours of physical therapy, my right arm and right leg remain mostly paralyzed. But instead of focusing on the things that I cannot do, I've tried to focus on the things that I can do—and live without limits. But one thing that never left was my desire to contribute to society.

Mark and I had begun talking about if and how we could get involved in helping reduce gun violence. That discussion actually started during a vacation we took in July 2012. The day before we got on the plane, the news was dominated by a gunman opening fire in Aurora, Colorado, killing twelve and injuring fifty-eight others. It was absolutely horrifying. In my career, I've always

sought to find the common ground. So, on that plane, while we thought about Aurora, both of us realized that more needed to be done to bridge the divide between gun owners, like us, and the majority of Americans who simply want their communities to be safe. Those conversations continued. But it was when twenty first- and second-graders were murdered in their classrooms at Sandy Hook that we decided to launch our fight. The country was outraged. We were outraged. We wanted to chip away at the conventional wisdom that nothing could be done about this country's gun-violence crisis. We can have disagreements about what exact laws should be passed, but when Congress refuses to even debate policy solutions, much less take any meaningful action, then it's time for a change. After the school shooting in Santa Fe (New Mexico) [in 2018], I remember hearing a student comment that she wasn't surprised a shooting happened at her school. She expected one would happen eventually. What a horrifying statement. We've all got to ask ourselves: is that really the kind of country we want to live in?

There is a time to compromise and a time to be tough. I think of my friend, former senator John McCain. He didn't mince words. Yet he also sought to hear people out. So, you stand up for what you believe in, while recognizing that in order to make change happen, we ultimately need to bring people together. In Congress, I made sure all the legislation I introduced was bipartisan. I knew we—in Congress and in our country—were at our best when we worked to find common ground. But there were also times that called for courage. The fight against gun violence requires compromise at times, but we must also recognize that when it comes to protecting the lives of our kids and doing everything in our power to stop the carnage, there is no other side.

Mark has been an inspiration to me—since the shooting, he's never wavered. I also draw inspiration and courage from those that have been down hard roads themselves. Leaders like John Lewis. I've learned a lot from him, and always remember something he once said: "We may not have chosen the time, but the time has chosen us." These can be hard times. Even scary times. But I remain hopeful because of the strength I've seen from our children. They have pointed out that America has failed to keep them safe and are following in the footsteps of our country's heroes who, at critical moments in our history, have stood up and said, "Enough. It's time for change."

"The fight against gun violence requires compromise at times, but we must also recognize that when it comes to protecting the lives of our kids and doing everything in our power to stop the carnage, there is no other side."

—Gabrielle Giffords

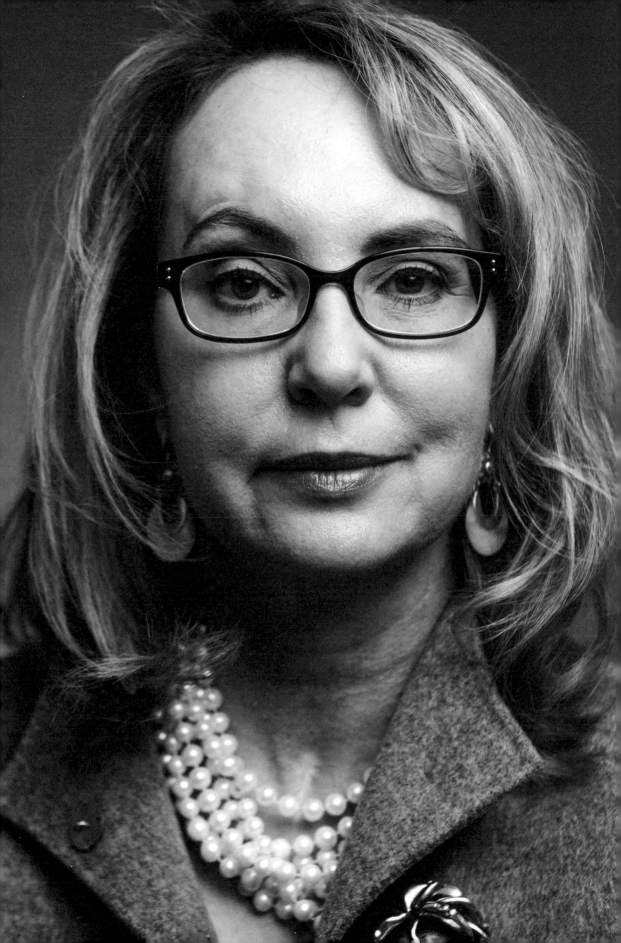

Andy Shallal is an Iraqi-American artist, peace activist, cultural entrepreneur, and philanthropist, whose restaurants, bookstores, and performance venues in Washington, DC, are gathering places for progressive political and artistic events. He is the founder of the Peace Cafe, which seeks to promote Arab-Jewish dialogue. Shallal ran for mayor of Washington, DC, in 2013.

ANAS "ANDY" SHALLAL

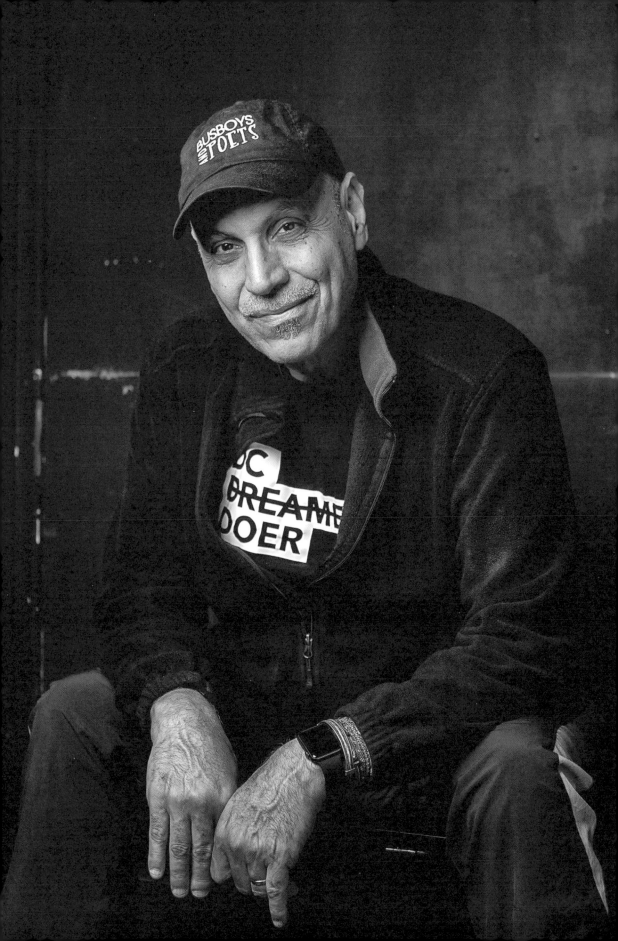

"If there's one thing that good activists, the ones that have been doing it for a long time, have in common, it's that they have such a complete belief in humanity."

—Andy Shallal

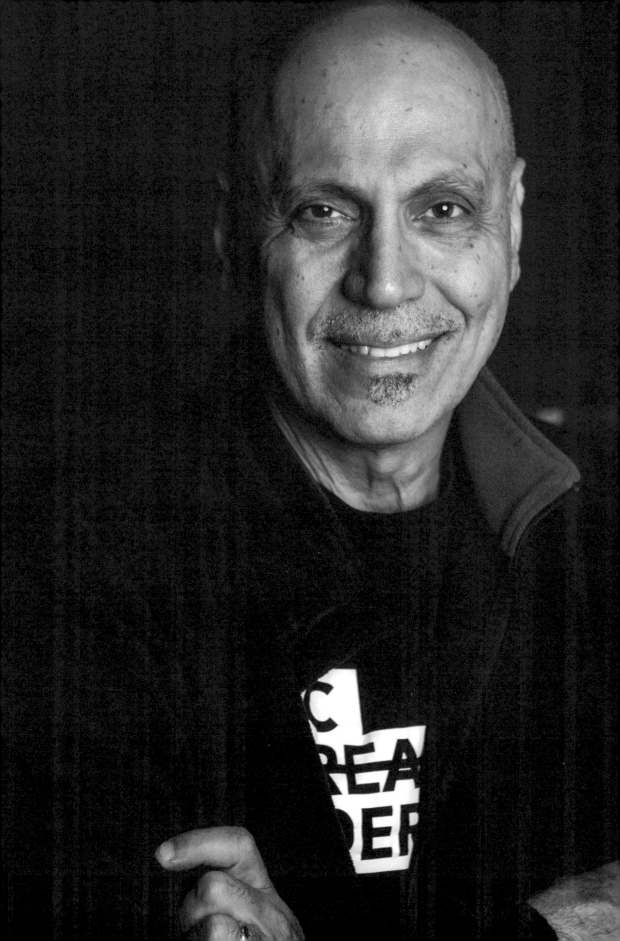

I was ten when we came to the United States from Iraq. It was 1966, and the Vietnam War was at its height. Lots of energy in the air. I had significant culture shock, not understanding what's going on, seeing a lot of young people very much engaged, because back then they had the draft and young people had skin in the game. Then, 1968 was the assassination of Martin Luther King—that was a very significant moment as well, and time for me to think: *What's going on here?* I'd come from a world where revolutions happened fairly regularly, but to see this happening here in America, the place where I thought life was perfect?

I remember everybody walking out of class one day, sitting down in the hallways and refusing to go back; it was a sit-in. There was no Facebook or Twitter—we didn't have that kind of social network—but there was something in the air. Everybody kind of whispered to each other that we're going to walk out of class at a certain time. And everybody did. The principal came on the sound system and, remembering it now, I think it was amazing the way he spoke to us about the importance of being engaged; how proud he was of us. Language you don't hear these days when it comes to civil disobedience. Now, you get pepper-sprayed. So, the idea that he would actually come out and say, "Hey, I respect your concern, this is an important issue for the country. Please go back to class because you've got to study." People did go back to the classroom in short order, but there was this sense of empowerment, I guess, that came through. That you can actually make an impact, a difference, and adults would listen. And that stayed with me.

Too often when we think of trying to make change, we think of statistics and numbers and convincing people by those things; the reality is that most people are convinced by touching someone, being with someone, hearing someone, and music and art. I've seen, through the bookstore and restaurants, how food is so powerful as a way to bring people together, have them talk about the most intimate things, and become friends. That's usually how change happens. We would do these peace cafés, Arab–Jewish dialogues, meetings about presidential platforms, author conversations, music, art, roundtable discussions on all kinds of issues—LGBT, women's issues, you name it—a hub where a lot of interesting people come. Because we have the need to be connected to a bigger story than just our own. I think you feel your humanity when you're involved. It connects you to human beings in a way that being inactive doesn't.

You know, sitting on the sideline watching the world crumble before you, you feel helpless. You can't do anything, it's really depressing, and you check out. People need joy. If you don't have joy, you burn out very, very quickly. [Historian] Howard Zinn, who was really probably my biggest inspiration, used to say that a hopeful life is made with a succession of things that happen that are positive. If there's one thing that good activists, the ones that have been doing it for a long time, have in common, it's that they have such a complete belief in humanity. The sense that people are just good. And the world is good. And if you keep fighting, you'll get there.

Gustavo Torres joined CASA, a Latino and immigrant advocacy organization, in 1991 as an organizer and has served as its executive director since 1994, dramatically growing the organization's membership, impact, and influence. Torres first became involved in political organization in Medellín, Colombia, where he was born into a politically engaged family. He was forced to flee because of political persecution and violence.

GUSTAVO TORRES

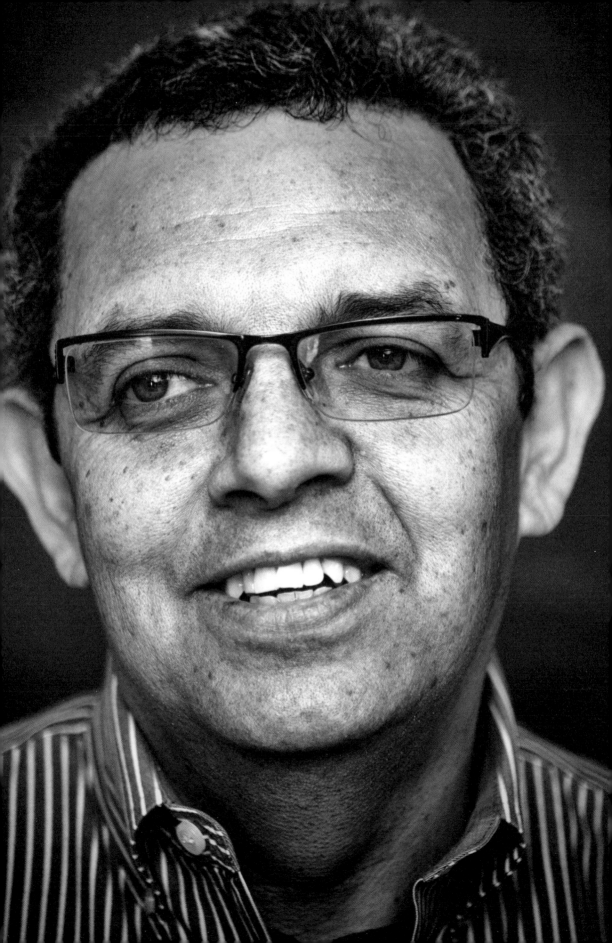

I was a little scared when I went to my first union meeting. A lot scared, honestly. They said, "You need to be careful. Somebody needs to be in the door watching to see if people are coming." I said, *Why is that? You are doing something that is peaceful*. During that time, the paramilitary groups started to kill a lot of people—union leaders, students, et cetera. Because they accused all of the people in the union—not only my union, but unions in general—that we were members of the guerillas from the left wing. So that was my first impression, like, *Oh my God. I need to be careful with this*.

But it doesn't stop me. I keep coming to meetings, rallies, and events, and participate in different negotiations and all of that. We were part of SINTRAPOPULAR, the union of workers who work in the bank. It felt so empowering. Like, I can express myself, can listen [to] the concerns of people, can share my values. Becoming a member of the union played a major role in what I am as a human being.

Then, at university, we organized hundreds and hundreds of students demanding better treatment and better participation in the decision-making process. It was an amazing feeling. But, because of that organizing, they removed us from university, like, thirty of us. We demonstrated that it was political persecution and we won [our case]. But the situation [got] even worse. Ultra-right paramilitary groups started trying to kill us. I saw so many friends killed during that time. Friends from the unions, and students killed right on campus. So, I make a decision that I have to leave the country. And, because I left, they kill another of my brothers. He was also engaged in social and political activities. It destroyed me. Because I feel that I should be there. He was younger; I was his role model. It was a very difficult time.

I became a journalist and researcher in Nicaragua, El Salvador, Guatemala, Honduras. And met my now ex-wife in Nicaragua. She told me, "I want to finish my master's in Johns Hopkins University." I'm like, *Where the heck is that?* The idea was for a couple years until she finished her master's. Well, twenty-five years later, I'm still here.

I started to work in CASA as a community organizer. And I was so happy. Oh my God. What an extraordinary opportunity. Organizing day laborers right here. It was my passion. To me, probably the most extraordinary difference between CASA and a traditional nonprofit organization is we are in the business of building power. We are changing lives and changing the system rather than just providing services. Don't get me wrong: Providing services is so critical and is very essential. And, when I see somebody who just comes here, and then [goes] from day laborer to homeowner and business owner—that is also building power. But when you see people fighting and going to civil disobedience, and rally and participate very actively in changing policies in Annapolis (Maryland) and Richmond (Virginia) and at the federal level, I feel so proud. And I feel that I'm making a little contribution to that process.

Together, we are creating a mechanism for people to be part of something big— something extraordinary to help to change this country. I can tell you about domestic workers, day laborers who arrive [and say], "The employer didn't pay me and abused me and mistreated me, can you help me?" So we come together, and work with them. And they become active. Mobilizing people. Recovering the monies. Going to rally in front of the embassy or the employer. It's a beautiful, beautiful moment, the way people feel so empowered. People who come without hope. And because they see solidarity here in the organization and passion for justice and for dignity, they feel empowered. Or, the situation right now with immigration status. You know, they come because they have been arrested by ICE (Immigration and Customs

Enforcement), ready to be deported. And we start to organize them and work with them, and they fight back. They say, "I don't care [about being] undocumented anymore. I want to pass immigration reform. I want to pass the DREAM (Development, Relief, and Education for Alien Minors) Act. I want to mobilize." They come and testify.

Sometimes I'm discouraged, yes. Like when I met with President Obama and also the vice president about immigration reform. It was a privilege, but at the same time, a big responsibility. Because I am coming to share with the president how our community is suffering. I really internalized that I was not speaking for me; I was an instrument to communicate for my 55,000 members. And regardless that he was a really nice person, with extraordinary charisma, how our community feels that his administration is mistreating them. One of the challenges was the thousands of thousands of unaccompanied kids arriving. And he was not very receptive. And the vice president even worse. And we had a big fight in the White House about this. The meeting was for around, like, two hours. And they said, "We cannot receive everybody here. I'm sorry. Those people need to go back to their country." It was horrendous, a really, really sad moment. But, at the same time, gave me a lot of energy to keep fighting back.

So the next day, I was not inside of the White House, but outside in a civil disobedience demanding the administration change the policy. It was, like, 5,000 people [protesting], and 300 in civil disobedience—we didn't move and they arrested us. So it was using [those] strategies of in and out. Finally, the president changed the policy. We were very happy. And they created an extraordinary program.

The same thing happened with DACA (Deferred Action for Childhood Arrivals). Finally, after meetings and civil disobedience and thousands of people rallying and mobilizing, finally, he listened to us. And, of course, it was also a political moment. And he passed DACA. When I heard the news, I said, *Oh my God.* Unbelievable—1.5 million people benefit.

But honestly, it is not about Obama or Biden or Trump. It's about the system. The system that we create about immigration is totally broken. And you even can have a president who is progressive and still commit these kind of atrocities. And, of course, [the Trump] administration is even worse. It's totally criminal from my viewpoint. But still, the crisis about our kids, it doesn't start with this administration. It's the system [that creates] these kind of conditions. And it's not fair for our community.

This is in my blood. I need to do it. I left my country to avoid [being] killed, but it didn't change my principles. It didn't change who I am as a person. I cannot see me doing another job than working and organizing and building power with my community. Right here, in Colombia, wherever I am.

114

"This is in my blood. I need to do it."

—Gustavo Torres

Jasilyn Charger, of the Cheyenne River Sioux Tribe, is a cofounder of the International Indigenous Youth Council (IIYC). She coordinated a 2,000-mile run from the Dakotas to Washington, DC, to draw attention to protests at Standing Rock, over the Dakota Access Pipeline (DAPL), which helped attract thousands of protesters to the cause. Known as a "water protector," she was also involved in successfully fighting the Keystone Pipeline (KXL).

JASILYN CHARGER

When I was eighteen, I was really done with the rez [reservation], and so I moved away. A couple of my friends died from suicide while I was gone. And a couple more got murdered. When I came back, it was very traumatic. So many of our people we know end up trying to kill themselves. You just feel so alone. Like, nobody's really going to help. *No one's going to help me protect my family, so what do I do?* And it turns into depression. They start hurting themselves through drugs and alcohol, and they start giving up.

My friends, we were angry. *What the hell is going on? What is our tribal government going to do? What is our school system going to do? What do we do?* That's what really kind of drove us. My nephew, Joseph White Eyes, he's only a year older, was a youth organizer here at the teen center. He really educated me—pushing myself away from the negativity: the drugs, the alcohol, the partying. Showing me nonviolent direct-action books, pictures of places he'd been, people he'd met, and sharing his stories with me. He told me, "If there's something you don't like on the rez, you can change it." He brought it to my attention that you have rights, you have a voice. That there are things you need to know that people aren't automatically going to tell you, because they benefit from you not knowing. He started with protesting the taking of the buffalo, and that fight projected him to the Keystone XL fight. I was, like, *Wow. I want to be able to live my life this way.*

So, I got involved in a local youth movement here—the One Mind Youth Movement. And they picked me and my friend to send to Washington, DC, for the Our Generation, Our Choice march. This was our first time on a plane, our first time going to Washington, DC, my first rally. I knew it was going to be something extraordinary, but never expected to feel the way I did. In that moment of being on the stage, you have all these people in front of you—thousands of people. At first, I wasn't a very good speaker. I was just, like, crying and trying to get the words out. I knew that would happen, and so I wrote a poem. And that worked, and they loved my poetry. It was so awesome: We occupied two four-ways early in the morning when everybody's trying to get to work. It just made me feel like I have a voice now. Like, *I can make change through my actions.* We felt empowered.

When I came back, I saw David Bald Eagle, one of the chiefs of our reservation who had taken me in when I didn't really have anywhere to go. I told him I was so embarrassed that I started crying. He was drinking his coffee, and he just put his coffee down, like, "Sit down. I need to talk to you." And he scolded me. I was like, *I thought you'd be proud of me, or happy.* But he was, like, "You told me that when you were crying, you couldn't speak because you were scared." He told me, "Whenever you speak in front of people and say you're from this reservation, you're speaking on behalf of everybody here. What you say, and what you do, reflects upon all of us. You have to be strong, to speak with conviction and passion. You can't be scared. Because it's not about you. Your voice comes from everybody you have ever known and loved, and all the painful things that they've gone through. You're speaking for them." Once he said that, I just wiped my tears, like, *Yeah. I understand.* And ever since, I've always tried to speak from my heart and take all the things that I've learned, and know, and experienced from the lives around me.

We started lobbying our tribal government to get more of the things we wanted done. We started telling more youth what was going on. Because a lot of them didn't really know, and they're like, "Whoa. Something needs to be done." Exactly. When you give them the information, they inspire themselves. No one's too young to be a leader. No one's too young to start fighting for themselves.

Two months after we defeated KXL, we got a call-out from Standing Rock over the radio, a call-out to Indians across Indian Country. Like, "Hey, we're having a No DAPL meeting about this pipeline going through our reservation. Come and show your support and share your stories and your wisdom." Our mentor was like, "Who else wants to go?" We took a whole van full and went up there. They were really surprised, like, "Wow, we put a call out and we expected a lot of men to come. A lot of chiefs. And the youth showed up." They didn't really expect youth to care. Like, "Oh, video games and Facebook and Snapchat . . ." But we were doing this for all of our friends and family who can't fight for themselves. To show them that no matter how much pain you go through, no matter what your situation, no matter how hopeless you feel, you keep on fighting.

We do have those people who come and tell us, "You're not supposed to do this." It's just not how it's done in our culture. One of the examples of that is when we ran to Washington, DC, to bring attention to Standing Rock. We got a lot of backlash from the male figures of our community—the warriors, the headsmen, and a lot of the elderly. Because they felt that we were out of place. They were saying, "We wouldn't send our women and children to war to meet with head officials to negotiate on our behalf. That's not the women's and children's places." And we were just, like, *Well, if you wanted to do your role, you should have been the one to offer up to run for us. If you want to say that, then do something about it.* Nobody was really camping [at Standing Rock] before we started running—just, like, fifty people. And when we came back, there were thousands of people camping everywhere. I've never seen that many people camping together. We opened up eyes. We made people listen. Even our elderly. We made them stop fighting each other, and start fighting for each other. Our tribal people came because we challenged them, like, *Hey, we're running across the country. What are you going to do for this? What are you going to sacrifice?*

I try to make my ancestors proud and my family proud. Because I want my elderly to leave this world knowing that the future of our people rests in good hands. And whenever they see us fighting on the front lines, and even getting hurt and getting beaten, we're still persevering. Because our ancestors went through so much to just exist, just to have rights. Just to practice their own culture. They survived through hell and back. They marched across thousands of miles just to be placed on this reservation. Families were broken. People were lost. And I can't live with myself without knowing I made the exact same commitment.

Native American children, we inherit so much stress, so much pain. And when we grew up, it's like, *Why are my people like this?* We don't like it. We're not satisfied. So, I'm speaking up for what I feel, and I'm trying to do what's right by my people. A lot of people look at me as a youth leader, but I feel like I'm more of a conduit of energy and information. No one's too young to start fighting for themselves.

"No matter how much pain you go through, no matter what your situation, no matter how hopeless you feel, you keep on fighting."

—Jasilyn Charger

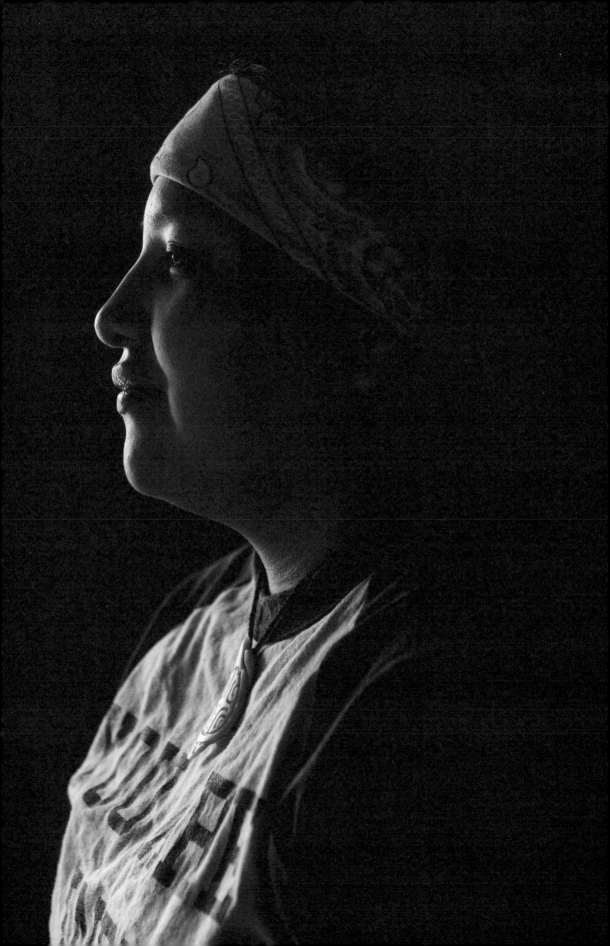

"No one's too young to be a leader.

No one's too young to start fighting for them- selves."

—Jasilyn Charger

Grover Norquist is president of Americans for Tax Reform (ATR), and has been a powerful conservative voice advocating for limited government and lower taxes. The organization is best known for its "Taxpayer Protection Pledge," which asks lawmakers to promise no net increases in taxes. Norquist was also a co-author of *Contract with America*, a document released by the US Republican Party during the 1994 congressional election campaign.

GROVER NORQUIST

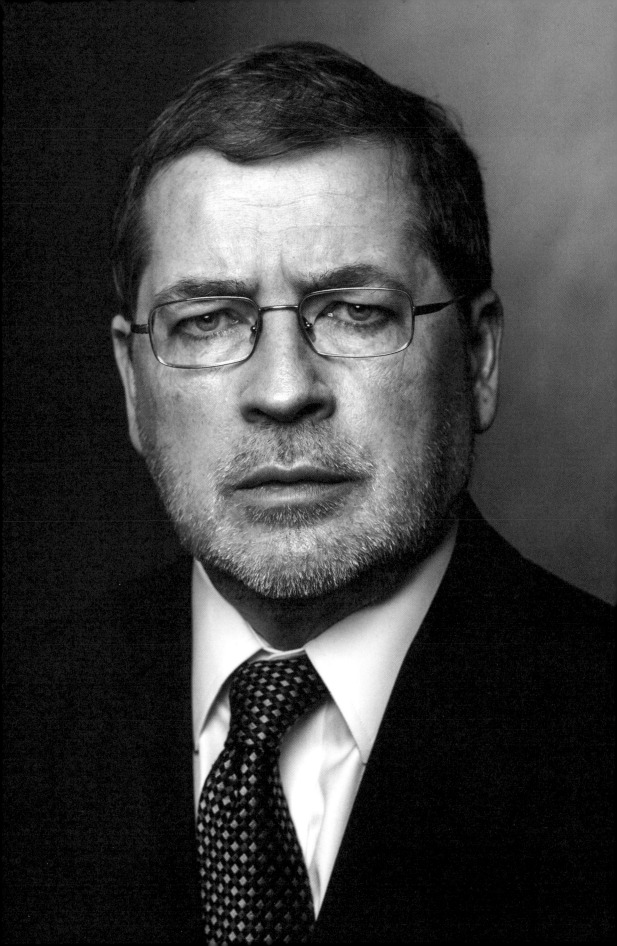

"Gun people. Homeschoolers. Vapers. Uber drivers, Lyft drivers, Airbnb. The goal is liberty. They all want to be left alone; they all want freedom."

—Grover Norquist

I grew up during the expansion of the Soviet Union, and I think my first political thoughts were from reading books about it—Whittaker Chambers's *Witness*, *I Led Three Lives* by Herb Philbrick, even J. Edgar Hoover's book on communism. My public library sold off all their conservative books, so I picked them all up for, like, a nickel. So, even as a kid, I had a pretty good idea of what I didn't want: Communism, overbearing government. The government gets too big, it can get ugly—a lot of dead bodies. I just think freedom was self-evident. So, in '68—I'd be twelve—I took a train into town and worked on the Nixon campaign. Then, in '72, I worked on the campaign again and on House races.

I've ended up being in political places where nobody else was doing what I thought needed to be done. The Reagan campaign in '80, they were taking all the literature out to the suburbs. So we'd go to South Boston and do the bars. Hispanic bars, Eastern European restaurants, different churches. These guys all were big on Reagan and down on Carter and weren't being invited to the Republican Party.

Ronald Reagan changed the party, changed the country, changed the world. That's the model: Change the party. Change the country. Change the world. When I created the Taxpayer Protection Pledge, which says no net tax increase, it was for a particular piece of legislation. But then I realized, that's not what this is. This is redefining the modern Republican Party as the party that won't raise your taxes, which then forces them to be the party of entitlement reform and government reform. Because, unless you take tax increases off the table, you never reform government.

To expand the coalition, you look for people who are being picked on by the government. Sometimes on purpose; sometimes they're just stepped on because the government is big, fat, and uncoordinated. And then you bring them in on the pro-freedom thing that motivates them. So, you have evangelical Protestants and conservative Catholics and Orthodox Jews, Muslims, and Mormons—each one thinks everybody else is going to Hades, but: "I need to be free to go to heaven and practice my faith with my kids, and I understand that if I'm going to be left alone, we all have to be left alone." Gun people. Homeschoolers. Vapers. Uber drivers, Lyft drivers, Airbnb. The goal is liberty. They all want to be left alone; they all want freedom.

What made the United States different is a focus on liberty, as opposed to Europeans who try and get through the day and drink wine and have fun and something, but liberty doesn't keep them up at night. There's no excuse for why the United States does better than other places other than freedom. We're not nicer. We're not bigger. We're not some ethnic group or something. What made the United States different is a focus on liberty. If you lived in Belgium, it wouldn't matter. You could get everything right in Belgium and still get eaten by the French or the Germans or the Russians or someone. But the whole world moves in a good direction or a bad direction based on whether we are being a free country and good model—or not paying attention and we let other people eat the place up.

That is why I've worked to build a coherent movement to move us toward greater liberty and away from statism. It's a recognition that you have to do this, because other people aren't doing it. And it needs to be done. And we're not in Belgium.

Congressman John Lewis, a Democrat from
Georgia, was a student leader in the civil rights
movement, organizing sit-ins, and was one
of the original thirteen Freedom Riders. From
1963 to 1966, Lewis was chairman of the
Student Nonviolent Coordinating Committee
(SNCC). He has served in Congress
since 1987. In 2011, Lewis received the
Presidential Medal of Freedom.

JOHN LEWIS

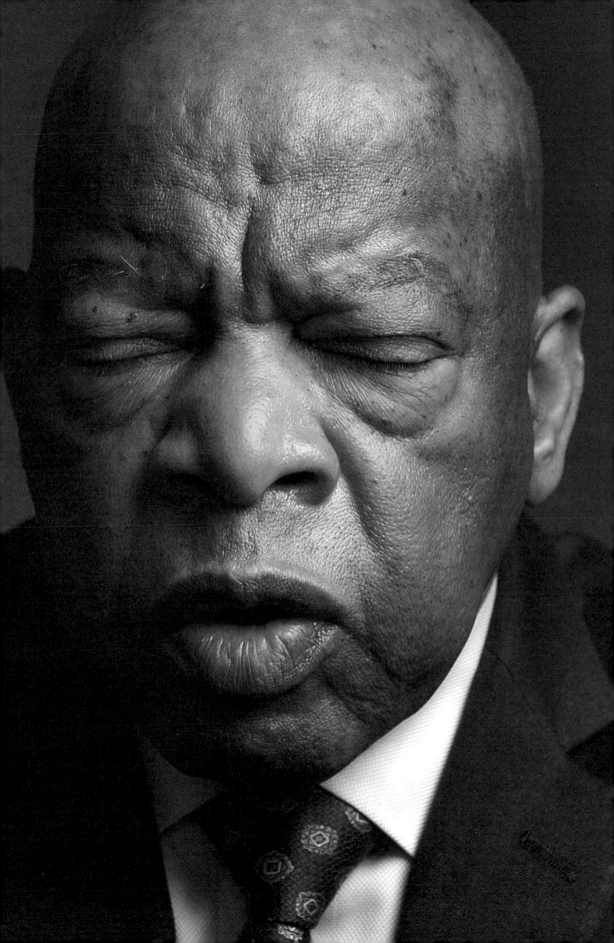

"I felt free.
I felt liberated.
I felt like I
crossed over.
That you're in
this, and you
cannot turn back.

That this is not just for this moment or for this day or for next week or next year. But a way of life."

—John Lewis

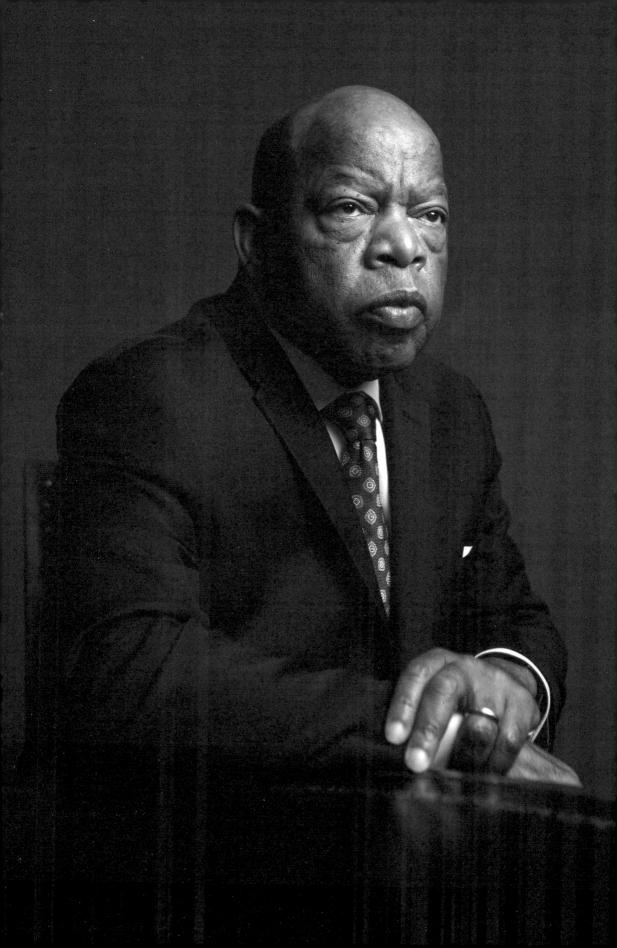

I grew up in rural Alabama. And I remember some of my brothers and sisters and first cousins, we made a trip to the little library about ten miles from our home in this little place called Troy. I saw the signs that said "white" and "colored." I didn't like it. We wanted to get library cards, wanted to check out some books. But we were told that the library was for whites only, not for coloreds. I would ask my mother and my father and my grandparents and my great-grandparents why. They would say, "That's the way it is. Don't get in the way. Don't get in trouble."

But one day I heard Dr. King speak on the radio. 1955. I was fifteen. It was an African American station called WRMA, based in Montgomery. Seemed like he was speaking directly to me, saying, "John Robert, you can do something. You can make a contribution." So I followed everything I could about Martin Luther King, Jr., and the bus boycott. The words of Dr. King and the action of Rosa Parks stirred something up. That you cannot be at home with yourself when you see something that you know is not right. Not fair. Not just. You have to do something. You have to say something. It gave me a sense of hope.

I met Rosa Parks when I was seventeen. The next year, I met Dr. King. Changed my life. Inspired me to get involved in the movement. And I met James Lawson, a young minister, who started teaching us students in Nashville (Tennessee) the philosophy and the discipline of nonviolence. Preparing us to go and sit in on a lunch counter, stand in at a theater, preparing us to be leaders, to be activists. And I knew that I was on the path.

The students in Greensboro (North Carolina) were the first. A few days later, we started sitting in in Nashville. And it spread all across the South like wildfire. I came to that point where I was never, never afraid. Even when people would come up and spit on me, or pour hot water, hot coffee, hot chocolate [on me]. Or pull me off the lunch counter stool. But we were told, after a series of sit-ins, that if we continued to sit in, we would be arrested. I'd never been arrested. Never seen the inside of a jail or prison. During those days, the young people, especially young men, used to talk about being fresh—being sharp, or clean. I wanted to look fresh if I was going to go to jail. So, I went down to a used men's store in downtown Nashville and bought this suit. A vest came with it. I paid five dollars. And on the day that I was arrested, I looked fresh.

The moment that I was placed under arrest, I felt free. I felt liberated. I felt like I crossed over. That you're in this, and you cannot turn back. That this is not just for this moment or for this day or for next week or next year. But a way of life. There's something I call the spirit of history. Sometimes, you're tracked down by a force, and you cannot turn away. So, I never thought about saying, *I'm tired. I'm ready to drop out.* You have to continue to pick 'em up and put 'em down. Because there's so much work to be done. And you never know how much time you have. And you have to use your time wisely.

I've had some moments. But the worst, I think, was in Selma (Alabama), on the bridge. We were beaten—not by a mob, but by law enforcement,

"You have to believe, somehow and someway, in the possibility that we will reconcile to each other as humans."

—John Lewis

state troopers. I thought I saw death. I thought it was my last nonviolent protest. But I had what I call an executive session with myself. I said, *If I die, if this is the last protest, I'm doing what is right.* Hundreds and thousands and millions of people could not participate in the democratic process. My own mother, own father, my own grandparents could not register to vote. And that helped liberate my spirit. And I knew that by what we were doing, the day would come that voting rights would pass and be signed into law. And that's exactly what happened.

You have to believe, somehow and someway, in the possibility that we will reconcile to each other as humans. So you study. You meditate. And you forgive. On the Freedom Ride in Rock Hill, South Carolina, members of the [Ku Klux] Klan beat us and left us in a pool of blood.

In 2009, one of the guys that beat us came to this office. He was in his seventies. He came with his son. He said, "Mr. Lewis, I'm one of the people that beat you and your seatmate. Will you forgive me? I want to apologize." His son started crying first. Then he started crying. They hugged me. I hugged them back. And the three of us cried together. That is the power of the way of love. The power of the philosophy of nonviolence. You come to that point where you respect the dignity and the worth of every human being. You cannot become bitter. You cannot become hate. I can hear Dr. King saying over and over again that hate is too heavy a burden to bear. One thing I regret more than anything else is that, during the height of the movement, many of us, and I include myself, didn't spend more time with Dr. King. Because, you know, he was so young, and I think in the heat of the movement, we thought he'd be around a very long time.

He taught us that nonviolence is one of those immutable principles that you cannot deviate from. And that concept will continue to influence me the rest of my life. So, even if someone is beating you, knocking you down, even if you're down on the ground trying to protect your head, you try to maintain eye contact. Let the person who's trying to hurt you see your humanity.

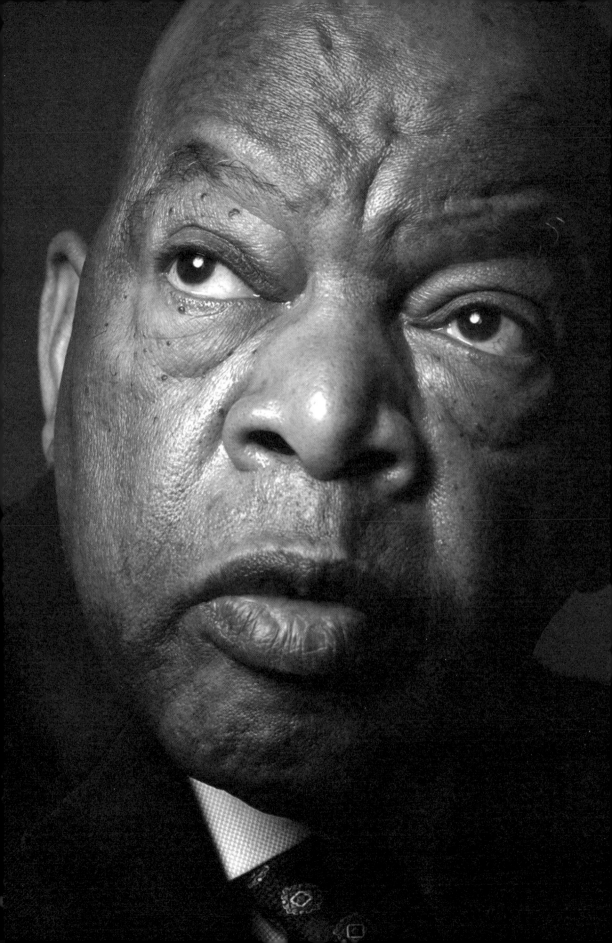

Jeanne Mancini is president of the March for Life Education and Defense Fund, which hosts the March for Life, an annual march on the anniversary of *Roe v. Wade*. She previously worked at the Family Research Council and the Department of Health and Human Services.

JEANNE MANCINI

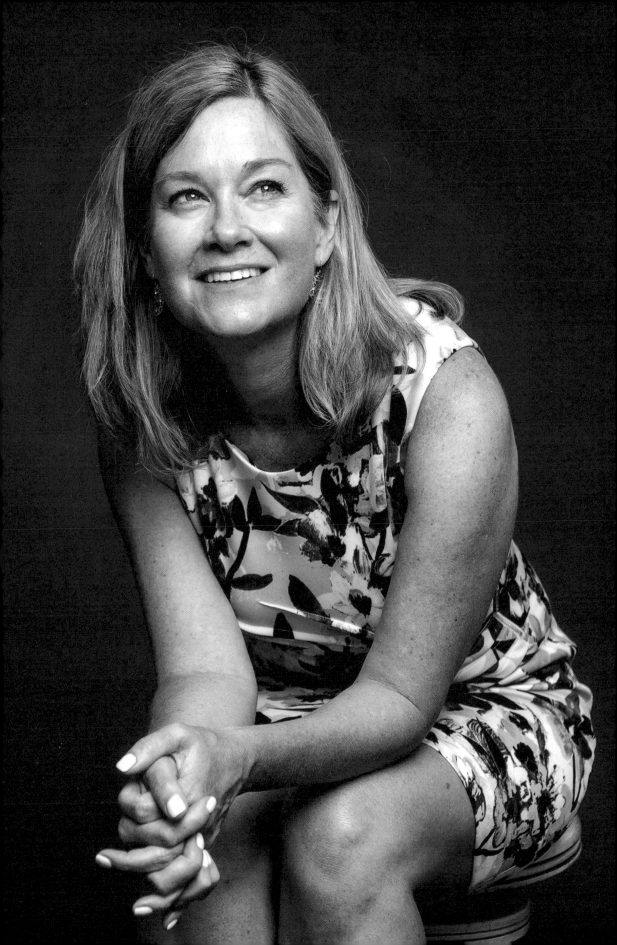

"I believe that everybody has inherent human dignity from conception to natural death. And each person has the right to live out their unique mission."

—Jeanne Mancini

My family was a bit of a leftward-leaning Catholic family. We went to church every Sunday, said grace before meals, and social justice was very much instilled. But I turned out a little differently than most of my siblings, a little more "religious." I had an experience when I was in high school that was profound and life-changing for me, a retreat called Youth Encounter. I think it was the combination of getting away—it was totally in nature—of hearing affirmations they had gotten friends and family to write, and a series of talks there about how there was a plan for my life and that I'm a unique, unrepeatable person in human history with human dignity before God. And that's true of everybody. It was just a beautiful experience of God's love. So, I think all of these different forces coming together kind of opened my eyes and turned on the lights of my life. And I came away from it with a sense of being beloved. A sense of mission. Which, in some ways, informs what I do now.

After college, I went into the Jesuit Volunteer Corps and worked in a youth crisis shelter and in residential treatment homes with kids who had either been sexually abused, or even had been molesters. We're talking deep, deep wounds. And I went through a whole kind of philosophical grappling: Would it have been better if these kids never lived? Would that have been more merciful? I came to the opposite perspective—every life is a gift. Who am I to judge the value of this one's life or that one's? They could discover the cure for AIDS. They could be the first woman president. So, that was very formative in my ultimate calling to pro-life work. I believe that everybody has inherent human dignity from conception to natural death. And each person has the right to live out their unique mission. I can't think of a more important social justice cause.

Waking up after the 2016 election, I will say I thought of the Supreme Court. That was really important to me. I'm actually an independent voter. But I feel so strongly about

the pro-life issues that I usually end up voting pro-life. Which, these days, tends to be more Republican. And it's incredible what we've seen in the last months; the conservative voice is being taken more seriously. Right now, we're being asked, the March for Life, to submit our founding documents and all of our papers to the women's history library up at Radcliffe. They came down and visited and basically said, "We know that we haven't always given both sides a voice."

That's important, because there's so much divisiveness right now. The level of tension is unlike anything I've experienced. You really take a personal kind of cost, you know. One of my very best friends from college sent me a text within a week of the election saying, "My God, I read your quote. You did this. Our friendship's over." And I'm, like, *What in the world? a) I don't know what quote you're talking about. b) Talk to me about this; you don't even know where I stand on it. And c) We're "over"?* That isn't friendship. Respectful dialogue is something our culture needs more than ever right now. And I think a starting point is that everybody is coming at this with a good heart. So, to recognize that and see the good, and then to try to talk, instead of assuming the worst.

Frankly, it's a scary time to be a person that cares so much about this that you're going to put your neck out. And for folks like me, whose issues can be considered a little bit more contentious, there can be so much animosity directed toward us. You kind of want to go back into your little cave because it's gotten so ugly. That's what really makes me cry, that you can't even stand up for what you believe without being attacked for it anymore. But you can't back down because of fear, or what people think, or your reputation. You have to do what you know in your heart is right. How can you not?

Linda Sarsour is a Palestinian American
and Muslim American racial justice and
civil rights activist, cochair of the 2017
Women's March, and a board member of
the Women's March national organization.
She is a former executive director of the
Arab American Association of·New York.

LINDA SARSOUR

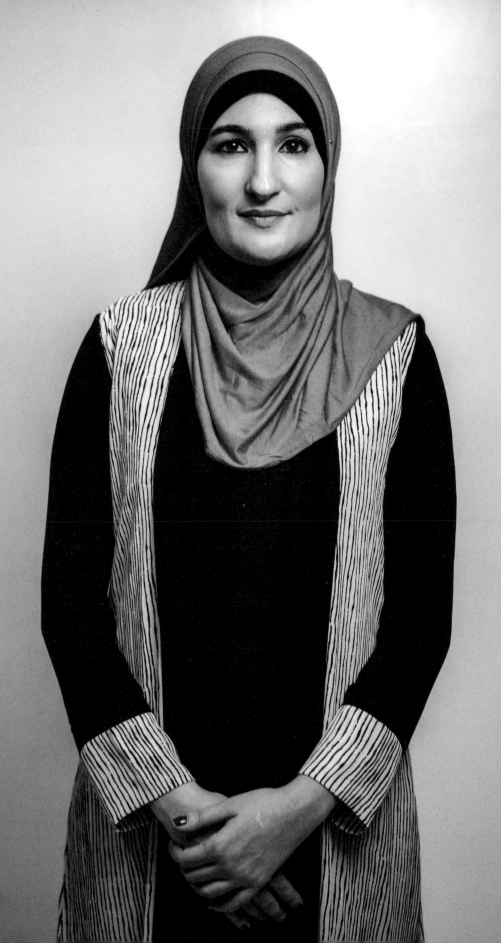

"I'm a person that lives in these two worlds: This gritty Brooklynite, proud American, but at the same time, I'm Arab American, Palestinian American."

—Linda Sarsour

I am a New Yorker, born and raised in Brooklyn, and a daughter of Palestinian immigrants. And so, growing up, I saw protests. I saw people organizing about Palestinian human rights, things happening in the community; my mom was involved. But, I think for me, what I call my radicalizing moment, and why I'm actually here in this moment right now, was 9/11. I know that 9/11 was a transformative moment for probably everyone in our country. But, for me, as this, like, gritty Brooklynite, just so proud of being from New York and from Brooklyn and American, it changed my life forever. Being a college student and watching it unfold, coming back to my own community—and I'm talking physically walking from my college campus in Brooklyn all the way to southwest Brooklyn, where I'm from—the Bay Ridge/Sunset Park area, and seeing businesses closed that morning. All the doors bolted. At the time, I didn't know what had happened. I had walked all the way home without knowing.

My mom jumped in the car as I was walking into the house. And I was like, *Where are you going?* She was like, "I got to go pick up your brother from school. It's not safe." And I was like, *Why are you not wearing your hijab?* I felt nauseous, like, *What's going on here?*

Of course, I finally realized what had happened by going inside and watching television. Then, that week there were raids on coffee shops in Bay Ridge, men laying out in the streets of our community, told to get down. Law enforcement carrying AR-15s. And this is in New York City. So, as a young person, I was, like: *This doesn't seem right. Why would they do this? What did these people have to do with it?* I'm just dumbfounded watching the treatment of people in my community. Then, being at the mosque in the weeks after 9/11 and seeing women come crying to the mosque saying, "They took my husband. I haven't seen him in a week. Please help me." You know, these are women who are immigrants, who have come from countries that have police states. Women who, English was not their first language. And as someone who spoke fluent Arabic and fluent English, my first role was translator, being able to pick up the phone to find attorneys, help locate husbands and locate sons in different detention centers in Elizabeth, New Jersey, and downtown Manhattan.

The first time, it was a man from Morocco. It was five days since his wife had seen him, and he had a cute little four-year-old kid. So, helping them through the process, finding him, and actually getting to see him, I felt powerful. I felt like, *This is where I'm supposed to be. There must be a purpose here.* You know: *Why me?* I'm a person that lives in these two worlds: This gritty Brooklynite, proud American, but at the same time, I'm Arab American, Palestinian American. I'm Muslim. I'm from this community. So that was my moment. And it awakened something inside of me that has never gone back to bed.

Being a Muslim American activist, I've been targeted by the right wing in a way that is very dangerous. Vilification of my character—like, if people just met me through the internet, they would think I was a monster. I've tried to shelter my

"I haven't given up on my country. I believe in the potential. I believe in the Constitution. I believe that this is the land of religious freedom, and that that applies to Muslims."

—Linda Sarsour

kids, but I mean, one day my daughter asked me, "Mom, you think that you'll get shot?" I was like, *Whoa, whoa. Hold on a second here.* Of course, I'm the parent that's like, *Nope. That'll never happen in America.* But there's a lot of risk involved.

You start feeling a little inadequate. Like, is it out of my control enough that I shouldn't even be wasting my time? That I should be finding some other thing to do with my life? But then I think to myself, *What if I didn't do this work anymore?* It would send a message to people in my community, that it's not safe. That I have come to terms with the fact that we're just never going to be wholly free. That this country's just never going to accept us for who we are. And I don't want to send that message. I haven't given up on my country. I believe in the potential. I believe in the Constitution. I believe that this is the land of religious freedom, and that that applies to Muslims. And if I have to make it apply to Muslims with the work that I do, I'm going to do that.

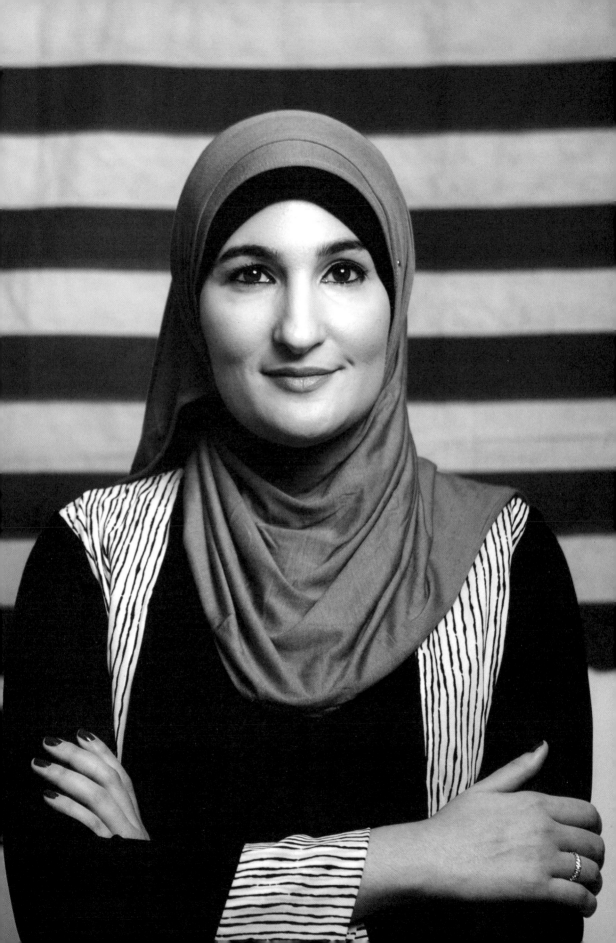

"Once you're free, you can't go back into the box."

—Marian Wright Edelman

Marian Wright Edelman has been an
advocate for disadvantaged Americans for
her entire professional career. She founded
the Children's Defense Fund (CDF) in 1973
and now serves as its president emerita.
She was the first black woman admitted
to the Mississippi bar and received the
Presidential Medal of Freedom in 2000.

MARIAN WRIGHT EDELMAN

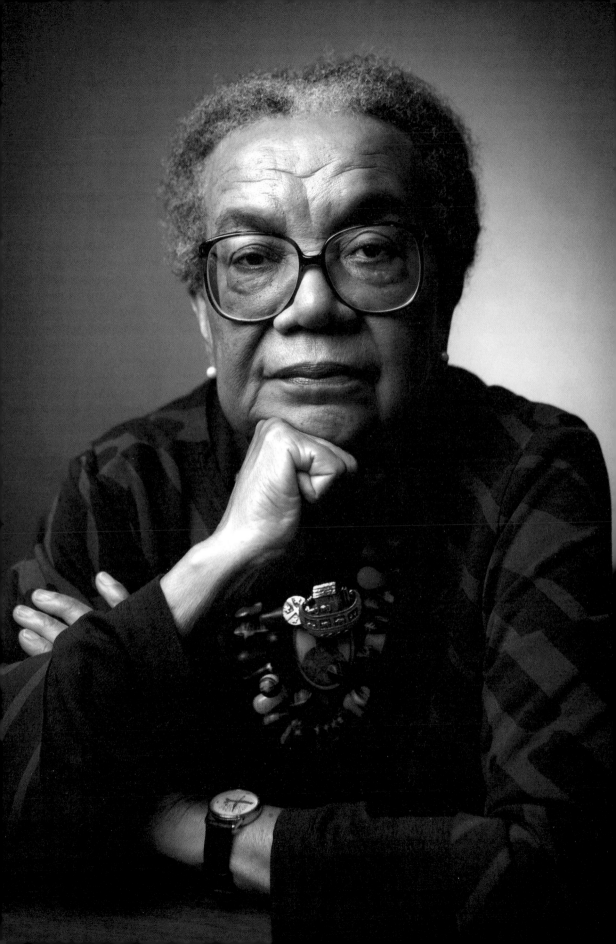

I grew up in a small, segregated Southern town in South Carolina. But we had a parallel set of messages at home. We were clear that the outside world should not define who we were internally. We always had books in our home, even when we didn't have a second pair of shoes. We always knew about the great black role models. And my parents instilled a sense of service. Their bottom line was, God runs a full-employment economy. And if you just look at the need and ask what you can do, you'll never lack for something meaningful and purposeful in your life. All I've done is follow the need. It's what my parents did, and what I was taught to do to deal with injustice in my childhood.

We lived on a highway, and there was a big accident one night. And we all ran out of the house to see if we could help. It turned out there was a black migrant family and two white truck drivers. The ambulance came, saw that the white truck drivers were not injured, saw that the black migrants were, and they drove off. That's the kind of thing that never leaves your memory. You know, little minds just don't forget.

And down from our church, there was a creek. All the black people fished and swam in the creek. We learned later on that the creek was a hospital sewage outlet. Can you imagine? It's amazing anybody is alive. The white kids had a great wide swimming pool not too far away—you could hear them playing. But, when you saw something that needed to be done, you did it. My parents built a playground and a skating rink and a little dinky place where kids could come and play at night and on weekends behind the church. And when there was no home for the aged and this distinguished, wonderful old man began to wander the streets, my parents built an old folks' home across the street. We all had to cook and clean. We didn't like it, but that's how we learned. And my mother, we had to close her down the year before she died, because she was still running the home for the aged—all of whom were younger than she was!

But we were so lucky with role models. At Spelman College, we had the best preachers in America come through that compulsory chapel—Howard Thurman, Dr. King—until we were so instilled in history, in social responsibility, and in service. I can repeat Dr. King's speech absolutely verbatim. It already was in my DNA, but it really got reinforced. And then the greatest gift happened in my sophomore year: Howard Zinn nominated me for a Merrill Scholarship. I went to study at the Sorbonne in Paris and then Geneva. I remember just the feeling of being in the Luxembourg Gardens. First time in a public space without having to look in every direction. It gave me the opportunity to see what it felt like to really be free. It was just glorious. And once you're free, you can't go back into the box. I knew that I was not going to fit back into a segregated society.

I wanted to go back to Europe and study nineteenth-century Russian literature. Go into foreign service. Because I had loved it. But it was the beginning of the student sit-in movement in Atlanta. You see what is happening. And, hell, you get mad. And you follow the need. I applied to law school at the last minute. I went to Yale. And I hated it. Oh my God. What did future interest and the law against perpetuities have to do with police dogs, and all that stuff?

All my friends were in Mississippi. They paid my way to go down there during spring break, 1960. Oh, my goodness. The first thing we heard was there had been a shooting in Greenwood. Voter registration had stirred up things. The community was terrified. But they didn't want people to think the shootings would scare people from voting. So, they said let's walk to the courthouse together to register to vote. And there was the biggest crowd you ever did see. There were all the police cars. It was awful.

Bob Moses, who was one of the bravest men I ever knew, and Dave Dennis and Jim Forman were at the front of the line. They sicced the police dogs on them. I mean, I still cross the street if I see a German shepherd. They were throwing everybody in jail—all the leaders. They immediately took them down to the courthouse to try them. We had three black lawyers in the state at the time who took civil rights cases—ninety-five miles away. So, I went running down to the courthouse—I had one whole quarter of law school, right?—with the mob. And tried to go up the front steps. They pushed me down the steps, and I went around to the side to try to get in. And they wouldn't let me in. And I got so mad, it got me through law school.

My first week or so of practicing law in Mississippi, a young boy, about sixteen, had just come up from Meridian, Mississippi, and was walking with a group of other young people to Jackson. The police arrested them—for no reason—and shot him. And the poor parents had to come and take clothes to the undertaker. Somebody called me up, said, "Would you go with the parents to take him burial clothes?" I said yes, but I had no intention of going into an embalming room. I was going to sit in the waiting room while they went to identify their son. Well, I realized that they didn't want to go without me. So, I went in with them. I had never seen a body that had had an autopsy. This was a slender, sixteen-year-old boy. And he had been killed in a jail cell, a few hours after he had come to Jackson. It was horrible, horrible. I had nightmares for years.

But the courage. The courage. Of people who wanted their children to have a better life. In school desegregation cases, you'd get the plaintiffs, and the next morning their names were up on the telegram post, all of them. They were shot at. They were pushed off plantations. You'd hear bombs go off every afternoon in Jackson, whether it was a synagogue or someplace else. It's amazing what you can get used to living with. You know, we were taught to crank up your car, but leave the door open in case there's a bomb in it. But there comes a time that you're just not going to accept limits. You just get a level of tolerance where fear just disappears, okay? And that's really quite an exhilarating and a freeing thing. My theory of change is the parable of the sower. You've got to plant a lot of seeds because the sun is going to burn up some, and people are going to step on some.

So, you say what you believe and you fight for it. I'm obsessed with ending child poverty. I don't want my grandchildren and great-grandchildren having to fight these issues all over again. What children need is somebody who

"I don't apologize for not going away. I hope I'm a soldier in a truth fleet. I mean, you knock me off, I'm going to come back. Because right is right. Justice is justice."

—Marian Wright Edelman

will bite any hand that hurts them. We need to speak the truth to friends as well as non-friends. And to be standing there when everybody's slamming the door in your face and say, *We won't go away.* I'm sure people think I'm unrelenting. That's true. I'm guilty. But I want for other people's children what I want for my own children and grandchildren. So, I don't apologize for being passionate. I don't apologize for not going away. I hope I'm a soldier in a truth fleet. I mean, you knock me off, I'm going to come back. Because right is right. Justice is justice.

I quote Dr. King all the time about the importance of moving forward: If you can't fly, you drive; if you can't drive, you run; if you can't run, you walk; if you can't walk, you crawl. But you keep moving forward.

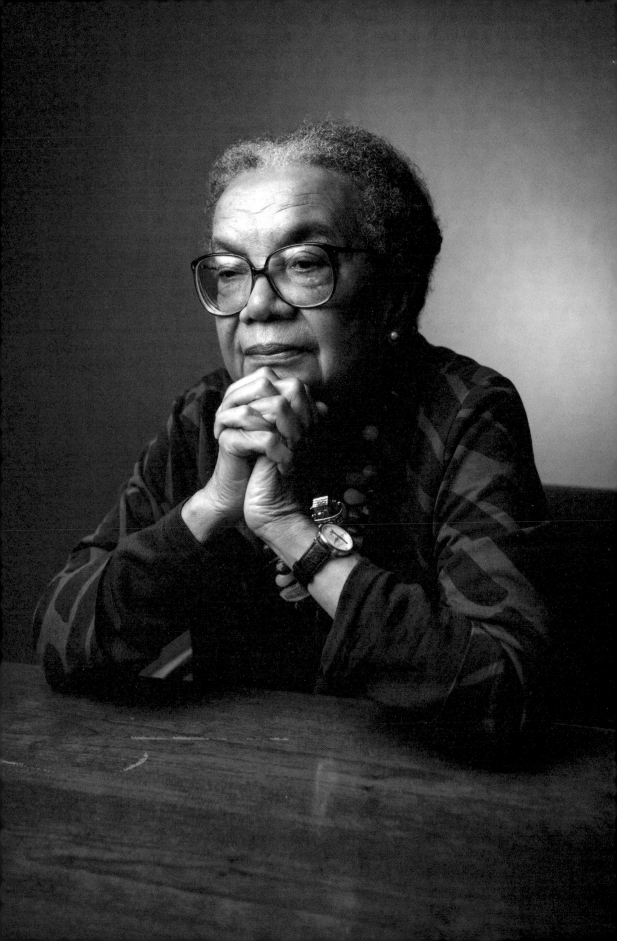

Micah White is an activist, author, and public speaker who cocreated Occupy Wall Street (OWS), a global social movement that spread to eighty-two countries, while an editor at *Adbusters* magazine. He is the author of *The End of Protest: A New Playbook for Revolution*, and ran for mayor of Nehalem, Oregon, in 2016. He is the cofounder of Activist Graduate School.

MICAH WHITE

"You find an injustice that you want to change. You research the issue. And then you try something. Anything.

Then you fail, probably, assess why you failed, and you try to use every experience to move forward."

—Micah White

At thirteen, I didn't stand for the Pledge of Allegiance. It felt horrible, of course. Extremely uncomfortable. I still feel uncomfortable whenever I protest today. It's hard to stand against the status quo. The teachers would say stuff, and you're young, it's not like you can actually defend yourself. You can't even articulate why you're doing something; it was more of an intuitive thing. It had to do with "liberty and justice for all"—and [how] that's not true. When I look back, I'm sure there was personal stuff going on in my life. I don't know. It was like an exertion of self against this world that we live in. My parents are interracial and they would tell me stories when I was a kid: "Oh, we would go to a restaurant, and they wouldn't serve us." Up until the late 1960s, it was illegal in some states in America for them to be married. They were the first generation after that court decision, and it was still taboo. That gave me a feeling of not fitting in with either side—black or white.

Basically, from that point forward, every year I would come up with a new campaign. I got really interested in underground student newspapers, and did one of those—got suspended for five days. I created an atheist club at my high school. And that was huge: I wrote an editorial for the *New York Times* and was on Bill Maher's *Politically Incorrect*. I sued my school with the help of the ACLU (American Civil Liberties Union) of Michigan to fight drug testing of student athletes. Then, after 9/11, I started an anti-war organization at Swarthmore College. And then Occupy.

I think some people are born with a capacity to play music, and I have a capacity to look at a campaign and be, like, *Seriously, if we do this, some crazy stuff's going to happen*. Like, an innate sense. So, then I'll go do it and it'll explode. I think it's the ideas that make me a little bit scared. It is like a physical feeling. Like, with Occupy: *Oooh, asking people to sleep in the streets. Mmm. That's intense*. But you listen to yourself. You find an injustice that you want to change. You research the issue. And then you try something. Anything. Then you fail, probably, assess why you failed, and you try to use every experience to move forward. My experience has been periods where there's these peak campaigns. And then, in between, nothing. But I've learned that something's going to happen. Like, I'm going to totally be involved in something huger than Occupy. I know that absolutely.

You can't force it. I think a lot of it is not in our control. Like, Occupy would not have happened if the Arab Spring wasn't happening. The Arab Spring would not have happened if food prices weren't high. Food prices were high because of climate change hitting Australia. I think that Occupy spread so far and so fast because people thought: "I heard about this thing. I'm doing it in my town. I created it." You know? You have to have an idea that people take up as their own. But, at the same time, a lot of what hamstrings these movements is inexperience. You need someone or a group of people who have the capacity to say, "Okay, we need to switch that idea now. Let's reorient." You have to have the capacity to change.

Micah White

"I firmly believe that Occupy was just a tremor of a much larger earthquake to come. We could give birth to a poor people's uprising worldwide."

—Micah White

I firmly believe that Occupy was just a tremor of a much larger earthquake to come. We could give birth to a poor people's uprising worldwide. Because it's a continuation of what I've experienced. Do you know the story about how Trotsky bumps into Lenin dancing in the snow because the Russian Revolution has lasted longer than the Paris Commune? He had a very deep sense that this was a continuation of previous uprisings and that it had finally broken through some sort of threshold. And now we could have a social movement that [could take] power in many countries very quickly. And it would surprise everyone.

Sister Megan Rice is a peace activist and
Catholic nun, and grew up in a progressive,
socially active Catholic family and community
in New York. Sister Rice taught in schools in
Africa for decades before returning home at the
age of seventy-five to focus on peace actions
with the Ploughshares movement, such as the
event at the Oak Ridge, Tennessee, nuclear
facility that landed her in jail at age 82. She
lives in Washington, DC.

SISTER MEGAN RICE

We knew something was going on that was very secret with the man next door. I can remember my mother saying, "Dr. Hecht is doing something that he can't tell his wife or his daughter. And he can't tell us." Working on a secret project three minutes away at the Columbia physics building. 1940. As I look back on it, I had a feeling that it wasn't good at the time. But, I don't think it was until maybe 1950 that I [learned] Dr. Hecht was working on the Manhattan Project. Because, by that time, it had a name.

They looked upon it as what ended the war. Now, we know that's not really true. In September or October of 1944, dialogue was going on—secret, hidden negotiations—between the Japanese emperor, or his delegates, and the United States. Negotiating that it didn't have to be used. But there was this whole military industrial complex that wanted it to happen. I mean, huge amounts of money had been appropriated for building the bombs. So, you have always this other side to war, the economic hidden agenda. Which is very hard to accept.

My uncle, by happenstance, was among the first group of marines that occupied Nagasaki, maybe five or six weeks after the bomb. He was there for the next six months, so just saw everything. He was rather silent when he came back. Probably unable to share it with people and had to process. But I suppose he was processing it for the next twenty, thirty years. He helped organize the atomic veterans—those who had experience in Nagasaki and Hiroshima. It stuck with me very much. And when I'd come home on leave from Africa, we'd demonstrate at nuclear test sites—Catholic Workers were always very much in the organizing of that—and investigate the nuclear industry in this country. Then, in 2012, we went to Knoxville (Tennessee), looking to do an action.

Early in the morning at the Oak Ridge Y-12 nuclear facility, we cut a flap in the chain-link fence. And we just crawled through it. We were thin, smallish people, so we got through in fifteen minutes. There was an outer fence that was old and rusty in the woods, and that was nothing. And then there were three more fences we had to cut through. But it happened very quickly; they used bolt cutters. And we were delighted. We were able to get in and do what we planned. We had spray paint—people knew what they were going to write. I had tape that I had made, you know, danger tape, and I tied it around the three pillars. That didn't take more than five minutes, I'd say, and we finished doing what we wanted to do. And we lit candles so that we would be ready to welcome the people, you know, symbolically the candles are light. We were bringing truth to the place.

And, what else? We had a Bible. Various things to present to the officer or whoever came. And, gradually, this person that we had seen driving around the perimeter came inside the outer wall and the building. Very slowly, very politely. And we were ready to greet him. We had a statement. And we said, *Will you listen to us?* He didn't say no. So, we started reading this very prayerful kind of statement: *They shall beat their swords into plowshares.*

And nation will not show war against nation, and why we were doing it. We got through the whole thing. He was alone, and just very polite and nice. He knew that we were not violent.

And then another vehicle came. The second vehicle had two people with guns in it. They made us lie down right away. And then handcuffed us to the back. We sort of expected it, you know, all of us had been in other demonstrations, arrested, [gone] to the police station, and seen where people had to lay down or whatever. The normal course of events. And I was friendly with so many of the people who had done Plowshares actions. People, like Phil Berrigan, who had done about eleven years in prison.

Before our action, the night before, we had a very serious time of discerning. We were about eight altogether, and some realized, one after another, that they were not able to face [jail] time. You know, they had children and things like that. So those of us who felt free and able were the three: Greg had done four or five actions, so he was kind of the leader; Michael had done two, I think; and I hadn't done any. That was 2012; I would have been eighty-two. But, I mean, I was healthy. And I had nobody depending on me at that point. I said to myself, *Now I'm free.* The order doesn't really need me. I'm not making any big contributions here. So, certainly I should be one of these people. I said to myself, *How can you not?* You know, I didn't even have family to get concerned. And my order knew that I was doing this. And they were fine about it—although I didn't ask if we could do something that was against the law . . .

We were sent to prison for twenty-five months. But we don't see it as being illegal. We see it as necessary. We had done research, and, as we said, are all responsible to expose and oppose nuclear weapons. So that is primary. [They're] against humanitarian law. So the fence is illegal. The building is illegal, immoral. And so cutting a little hole in a fence where they're, you know, making highly enriched uranium is no comparison.

You know, so often talking to people about nuclear weapons, they say, "Do we still have those?" They don't realize how much is going into it all the time. Thrown away. I mean, it's mutually assured destruction. And that's what we try to get across every time. Even two bombs could destroy the planet. And the United States is getting ready to spend $1.4 trillion making more nuclear weapons. I mean, if all the appropriations for war and the military could be turned into, say, life-enhancing alternatives that are really needed, what kind of an economy would we have? What kind of life would we have? You know, realizing that your tax money is scandalously appropriated, so it goes into private pockets of the contractors. That kind of information needs to be revealed.

So, I advise people to find out how many nuclear weapons exist, in which countries, and [to] spread the word. And having been, by circumstances, going back to my uncle and his experience in Nagasaki and my neighbor, right up close to it and lived through it, it's my responsibility to keep on letting people know.

Leah Greenberg and Ezra Levin both worked as congressional staffers on Capitol Hill, together with their Indivisible cofounders, Angel Padilla and Jeremy Haile. Indivisible began with the publication of a twenty-three-page Google document, *Indivisible: A Practical Guide for Resisting the Trump Agenda*. This husband-and-wife team serve as coexecutive directors of Indivisible.

LEAH GREENBERG

EZRA LEVIN

Form

IVISIBL

CTICAL GUIDE

; THE TRUMP AGI

Ezra: Building a movement—that's not actually the space that I come out of. I'm more an anti-poverty think-tank advocate wonky kind of guy. Which is related, but different. It's the end result of the work that folks are doing on the ground. But after the [2016] presidential election, we were going through the stages of grief just like everybody else. I got stuck on anger for a while, trying to figure out what exactly we could do. We sent out an email to all our friends in the DC area—just people we worked with on Capitol Hill or in the progressive advocacy space—and started pulling together a group just in our living room to talk about, *Okay, what do we do?*

Then, for Thanksgiving, we were back in Austin (Texas), where I'm from, meeting in a bar with a college friend. She was telling us about this Facebook group she was part of, and how there's a ton of energy out there, but Congress is a black box if you're new to the process. So, the huge goal of resisting the Trump administration's agenda when there is unified conservative government looked hopeless.

Leah: Our friend was saying people just feel like they're screaming into the void. And we were like, *Well, we know that local action is really powerful. We've seen it. Let's reverse engineer what we've seen and put it to people's use and help them understand what calls to Congress do.* We were like, *Well, we need a clear tool kit that explains how members of Congress respond to stimuli and what organized constituent action is.* We were immediately excited because it was something that we, with our congressional experience, could do to give people a sense of their own power.

Ezra: We saw the Tea Party effectively assert that power and take down an incredibly popular president—with huge congressional majorities. They didn't win all the time. But they slowed down the policy-making process. And, in some cases, either watered down the legislation or straight-up beat it.

Leah: Because organized constituent action can have a really outsized effect on how members of Congress think. They changed the environment in which everyone else operated.

Ezra: Which is amazing. Because this was a relatively small number of folks who were spread out throughout the country, but implemented pretty basic tactics to take down a federal policy agenda. So, we believed that was a strategy that could work in this environment. By Sunday night, we had hammered out a first draft. Then, it was about two weeks of getting comments, mostly from former congressional staff, and revising.

After we tweeted it, we were, like, *Oh my gosh, twenty people are reading it!* And then it went up to, like, ninety-five, one hundred, and it kind of stopped— it turns out Google Docs stops counting at one hundred. But then what happens is, if a Google Doc is getting a ton of traffic, it starts popping up with an error message saying: "This has an unusually large amount of people viewing it, so some features are disabled." So, within an hour or two, you

"People just feel like they're screaming into the void."

—Leah Greenberg

couldn't download or print the guide. There were just too many people trying to view it. I was at a staff retreat for my job. And my phone was blowing up. Because George Takei tweeted it out, and Robert Reich found it—I mean, this is all within twenty-four hours. It's a weird thing, right? Hey, read this twenty-page guide of democracy that we think could be really useful . . .

Leah: It took over our lives immediately. First, we were super excited that people were reading the guide at all. Then, there started to be these Facebook groups like Indivisible Rochester and Indivisible Columbus. People were really running with it.

Ezra: Now, we have 5,800 groups. There are at least two groups—and an average of thirteen—in every single congressional district in the country.

Leah: We had a lot of volunteers, but in early January it was clear that we needed to figure out a real, institutionalized way of continuing to be supportive. Because people were reaching out.

Ezra: We could have said, *Look, we wrote a Google Doc and that's all. More power to you. Figure it out.* But there was this movement growing, asking us for support. Once all this energy was out there, a lot of members of Congress were saying, "I'm not going to hold town halls." They don't want to look bad in local media. They're worried about having engaged constituents tell them that they don't like the Trump administration's agenda. So, we put out a guide on what to do when your member of Congress is hiding from you and how to form these constituent town halls.

The thing is, there was a ton of energy out there. Individuals taking it upon themselves to build groups at the local level. The fact that they're taking inspiration from the Google Doc and calling themselves Indivisible, that's great. But the really meaningful thing here is that this is a movement of thousands of people taking control of their country.

Nicole Maines is an actress on the television show *Supergirl*, where her character is television's first trans superhero. Growing up, Maines and her family won a landmark suit against their school system in the Maine Supreme Judicial Court, which guaranteed the right of a transgender child to use the bathroom designated for the gender by which they identify—the first such ruling by any court in the US. She, her twin brother, and their parents are the subjects of the book *Becoming Nicole: The Transformation of an American Family*.

NICOLE MAINES

"We can argu[e]
science, an[d]
about male [v]
brains and [o]
and all of tha[t]
that it boils
innate sense[s]

e about the
we can talk
ersus female
hromosomes
. But I feel
own to that
of self."

—Nicole Maines

The fight really started when I was in elementary school and we were trying to get the school to cooperate with us. Which, at first, went very well. At the time there was really no information on trans people, let alone trans youth, so we were all kind of feeling around in the dark together. And we took it step by step—everybody asking questions, and everybody cooperating and communicating. But in fifth grade, there was a new student in my class whose grandfather was a member of this Christian Right group. And he did not think that my using the girls' bathroom was acceptable. So, he used his grandson as a political pawn to follow me into the bathroom, and say, "We don't have to have fags in our school." Ten years old. I had never heard the word "fag" before.

Having this big, Christian Right group threatening a lawsuit [against the school] just turned everything upside down. The school banned me from the girls' bathroom. Which sent the message, hey, this kid is so different from you all that they need to be isolated and can't be permitted to exist in the same public space. It's so humiliating. Because you know how girls all go to the bathroom in packs. So, having to break off from the group, and go to your own separate bathroom—all I can say is it's isolating. And the bullying skyrocketed after that.

You know, we can argue about the science, and we can talk about male versus female brains and chromosomes and all of that. But I feel that it boils down to that innate sense of self. That instinct that we all have surrounding gender: We know what feels right, and we know what feels wrong. If you put a kid in gendered clothing that they don't associate with, they're going to tell you, "This is stupid." And that's what I was telling my parents. Pretty early— I mean, three, four years old—as soon as I could really vocalize. So I never was like, *I'm a boy.* Part of my introduction growing up was: *Hi, I'm Wyatt. I'm a boy who wants to be a girl.* It was always a part of my identity. You know, [my twin brother] Jonas was a boy, my dad was a boy, all my friends were girls; their genders were all very transparent. So, I didn't feel the need to hide who I was. Nobody else had to, so why should I?

It would result in fights with my dad. You know, me voguing in my reflection in the oven door. And him telling me to, like, flex my muscles. And I just could not be bothered. He really, really resisted. But, he never made it feel like he didn't love me; he just tried to make me not trans! I always had my mother working with me, but when we started being attacked by the Christian group and by the school, Dad really got on board. He was, like, "I don't understand all of it, but I'll be damned if you're going to come after my family." And, of course, now he's my biggest supporter.

We filed a lawsuit for unlawful discrimination. Because, under the Maine Human Rights Act, it was illegal for [the school] to do what they did. Since 2005, sexual orientation, including gender identity, had been a protected class in the state of Maine. And it became this whole big thing. After that, my mom, my brother, and I moved two hours south to go to a new school. And my dad stayed behind to keep his job at the university so, you know, we'd have income.

My parents told us that at this new school I couldn't be out about who I was: "Nicole is just going to be a girl—not the trans girl." Because, of course, every school talks a big game about zero tolerance on bullying, all that. And anyone who's ever gone to school knows that that is 100 percent bullshit. We just couldn't go through that again. We felt defeated. Drained. I mean, years of working with the school. Years of meetings and conversations and struggling, and it all just kind of came crashing down: moving away, leaving our father behind, back in the closet. It felt like they'd won. Like we'd been beaten. Just the act of hiding who I was was just so exhausting that I just kind of shut down. There is no other way to say it than that it sucked.

But it's also what fueled our activism again—lobbying in the state house and defeating [a proposed bathroom] bill and changing the mind of its cosponsor. I think a lot of the folks proposing these laws don't have a concept of who it is they're harming. It's much easier to target somebody when they're just this disembodied concept. So actually meeting me and seeing who this was affecting—a little kid—triggered a light bulb in a lot of their heads. Because it's a lot harder when you're looking a twelve-year-old girl right in the face to say, "You don't matter."

I wish I could kind of go back and give a little bit of the confidence I have around my gender now to me growing up, to me in fifth grade hearing "faggot" for the first time. Being like, *Don't even worry about it, you're going to be okay. And, oh, by the way, you're going to be a superhero—the first trans superhero.* Getting a trans superhero is like hearing the word "trans" for the first time on the radio after Lady Gaga's "Born This Way" came out. I mean, it just rejuvenated us with hope and confidence and self-love. Sometimes I still listen to it. I'm like, *mmmmm, gay, straight, or bi, lesbian, transgender life!* I love it. It's that visibility and acceptance, like, *I'm here too. I exist. I'm not alone.*

I've never been thrown in jail. I've never rioted against police. I've never thrown bricks through a window. After everything my trans ancestors went through, sharing my story about a bathroom seems kind of small in comparison. But if my story can help a school develop a gender-inclusive policy before they even have a trans student come out, it needs to be done, and sharing it is the least I can do. So then when that student does come out, it does not fall on them to be everybody's encyclopedia, to be everybody's guinea pig. I'm like, *Honey, don't you worry. Been there, done that. You just focus on you. You just live your best life.*

I mean, it's all about making it easier for future trans kids, for trans kids now, for trans adults, for all of us. I'm like, *I'm with all of you guys: I'm getting a trans superhero too.* I am just as excited. Because if you can be a superhero, you can be anything. And, as my dad puts it beautifully, the real superheroes are the trans kids who get out of bed every day knowing they're going to have a bad day.

Nicole Maines

Photojournalist Pete Souza served as chief official White House photographer for President Barack Obama for eight years, and previously as White House photographer for President Ronald Reagan. Souza's latest book, *Shade: A Tale of Two Presidents*, contrasts the Obama and Trump administrations by juxtaposing photos of the former with tweets, quotes, and headlines generated by the latter.

PETE SOUZA

"You're not going to shut me up."

—Pete Souza

I was never really active politically or anything like that, but I ended up covering politics a lot in my career. It's just more one of those things that you take certain turns in your life, and you sort of just end up where you end up. But, I've become more active post-White House, just on my Instagram feed. Which is not anything I would have ever expected I would have been doing.

It helps to have observed two presidents from two different political parties. Both of whom I thought were decent human beings, and both of whom I thought understood what it meant to respect the office of the presidency. And then this guy [Trump] comes along, who I think disrespects the Oval Office every day. Lies to us all the time. Bullies people. I felt I had a unique voice and that I couldn't just sit by and not do anything. I don't know that I could have lived with myself if I didn't speak out. I wouldn't be doing this if Mitt Romney was president, if John McCain was president, Jeb Bush was president, if John Kasich was president. I don't think it would have entered my mind. This is not a partisan thing. It's a citizen thing.

A couple days after the inauguration, there was a picture of the new Oval Office that I saw somewhere. And it was those gold ornate curtains and multiple flags. I was appalled. Like, *What is this? This is not the Trump Tower gold palace. This is the Oval Office*, you know? And so I posted a photo of President Obama seated on the Resolute desk with the curtains that he had. I think my caption was just something like: "Kind of like the old curtains better." And I may have said, "Don't you think?" I can't remember. So there was a double meaning there. People picked up on it right away. And somebody even used the term "shade." Which I didn't really know what it meant. And I was like, *Oh, maybe I'm onto something here.* And then there was the Muslim ban. And I posted something on that. Clearly, I had struck a chord.

The pictures that I post on Instagram—all publicly available somewhere—are a way to just respond to the crazy things [Trump] does. I'm using his words or his actions. But I'm not using photos of him. And also, hopefully, they are a reminder, or maybe even in some cases an education to really young people, that what's happening now is not normal. This is not the way the President of the United States should behave.

When I first started doing it, it was so subtle that, unless you were really picking up on the news, you might not know what I'm talking about. Then, last spring, I decided to take it further and do the *Shade* book. I think part of it was getting hate mail, a couple death threats. It's, like, *Screw you, man. You're not going to shut me up.*

I ran into a congressman the other day. And I introduced myself to him. And he goes, "I know who you are." I said, *Well, I just wanted to thank you for what you're doing*. He goes, "Well, I want to thank you for what you're doing." And I was just kind of taken aback, you know? I sort of forget the power of Instagram at times. It's crazy: I have more than two million followers. I mean, I've worked for four newspapers in my career. The combined circulation of those four newspapers does not equal the number of followers I have.

Some people say they thought it was unbecoming of me to be doing this. That I was supposed to be a documentary photographer for nonpartisan purposes, to document the presidency for history. And that I shouldn't be speaking out politically. I get it. It's totally fair to respond that way. But, I fundamentally disagree with that argument. I'm a citizen of the United States. I feel strongly about this, about speaking out, about doing something. And these are all public-domain photos. And I'm going to continue doing it. That's our First Amendment right. And I certainly think I'm doing it in a way that's a lot more respectful than the man in the Oval Office.

Tanya Selvaratnam is cofounder of
The Federation, a coalition of artists,
organizations, and allies focused on keeping
cultural borders open and demonstrating
how art unites us. She is active in the 50
State Initiative, started by the organization
For Freedoms, to use art to encourage civic
engagement and public discourse, and is a
producer and convener of numerous social
justice projects.

TANYA SELVARATNAM

"You have t
people tog
so they do
separate f
other—so
everybody

bring
ether
't feel
m each
hey feel like
s human."

—Tanya Selvaratnam

I actually believe that it does take one bad person to ruin the world. So, you have to bring people together so they don't feel separate from each other—so they feel like everybody's human. Have you seen *Wild, Wild Country*? It shows how totally normal, rational people can get swept up into a frenzy and do insane things because they're so seduced by one person and his philosophy. Things can go very badly quickly if you don't try to stay ahead of them.

I think what set me on my way was standing up for my people, because Sri Lankan Tamils were oppressed. Standing up for my mother because she was beaten by my father. And standing up for friends from South Africa under apartheid. And I've been very fortunate to have incredible teachers and elders in my life who really showed me how to be strategic and effective when it came to making change. I was also very fortunate to be amongst creative activist types who knew how to do things in a way that people enjoyed so it wasn't fatiguing. Like, in college, I became part of a group of misfits: we were gay, we were foreign, we were nerds, and very activist-oriented. Together, we formed a group called Students for Creative Action—staging protests, organizing events in such a way that you give people opportunities for joy while they're making change. That's always been very important to me.

I feel like gatherings are where a lot of the magic happens. If you bring the right configuration of people together that otherwise wouldn't meet. Around the time the travel ban was proposed, we formed The Federation, a coalition of artists and organizations to keep cultural borders open and show how art unites us. And with For Freedoms, we did the 50 State Initiative, the largest creative collaboration in US history. It was more than 700 activations and more than 700 artists doing billboards, town halls, exhibitions, and public programs in all fifty states and DC and Puerto Rico. The aim is to catalyze civic discourse through art, to get people to talk to each other and to listen to each other.

I thought For Freedoms' Norman Rockwell images revisited were especially impactful. Because it expanded the notion of what an American looked like. It took Norman Rockwell images and changed who was in the frames. In the originals, little to no people of color or people from different religions were represented. [But in the new ones] I saw myself, I saw my friends, I saw my community. And I felt overjoyed to see them. I think when you see yourself in the picture, you feel more like you have agency over your place in this country. Like you're not a bystander; you're a participant. It's about inspiring change. And humanizing people.

And that's hard, now more than ever, because of social media and celebrity culture and pop culture. There are too many people who use movements to build their own platforms, as opposed to use their platforms to build movements. And it's hard to filter through that noise. So, part of what I like to do with my work and the young people I work with, especially, is to help them realize that the most important thing to focus on is yourself and what you can do. And to build community so you're not alone. I'm an optimistic nihilist. Like, I think the world should end. But, until it does, I'll do what I can to make it better. Checking out is not an option.

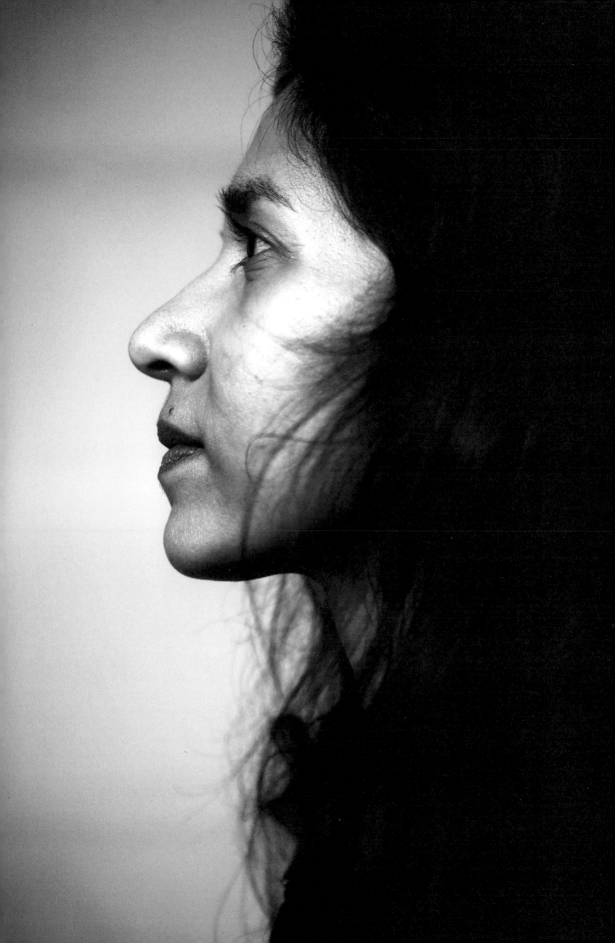

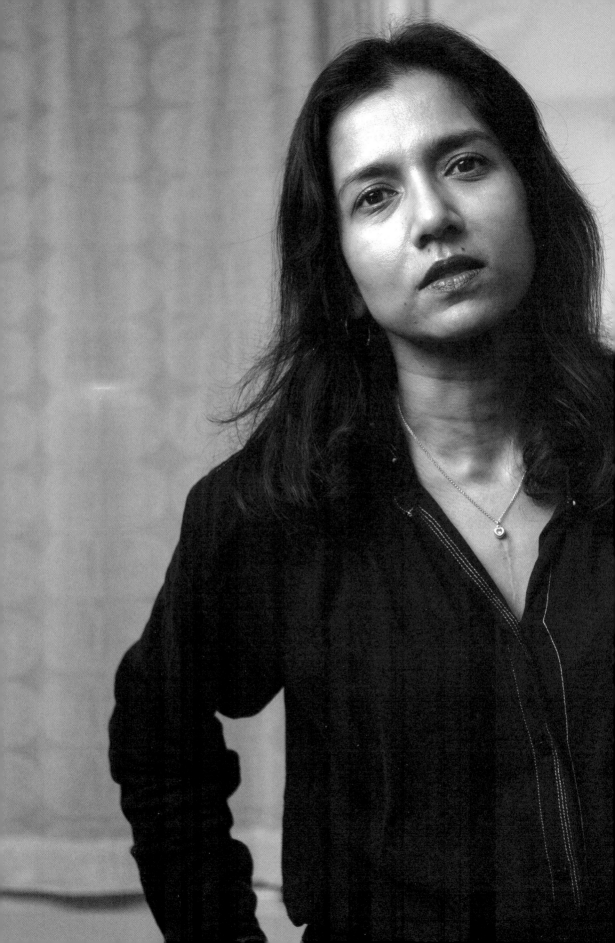

"Checking out is
not an option."

—Tanya Selvaratnam

Jayna Zweiman is an artist and design
architect who cofounded the Pussyhat Project
in 2016 to demonstrate solidarity, and to
protest negative rhetoric against women in the
previous state and federal elections. Millions
of people wore knitted pussyhats to the
inaugural Women's March in 2017, creating
a bold visual statement that has transformed
the pussyhat into an iconic symbol of support
and solidarity for women's rights. Zweiman is
currently engaged with the Welcome Blanket
project, a craftivist initiative that creates and
distributes welcome blankets to immigrants
and refugees arriving in the US.

JAYNA ZWEIMAN

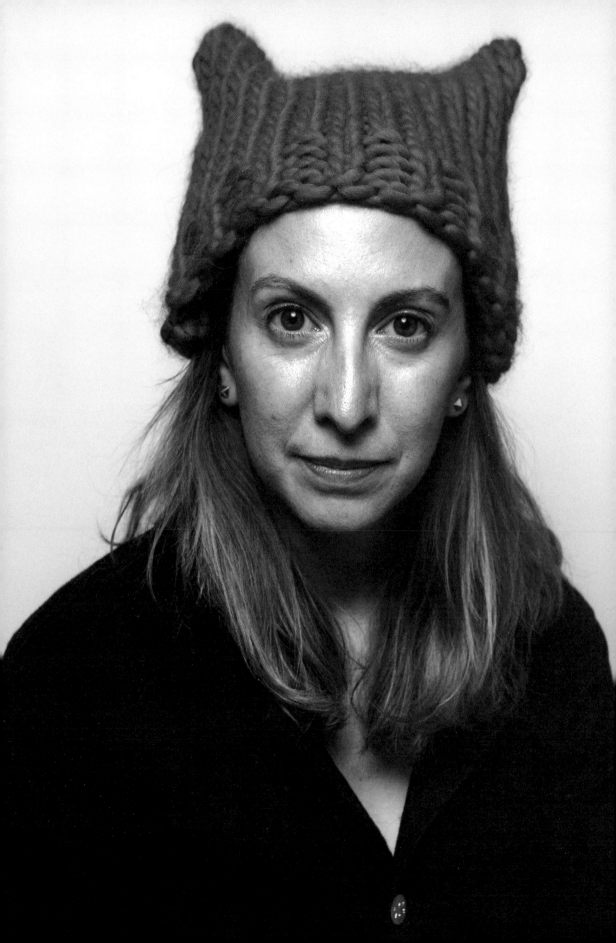

The Little Knittery has these open knit nights. A lot of regulars just kind of show up in the back and hang out. I roped in Krista Suh, who's [Pussyhat Project's] cofounder, to learn how to crochet. You can be the absolute worst one in the room, and you're totally welcome. And there was something that was so special about that during 2016, when it was getting nastier and nastier. And I was having this reverse experience of being exposed to more and more people who were all different ages, different backgrounds. Mostly women. And talking. Which was just wonderful. You know, there was a lot of anger and frustration, of course, but, talking. And then, when the election happened, and the [Women's March] was announced, I just had this complete desperation that I wanted to be a part of it.

But I couldn't go. In 2013, I had a really bad accident. A fourteen-foot rod just fell on the back of my head and my neck. That's sort of dictated what I can do, what I can't do. And I had that sense of: It's so unfair how some people get to go and other people don't. Krista was going and she was like, "Should I do some kind of performance? Strip naked?" We were in the Little Knittery, just a group of people in a knitting circle just kind of chiming in and she's like, "I could knit a hat. You know, other people could knit a hat." I grew up knowing about the AIDS [Memorial] Quilt, Spencer Tunick's huge group photos—and the strength and power of those experiences. And it just seemed like this was an opportunity to make a huge potential installation together, but also to create all of these spaces of people making things together. So, we had a two-part mission: We wanted to create a strong visual image on the Mall, with the idea that if you're seen, you're better heard; and to create a way for people who couldn't be there to participate.

We were aiming for a million hats really from the very beginning. So we had the idea to have a silhouette that was recognizable. Kat Coyle from the Little Knittery made the pattern. We asked for it to be really cheap to make. So, worsted wool, which, you know, you can get pretty much anywhere, and the absolute beginner project. Sort of like the diagram of a rectangle folded on its side. And then you stitch from the creases, put it on your head. You're done.

When we asked Kat what it's called, she kind of paused and was like, "Pussy Power Hat. You know, pussycat, pussyhat." Alluding to the fact that they're cat ears. Right? And also Donald Trump's hot mic. And the idea that you can't grab anyone by their body parts. That's just completely inexcusable. And being able to highlight that as something that you don't just forget. It took me, like, two days to get used to it; for me, it was a really uncomfortable word. And just through the act of using "pussy" without any sort of kind of negative connotation, I've taken back the word myself. But it's amazing how these words have so much power. And I think if we had named it the Pink Hat Project or the Kitty Cat Hat Project, it wouldn't have sparked as much conversation.

Really, all it was was setting down the barebones framework to do it. Everyone helped. Kat's on Ravelry, which is like Facebook for knitters, and then people within Ravelry were, like, "We got this. We'll be the group admins." All these people had their message boards about the Pussyhat Project. And Kat put the pattern up there so that everyone could have it. People made, like, instructional videos. People made translations. There were all these people just giving. And we had a template for a note that you could include where you could talk about women's rights issues important to you. So all these people who couldn't physically be there were literally heard one-to-one. Which just struck a chord with so many people, that this was a great way to get involved, help other people, be visible. Be heard.

It was incredibly empowering. Just the sense of connection with so many people that I've never even met in person. To hear from people what it meant to them, that it mattered. And we'd get the best email. My favorite one was this mortician. And she was like, "I got to tell you. This woman came in with her mother who, you know, died at a ripe old age. And we went to go look at her, and I guess she chose to die in her Pussyhat. And her last wish was to be cremated in it."

I met this woman who said that she was going into surgery for a double mastectomy and she wasn't going to be able to march. But, she made thirty hats—so she was everywhere. And she felt like she was there. Just that feeling of participation. We'd hear that it took people out of their depression. Because when people have something to physically do, it often helps. And people were connecting across generations with their families. And, you know, talking to each other. Just all these beautiful things that I've always wanted to do with space and with architecture and with art.

With architecture, usually you'll enter a competition and someone chooses you. Nobody chose us. There was no jury to decide whether we were good enough or not. Everyone chose us. And we could do it on a shoestring because everyone gave of themselves. It's everyone's.

It was my own limitation, really, that made me recognize, you know, so many other people might have reasons to not be able to go. And to extend this idea of the march and activism and participating to not just four hours in one place that you had to get to, but the whole preparation and the experience could become this thing that anyone anywhere could participate in. So, when I see all those hats, I don't just see the millions of people, but so many more! I had gone through so many years of isolation that it was wonderful to know that I had made something that, for other people feeling isolated, felt connected. It was this incredible feeling of, wow, with my own personal hurdles, I could actually do something for someone else that could help them deal with whatever hurdles they're dealing with. And I just felt so human. Like, wonderfully human.

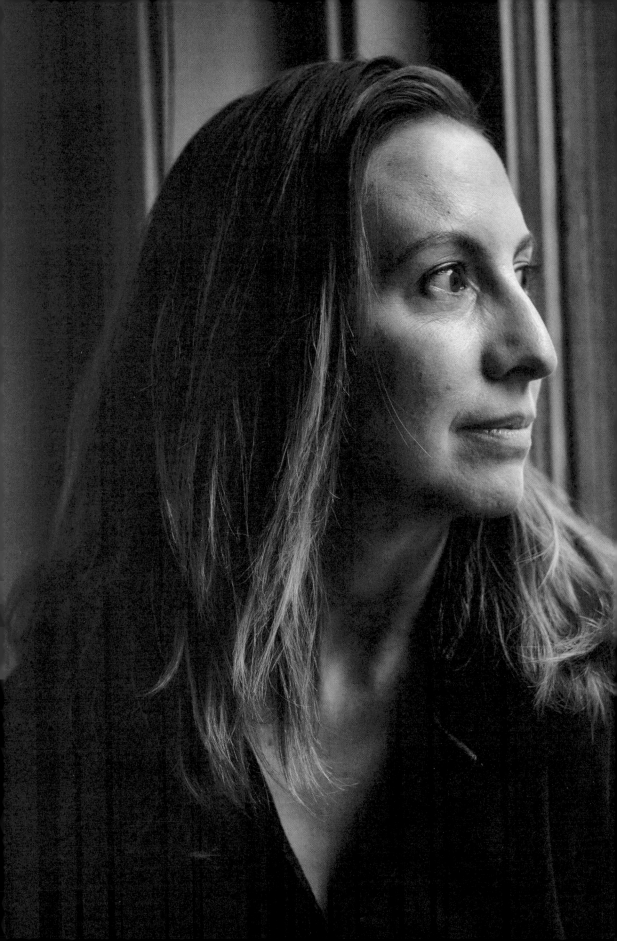

"It was this incredible feeling of, wow, with my own personal hurdles, I could actually do something for someone else that could help them deal with whatever hurdles they're dealing with. And I just felt so human. Like, wonderfully human."

—Jayna Zweiman

Phyllis Lyon is a pioneer of lesbian and feminist activism. In 1955, during the McCarthy era and "Lavender Scare," Lyon and her partner, Del Martin, helped start Daughters of Bilitis (DOB), a secret social organization and the first lesbian organization in the United States. After fifty years together, they were the first same-sex couple to be married in San Francisco in 2004. After that marriage was invalidated, they married again in 2008 when the California Supreme Court legalized gay marriage.

PHYLLIS LYON

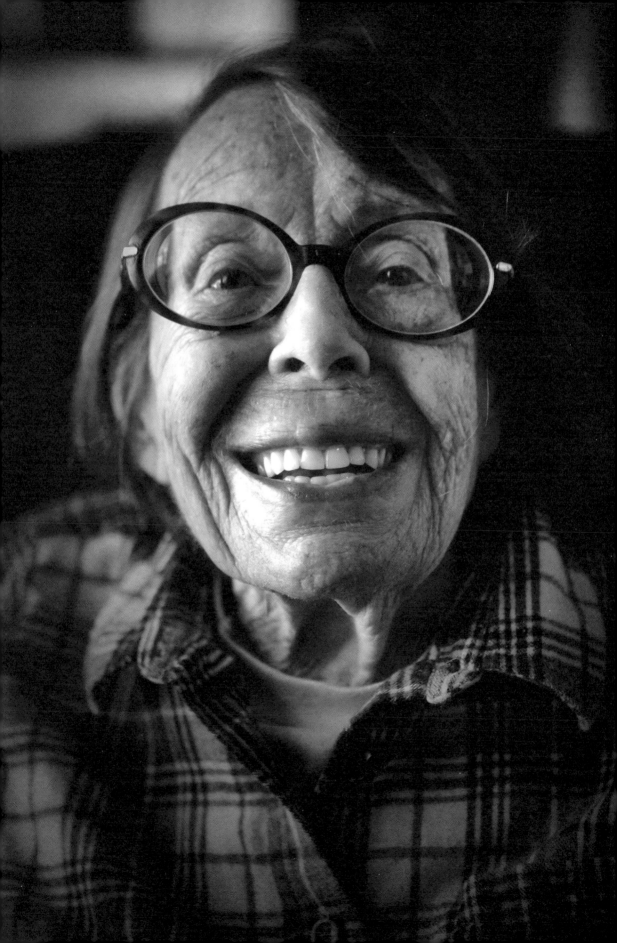

My biggest problem was my parents. Because I knew I was going to really rack them up. Mom was a Southern belle. Deep from the heart of Texas. Dad was from the north. I didn't talk about it with them, and I didn't want them to know. If you're a little kid, you might have asked, "What's a lesbian?" But the response would tell you that you shouldn't do that again. Gay men and lesbians were not "good people." They were not illegal, but they weren't supposed to be treated nicely. They were supposed to be ignored, I think. If you went to a doctor and said you were a lesbian or, you know, a male homosexual—they really didn't know what to do. Put you in a cell. Put you in a place where they can take it away from you, or something.

Del and I became friends when I came to work—it was a newspaper. She was helping me get organized and mix in, and so on. So, we worked together. And we became friends. I don't know that I knew much—or anything—about lesbians. Somewhere along the line, she must have told me something about lesbians. And I'm going, *Huh? What do you mean?* Then she would explain it to me. And I would think, *Oh. Hm.* And then, at some point in time, we got together! And it felt pretty damn good.

We helped start DOB, Daughters of Bilitis, Del and I. Bilitis was some kind of a Greek goddess or something. I'm pretty sure that DOB was the first lesbian organization in the United States; certainly in California. The reason was we wanted to meet more lesbians! Without having to go to the bars all the time and try to meet people that are getting drunk and so on. Better idea to get people together that you can talk to about all kinds of things. We just figured every lesbian, in those days, they'd be always scared to death they'd be discovered. It would kill their parents if they found out. Or, you know, their parents would throw them out the window. Or something. All kinds of dire situations. Lose a job.

People were scared, hiding. And they were excited when they found out about DOB. Because you could be a gay person and not know there were any gay people. So it was so good to meet other lesbians. You built your own community. And we began to grow, getting Daughters of Bilitis chapters in other cities and other states, too, having a convention every year. And we wrote a book: *Lesbian/Woman*, by Del Martin and Phyllis Lyon. I guess the first book came out in '72. [Reading from the introduction:] "The people described in this book are real. The incidents and situations are true. However, we have changed most of the names and places to protect the innocent lest they be punished for the infamous crime of being [a lesbian] . . ."

But when we had problems with other lesbians who didn't want anybody to tell anybody that lesbians existed, you got a little tired of that. They didn't care they couldn't just get married and stuff. They were sure that there wasn't any way they could do that. Nobody would let them. But things changed as time went by. People began to understand that lesbians or gay men were human beings. And should be treated like people. A lot more gays and lesbians came out.

We got married—twice. The first one was invalidated. Yeah. I remember that. Gavin Newsom married us. We were right in the middle of it. I guess Del and I had been more open than most gays and lesbians. We were happy that it was happening. We knew that we were legally married. But we also knew that we had done something that would help a whole lot of other lesbians. And [were] glad we could be helpful.

Neither one of us wanted to be historic. But we did want to do what we could do to help people like us. And it kept us busy.

Phyllis Lyon

"Things changed as time went by. People began to understand that lesbians or gay men were human beings. And should be treated like people."

—Phyllis Lyon

Ralph Nader has championed consumer rights, environmental protection, and public accountability during his decades of activism. Nader's advocacy has led to the enactment of several major pieces of legislation, including the Freedom of Information Act, and the National Traffic and Motor Vehicle Safety Act, following his groundbreaking exposé of the American auto industry, *Unsafe at Any Speed*. He has founded several watchdog and advocacy groups, including Public Interest Research Group (PIRG) and Public Citizen. Nader has run for president of the United States as an independent and third-party candidate.

RALPH NADER

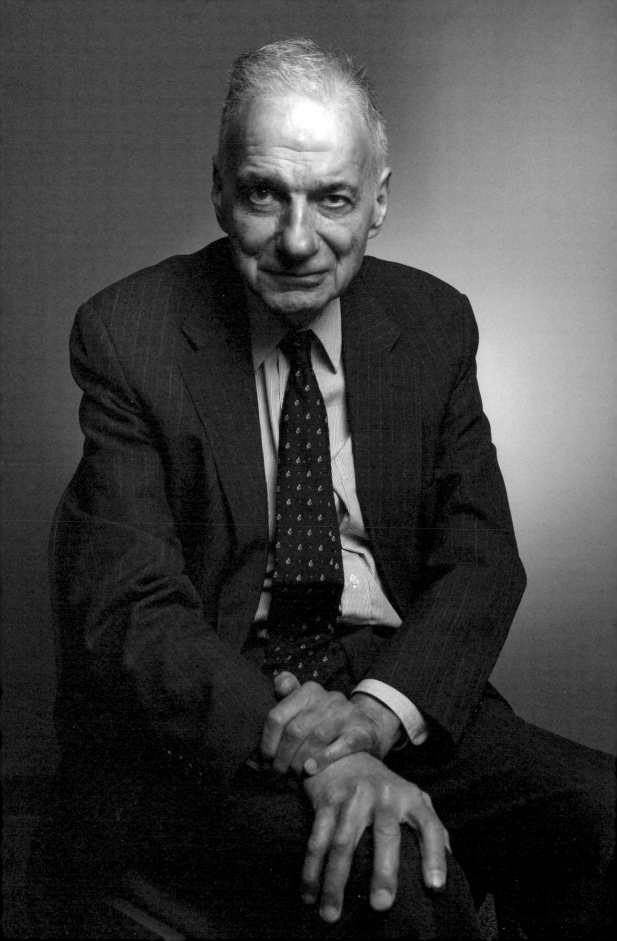

"My dad
say, 'If
don't u
rights,
your rig

would
ou
e your
ou lose
hts.'"

—Ralph Nader

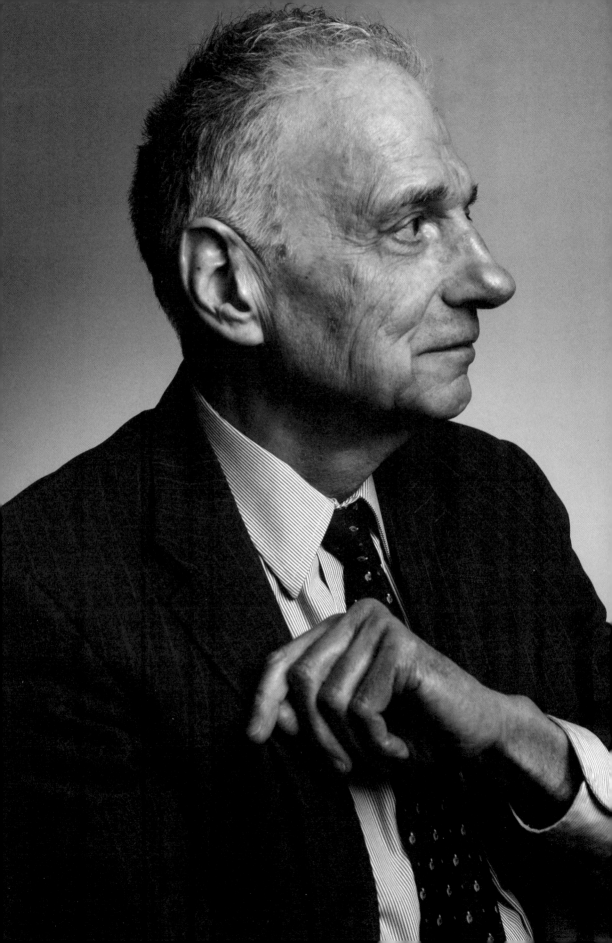

We didn't start with any money or power. Just knowledge and action.

People would say to my mother, "Mrs. Nader, you're raising four children. How do you find time to be active in the community?" And she said, "There's really not that sharp a line, is there? If the community isn't good, what kind of environment is it to raise a family?" That was part of growing up. It wasn't didactically done: You must be a fighter for . . . No. It was just, "You like to be free, Ralph?" *Yeah*. "Okay, well, you have to be responsible for that." The other side of freedom is citizen responsibility. You've got to go to town meetings. You've got to vote sensibly. My parents used to take us to town meetings, so we could watch and listen. My dad would say, "If you don't use your rights, you lose your rights." That is incredibly profound. Because that's what's happened to our society in the last forty years.

I read a lot of muckraking books when I was a kid. I'd be listening to WINS [radio station] in New York, the Yankee games, and I'd be reading. Like [Ida] Tarbell, the woman who exposed Standard Oil and Rockefeller. Great story. And Lincoln Steffens. Just the great muckrakers of our time—I devoured them. It was like reading mysteries. As I grew older, I would read books by Clarence Darrow. Oliver Wendell Holmes. People fighting against injustice. That's what life is about.

The best example is my mother. Our town was destroyed twice—1937 and 1955—by huge floods, because the channel for the Mad River was narrow and it overflowed. In '55, Hurricane Diana took half of Main Street down with it— buildings, car dealers, cars bobbing. Eleven people died. And so my mother got fed up. Because people in town would be talking about a dry dam, but they'd just talk. So, one day, Senator Prescott Bush, grandfather of George W. [Bush], came to campaign. She went to the reception and she stood in line patiently until she got to him. And she grabbed his hand and she said, "Senator Bush, we've lost life here. We've lost property. This dry dam is long overdue. Will you promise that you will get it done?" He tried to sweet-talk her. And she wouldn't let go of his hand until he said yes. And he got the Corps of Engineers to do it. We've never had a problem since.

See, most people know about injustice. They feel it. They complain about it. They grumble. And we just sort of said, *Okay, what do we do about it?* When I was at law school, I did a third-year paper on unsafe automotive design and the law. The absence of liability, absence of mandatory standards. And I turned that into the book [*Unsafe at Any Speed*]. I wrote a lot of things on it. So, getting the facts and communicating them. And then you ask, "Well, I mean, if you don't try to do it, who's going to do it?" Are you going to wait around for somebody to say, "I read your article, and I'm rolling up my sleeves?"

Look, all justice movements start from a few citizens. Then they get into the public arena. Then maybe into legislation. Or into corporate practice. Like recalls and so on. And all failures of a democracy flow from citizens staying

"It's so easy to have a vibrant democracy. We just have to want it. Value it."

—Ralph Nader

home, turning their back on the community. People grow up thinking, "Oh, you can't fight City Hall." And, by corollary, you can't fight ExxonMobil, right? Well, if you grow up that way, you don't even try. Students are not educated for forming a civic personality. They are educated into apathy, into passivity, into a reduced significance of themselves. So you don't develop the tools of democracy. Not just the values of justice, fairness, and all that. Instruments, however intangible, of sustaining civic engagement. Like the Freedom of Information Act.

It doesn't take some billionaire putting in, you know, a couple hundred million bucks. It doesn't take more than a few hundred people. How many members are in Congress? 535. How many are we? Who belongs to who? It's so easy to have a vibrant democracy. We just have to want it. Value it.

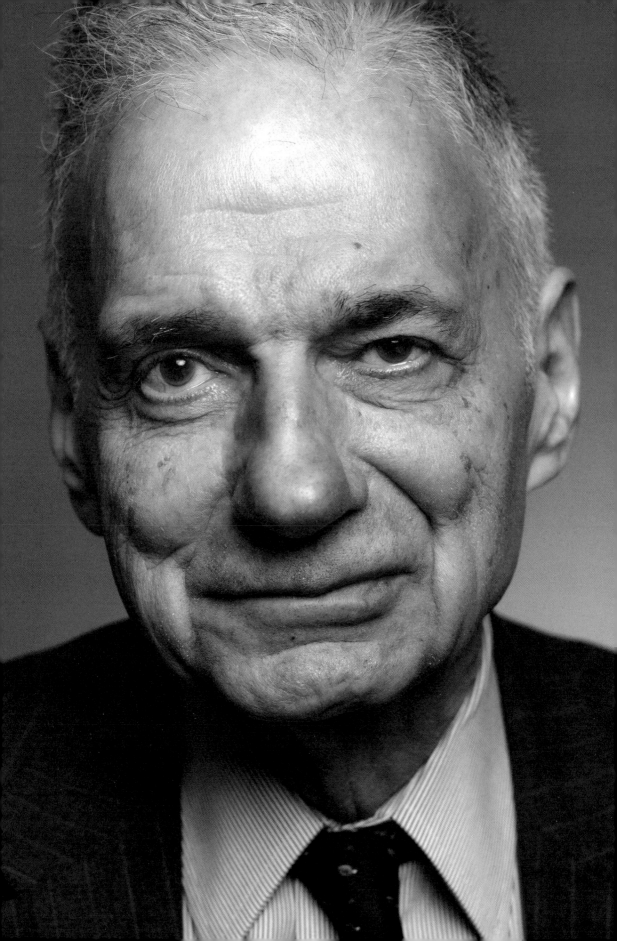

Civil rights activist Tarana Burke founded
what would become the #MeToo
movement in 2006 to support survivors of
sexual violence, particularly young women
of color from low-wealth communities.
Burke was named *Time* magazine's
Person of the Year 2017, with a group of
activists dubbed "the silence breakers."

TARANA BURKE

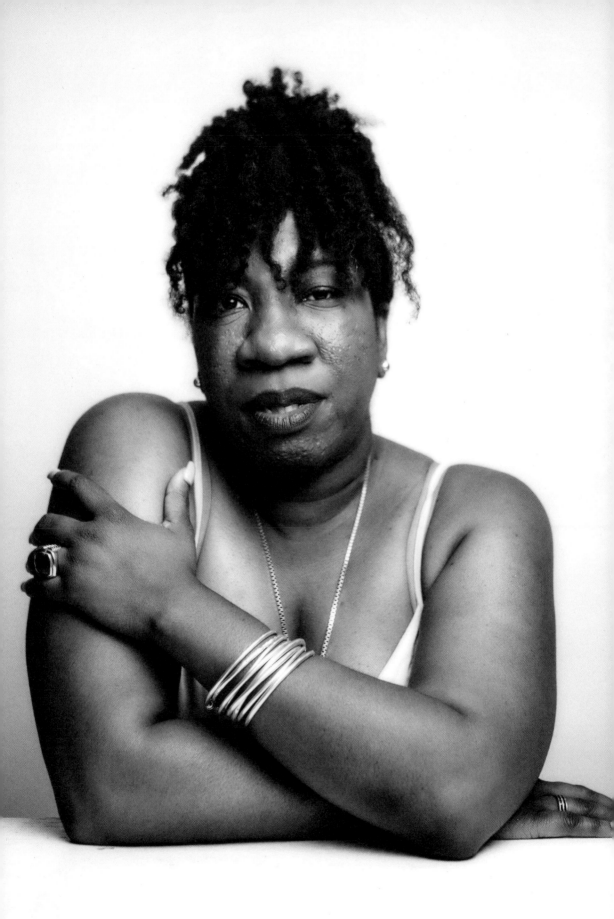

#Me

eToo

I come from a really conscious family. My mother had been part of the Black Power movement in the '70s, so I was raised with a lot of consciousness. I knew my history, and I knew the things around me that were unjust. But I didn't have an entry point to do something about it. Then I joined an organization when I was fourteen called the 21st Century Youth Leadership Movement. The crux of 21st Century was letting young people know, you're a leader—now. There's no waiting period. It was a huge mind shift for me. Like, I don't have to just read about this and be angry about it and debate it in class and stuff. We can go and do something. We can go organize the marches and rallies. We can do that stuff ourselves. And so we did. I never thought about being fourteen or fifteen. It just literally never occurred to me. Nothing about the organization, nothing about how we were trained, focused on our age. The model was essentially: Do the work. Learn by doing.

This is '88, '89, and New York is exploding with racial issues. It's just one thing after another after another. Yusef Hawkins was killed. The Central Park jogger case was the next year. We had just come back from a nine-day camp, and a girl in our program had been dating Yusef Salaam, one of the guys who was accused. She was just, "That's not Yusef, they didn't rape anybody." We were upset about their portrayal in the media—and not just about them, but also, like, it could be any one of us. And I remember saying, *We should have a press conference to tell these people that there are positive black youth, and they cannot criminalize black youth*. And I remember standing outside, and we made our speeches. We were high-fiving afterwards. It was a big deal for us, it was so powerful, like, *Oh, our voices matter*.

For a lot of people, it feels like we went from the civil rights movement to Trayvon Martin. Right? The work that we did in the '80s and '90s is not well-documented. They don't really understand that there were those of us fighting against police brutality for decades. You know, Abner Louima, Amadou Diallo, Eleanor Bumpurs—I mean, there's case after case after case that we were in the streets about.

There's no way that I could have been prepared for this #MeToo moment had I not had grounding in this work. No way. Part of the reason why the media shifted away from Alyssa [Milano] early on is because she could talk about her feelings, and her experience, or build on the momentum around Harvey Weinstein, but thinking about a movement, that's not her work. People were hungry to understand why this was happening. So, it gave me an opportunity to come in and say, *Listen, what this hashtag has done is allow you to see the breadth and depth of this issue. And now we need to dig into the issue*.

We have never confronted sexual violence in this way in this country. We've never taken a step back to listen, to really understand the effects of sexual violence, from sexual harassment to rape and murder. We've missed opportunities, from Recy Taylor to Anita Hill. And so, you're dealing with millions of women, mostly, who have been shamed into silence forever. That's not even an exaggeration. And people are pouring their hearts out, having

their own personal reckonings. Like, "Oh my God. I have an opportunity to say this out loud, and people will hear me, and I want to get this off of me." It's been wonderful to see all these people coming forward and talking about their experiences and sharing this hashtag on social media to say: "You're not alone." Particularly people who said it for the first time. You put it out in the world. It came out your lips. You're still alive. You made it. It's out there, and you lived.

But I think the media's done a terrible job of getting into the issue. It's fed the fire. In those initial articles, women were not calling for anybody's head. They didn't say, as a result of this, we want Harvey Weinstein out. We want him dead. The call was, we want the world to hear what we've been through. We want the world to understand the system that we are living in that allowed this [to] happen. We want the world to see what it takes for a woman to survive and thrive in this country. But we skipped over that. And it became: These women spoke, Harvey Weinstein lost his job. These women spoke, Matt Lauer lost his job. These men spoke, Kevin Spacey lost his job. It became this sicko tennis match, almost. Like, "Ooh, let's see what's going to happen next." The problem is, culture shift doesn't happen in the accusation, it doesn't happen in the disclosure. Culture shift happens in the public grappling with these questions. So, we have to have, and be, comfortable with, a public grappling. Because nobody has firm, definitive, perfect answers.

When I meet survivors, there's a part of me that knows. I know by how they approach me; I can feel it. I have been this way before #MeToo went viral. I've been in places like Red Lobster—true story—and I went out on a limb, big time. It was a white family in Alabama sitting at the table across from me, and everything in my body knew that that little girl at that table—she might have been about eight—that something had happened to her. The mother went to the bathroom, I just went up and I said, *Your daughter's so beautiful.* And she's like, "Oh, thank you." *I said, I do work with kids and some of the kids I've worked with have experienced trauma.* I was being as vague as possible. *And this is going to sound really strange, but if you would talk to your daughter and make sure she's okay.* I said, *I try to tell all parents that.* She said, "It's so crazy that you said that. Our family is dealing with an issue . . ." The girl had been touched by a family friend. And me and that mother stood together in the Red Lobster bathroom crying.

This movement is about empathy. I just try to carry the message I wanted when I was a kid: It's not your fault, it's not your shame to carry, it's not your blame. And you're not out here by yourself; nothing's wrong with you. There's no special curse on you that made this happen.

I spoke in Philly the other night and a girl said, "How did you find your voice?" I said, *Listen, sweetheart. Your voice will find you. Follow your heart. Your voice will catch up.* If you're passionate about the environment, or racial justice, or whatever it is, try everything. The best advice I got when I was young was that I was powerful. Now. That there was nothing I had to do, or change, or

"This movement is about empathy. I just try to carry the message I wanted when I was a kid: It's not your fault, it's not your shame to carry, it's not your blame."

—Tarana Burke

become, to be powerful. Young people feel so limited. It feels out of reach to them, which is unfortunate. They don't know where to start. Every day I get an email, like, "I want to start a movement, and I'm just trying to figure out how I can get my hashtag to go viral." And I'm like, *Please stop. Just do the work. There are no shortcuts.* If #MeToo didn't go viral last October, I would still be marching around with my little "me too" T-shirt on and trying to get people to talk about it, trying to make a difference.

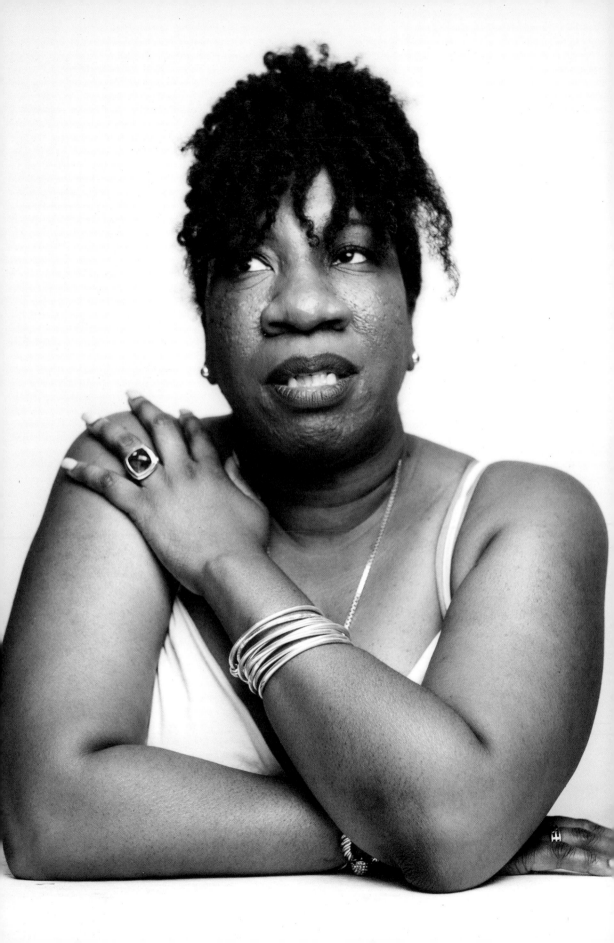

"You're still alive. You made it. It's out there, and you lived."

—Tarana Burke

Shepard Fairey is a graphic artist whose prints, murals, posters, and stickers in public places often critique social issues. Originally part of the street art movement, Fairey's work became widely known through his 2008 *Hope* image of then-presidential candidate Barack Obama, an image he describes as a tool of individual grassroots activism.

SHEPARD FAIREY

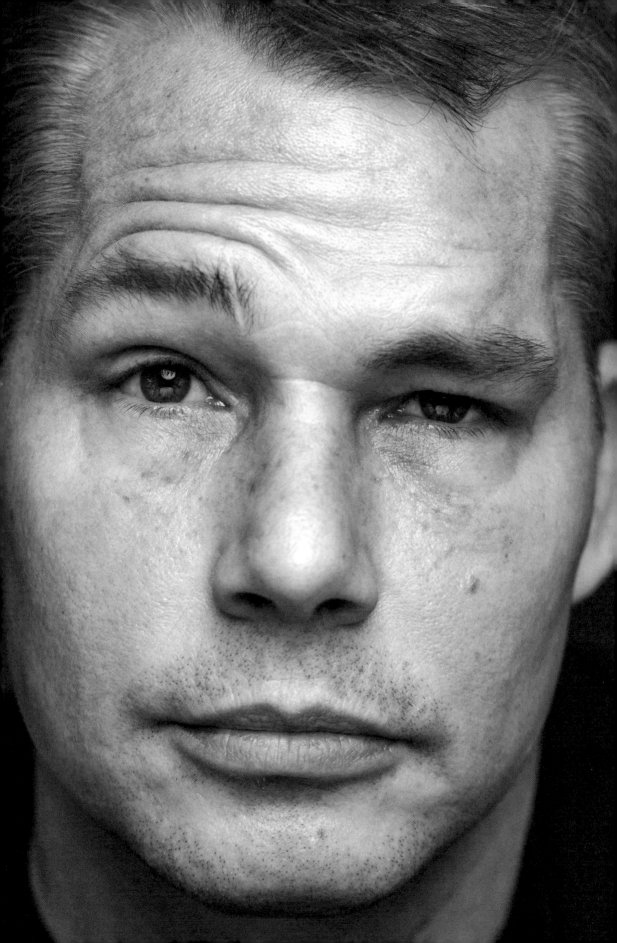

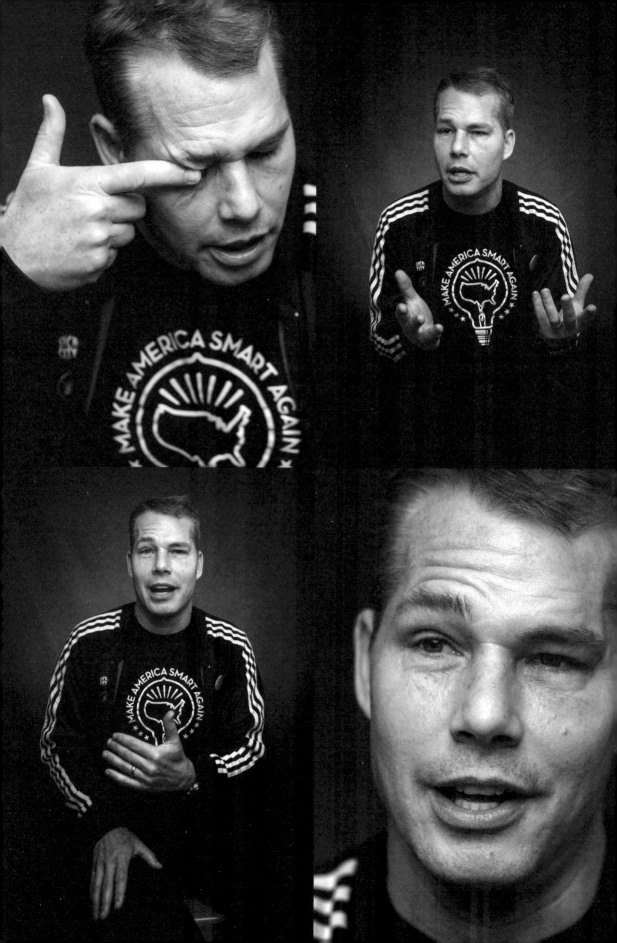

I got into skateboarding and punk rock when I was fourteen. Which led to reggae—mostly just Bob Marley. And really great lyrics, speaking about people being judged by the color of their skin, not the color of their eyes. In punk rock, you had the Dead Kennedys, The Clash. Some of the bands were more nihilistic or jokey, but some that I really connected to were speaking about social issues.

So, my love of punk rock, its culture, its creativity, and listening to [Dead Kennedys'] Jello Biafra say, "America wants fuel / To get it, it needs puppets / So, what's ten million dead / If it's keeping out the Russians?" Listening to this stuff really made me start to question—I didn't even know the word "hegemony" yet—but the idea of just accepting what was presented as dominant and comfortable. Because I grew up in Charleston, South Carolina. Conservative family. Conservative school. And when I say "conservative," they don't like to mess with the status quo.

My senior year of high school, we took a trip into LA, and all around downtown LA an artist had put up these unflattering portraits of Ronald Reagan that said "contra" above and "diction" below. It was 1987 during Iran–Contragate, and the artist was Robbie Conal. And this was the first visual analog to the Dead Kennedys' music I'd ever seen. I loved that it was a bold statement in public space, an act of defiance. It had a sense of humor, a point of view, politically. It was everything I was excited about wrapped in this one thing. And I thought, eventually, I'd like to do something like that.

I started making this silly sticker of André the Giant for some skateboard friends. And I noticed that even though my sticker was silly, just disrupting the control of public space with an image that wasn't advertising or government signage actually impacted people, and was creating some conversations that were a lot more profound than the sticker itself. It went viral before the internet, like a punk rock chain letter. And I started thinking about the control of media. That if you can plug into the right sources, something that is not that significant can all [of a] sudden seem significant. And perceived significance yields real power.

So I decided to evolve André the Giant into the OBEY campaign. With the idea that blind obedience is really problematic. People follow the path of least resistance subconsciously all the time, but when confronted with the command to "obey," it usually offends their sensibilities. It's like taking something in the ether and then just making it concrete so you have to deal with it. Sort of, "Wake up and think about the things you submit to," with a sticker.

I started touching on things like racism, police brutality, surveillance, in my work. And, prior to the 2000 election, I made an image of [George W.] Bush with an SS hunting cap on and a burning city behind him that just said, "It's your future, choose wisely." Oh, and by the way, he had a Hitler mustache, as well. When I look back at it now, it was an inflammatory image and probably

not particularly constructive. But it was the first time I had actually made a very direct political statement about something happening in the moment. It's actually a really brutal thing to come to terms with, that your country is not good a lot of the time, and when the Iraq War started, I sort of repurposed [the Bush poster]. Which got me death threats. So, being attacked and having 25 percent of my email list unsubscribe after I made these Bush things, all of that was painful for me. But what would have been more painful is just sitting by and watching it happen.

When I look at my heroes, like Joe Strummer, Chuck D from Public Enemy, [Bob] Dylan, Bob Marley, Barbara Kruger, Patti Smith, these are all people who manage to weave into their art—which can be like a Trojan horse—what they want to convey to the world. And that's very powerful. And I think beauty is powerful. Because when people feel the emotion that comes with beauty, I think they're much more open to what is universally human and compassionate. They say the mind follows the heart. And so, if I can prime them, if I can put them in the right mind frame with a visual, then I know that they're going to be less likely to immediately reject the more topical elements that are the second read. I'm actually trying to use the ways in which art can seduce constructively, positively. And I've found that my art is a great way that I can put something out there that creates a conversation that's not just an argument.

With the "We the People" series, I found it terrifying where we were [as a country], and I wanted to do something as unassailable as possible. You know: "We the People Defend Dignity. We the People Support Each Other. We the People Are Greater Than Fear." But we'd gone through such a period of anger and division, racism and sexism, and xenophobia leading up to the 2016 election that I didn't have high hopes that something that was about just celebrating people's humanity if they were nonwhite, or non-Christian, was going to connect. But at certain moments, people seem to be just thirsting to symbolize a pushback against awful things that are happening, or a recognition of something good. It just meant so much to me that three simple images could seem to say so much to so many people. When everything's about division and that's the status quo, it's actually punk rock to make it about unity.

I'm not religious, but my sense of spirituality is based on the belief that my actions make a difference. And believing that every action makes a difference is crucial to stepping into activism. I have experienced over and over again, that something I felt was never going to bear fruit, that failed, eventually grew later on. Every action matters. And not giving into apathy and defeatism is really important, not only as an activist, but also in just maintaining vitality and life in general. So, if you're creative, make something. If you have a platform, say something. If you don't have either of those things, support someone— there are so many different ways. Democracy isn't just voting. Democracy is being civically engaged.

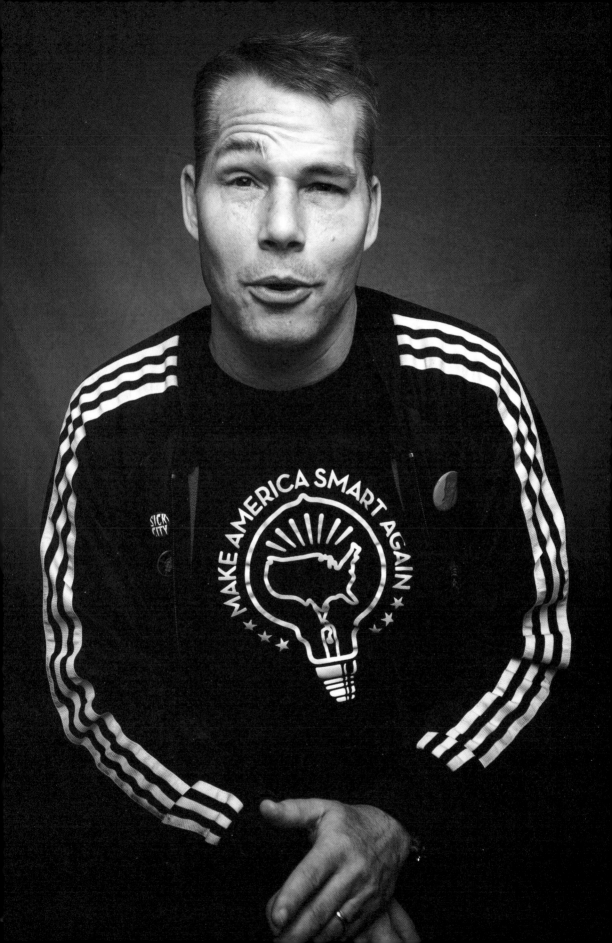

"Beauty is po
Because who
the emotion
with beauty,
much more e
is universally
compassiona

verful.
n people feel
nat comes
think they're
pen to what
human and
te."

—**Shepard Fairey**

Bob Kafka and Stephanie Thomas are
National Organizers at ADAPT (originally
Americans Disabled for Accessible Public
Transit) of Texas, which they cofounded in
1984. Both have been active in many direct
action and legislative campaigns with ADAPT
over the years. Thomas also created and
edited its newsletter, *Incitement*, to grow
membership and disseminate information to
thousands of individuals in more than forty
groups around the country. Kafka helped
start the Money Follows the Person program,
credited with getting about 100,000 people
with disabilities out of nursing homes.

BOB KAFKA

STEPHANIE THOMAS

Bob: During the battle for passage of the ADA (Americans with Disabilities Act), a lot of the "policy wonks" in the DC area were very successful in getting a lot of legislators on. And they sort of, not poo-pooed direct action, but, you know: "Oh, we didn't really need that." But, then it stalled.

Stephanie: The ADA was stuck in the House. And they were delaying and delaying voting on it. To push it through, I wanted to do something very in-your-face. We had a rally at the US Capitol. And I got a whole bunch of people who I knew would be up for this and said, "Let's come over here, you won't be sorry!" And at a certain sentence [in the speeches], we started to crawl [up the steps of the US Capitol]. And then a bunch of other people at the rally joined us crawling. And other people, they couldn't crawl but really wanted to do it, so they got carried up. So, there were all kinds of modes of people getting up there. Hundreds of people. Even a little girl, eight years old. It was really intense.

Bob: What ADAPT did with that crawl was—using theater—brought back the [idea] that access is a civil right. It focused on the commitment of people willing to get out of their wheelchairs and pull themselves up. Eighty-two steps, I think.

Stephanie: Some people got upset at us. They said it was being pathetic and so forth. But when I was younger, I lived in other countries and saw disabled people crawling all the time. If you don't have a chair, that's what you do. And what is more pathetic? Crawling, or letting somebody else tell you you can't go anywhere because they won't get you any type of mobility device? I think it's a lot more pathetic to just be placed somewhere and stuck there. I mean, I can see why people think of it as demeaning, but at the same time, I think taking the power of moving yourself is a lot more important. And I thought it was a really good symbol of just going for it, you know, and taking the least accessible part of the Capitol and saying, *Damn it, this is what you're making everybody do with your stupid not-voting on things*.

Bob: Generally, confrontation is not something people feel comfortable with. And I can tell you, and I'm sure Steph hears it all the time, chain yourself to something one time, and it doesn't matter how much policy you do, you're always labeled. "Oh, what are you going to chain yourself to now, Bob?" That type of thing. You know, how many times did we hear: "We agree with your goal; we don't like your tactics"?

Stephanie: A million. A lot of your initial training as a disabled person is to fit into an able-bodied or non-disabled world. I mean, it's a heavy indoctrination. And so, when you don't do that, when you confront, you really do get into an area that's very uncomfortable for a lot of people. So you try to pass, basically.

Bob: Sort of hiding our disability. Even the terminology: Not everybody else rides around in a wheelchair, not everybody else has a leg bag, or needs suppositories. You know what I mean? We have people who have been told by

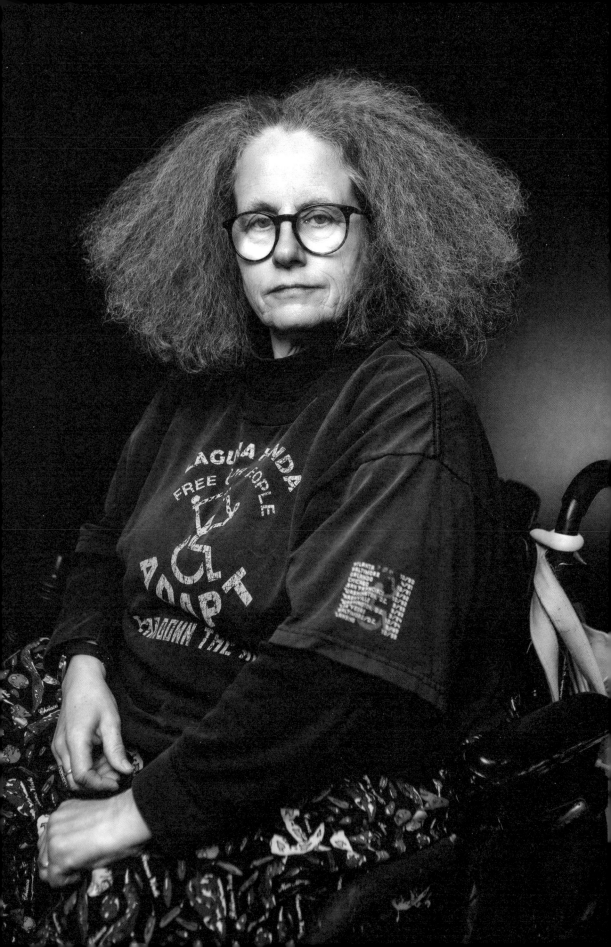

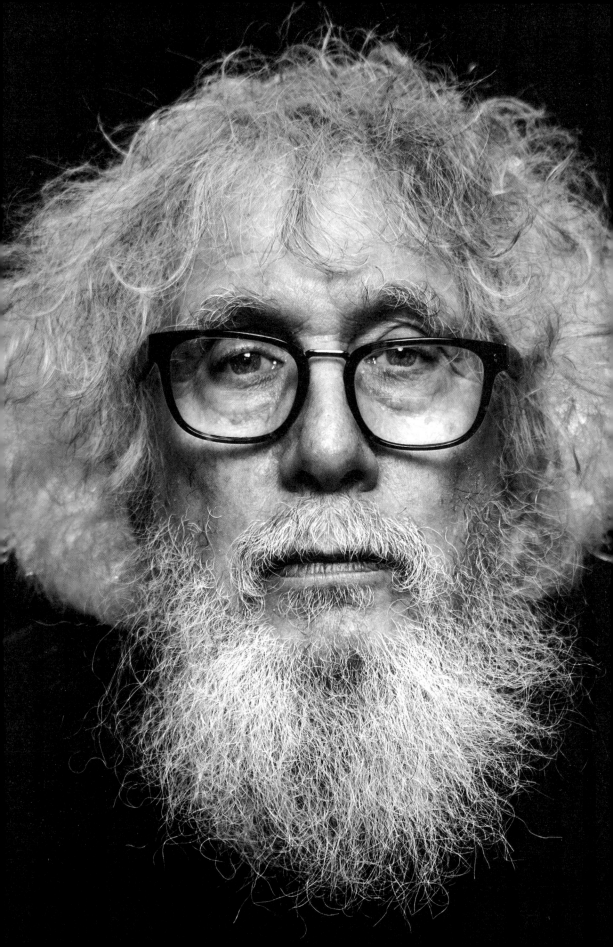

their parents, by special ed teachers, in rehab, "You're just a broken person." But we've seen dramatic change in individuals. People who have always been sort of mother-may-I, confronting for the first time, showing what the word "empowerment" really means. You know, if you're being oppressed, you need to break the be-nice. And it's hard to do that. And it doesn't mean being rude. It means questioning authority. There's so many of those moments, you know, people climbing on buses or putting chains on in the Capitol rotunda.

Stephanie: That moment of empowerment, and that accepting that you don't have to put up with that bullshit, is really a big deal. It's like an awakening. The first time I did an action, we went out in little, tiny groups of just two or three people and blocked buses all over the downtown area. I was with these two guys and we just rolled out and did it. You felt the group supporting you. I felt like they were holding me up. And I wanted to hold them up. And one time I was talking at a rally somewhere—I don't even remember what the subject was—but I mentioned that I often wear Depends because I don't have control of my bladder. And I could feel the crowd go, "Yeah." And I said, *Incontinents of the world unite!* And you would not believe the reaction that I got. Because it was, like, something you're never supposed to talk about. And it's a pain in the ass. And you got to deal with it. And all these people were, like, "Yeah, I do!" I just never forget that moment.

Bob: So many of the people that we've seen over the years in ADAPT, they actually are confronting those in power. You know, in terms of they have something we want, and they don't want to give it to us. I mean, if just giving information [worked], we'd be more than glad not to protest.

Stephanie: I got started in this because I had an accident and wound up in a wheelchair, and I wanted to take public transportation. It was called "public" transit, my tax dollars supported it, but I was not allowed on. And they had this very inadequate separate system for people with disabilities. It was such a joke compared to a regular bus. I mean, they could decide what trips they would take you on, like, just medical or just work. They didn't run the same hours. The price wasn't the same. You know, they made all these decisions about your life. It just enraged me. So, when I found out there was a group in Denver (Colorado)—ADAPT—working on these issues, I was really into it. I got a brochure in the mail for a training. But I was working and I couldn't take off. So I sent it to Bob.

Bob: I thought it was just a training, you know, but it really was my first entrée to direct action and organizing. The head of [the Urban Mass Transit Administration] was coming for a meeting. We ended up leaving the training room, and we surrounded his car, making demands. That was my first exposure. And it really felt good. For me, at least, I'm sort of a bureaucrat at heart, and it cleared out the cobwebs, actually got you in touch with your anger and focused it. You know, *Why the hell ain't this bus accessible?* Then, on day two, we did a protest at the old Washington convention center because the American Public Transit Association, the trade association for all the transit

companies, was meeting there. We ended up breaking through police lines. Mike Auberger, one of the leaders of ADAPT, went through this wooden thing. And I just followed him, like, *Whoa*. That was my first time protesting—and the first time I got arrested.

Stephanie: I was excited by the ADAPT brochure, and the stories that Bob told me sounded really cool. But they also sounded kind of nutty, you know? I didn't really think of myself as a street activist. But when Bob had just come back, we went to this hearing—the transit system here in Austin was just being created. I had made this really well-thought-out, logically written argument about why there should be lifts on buses and why that type of public transit should be accessible. I gave my whole spiel. And it was met with, you know, thank-you-very-much, pat-on-the-head, and don't-let-the-door-hit-you-in-the-butt. They just really couldn't have given a flip about what I said. There were economic arguments, social arguments—I mean, it was really comprehensive. Bob didn't have any notes, so he just took my notes, and he went up there and basically used the exact same thing that I said. But, he said, "I've just come from the ADAPT action in DC"—they had all been at the conference. And when Bob said that, it was like somebody had taken a cattle prod and shot them all in the butt. They all sat up. And they listened to everything that he said.

I was, like, *Wow*. And I thought, *Okay, this is what we need to do*. It was, like, painted in red paint across the sky, you know?

Bob: And it was almost classic out of the training: You do direct action to build enough power to get the "enemy," quote-unquote, to the table. So, Steph and I started ADAPT of Texas with our close friend Jim Parker. We decided that we were going to work on a focused issue: lifts on buses.

I think ADAPT's success is the combination of direct-action confrontation with policy. We have this constant tug on, what I call it, the pit bulls versus the policy wonks. Or, as Steph says, passion versus overintellectualizing. And also making it fun. Because if arrest is your only selling point, you're really going to scare off people. And then the thing which has kept me involved is community. When you're at one of the actions, people are helping each other. You really care about each other. It's family. And you can start small. You don't need hundreds of people, as long as you get focused. We've done stuff here in the early days, when you only had five or six people, that were very effective. So, if I had advice, it's just do something. Even if it's wrong. And then fix it. So, do it, fix it; do it, fix it. Get people together—people willing to cross that line—tap into that anger, focus it, and just do what you can.

"The first time I did an action, we went out in little, tiny groups of just two or three people and blocked buses all over the downtown area. I was with these two guys and we just rolled out and did it. You felt the group supporting you. I felt like they were holding me up. And I wanted to hold them up."

—Stephanie Thomas

John Kerry, a decorated Vietnam War veteran, became active in the anti-war movement upon his return home, offering powerful testimony on behalf of the Vietnam Veterans Against the War before Congress about his experiences and conviction that the war was wrong. Kerry went on to serve as a prosecutor, lieutenant governor, and five-term US senator from Massachusetts. He was the Democratic Party nominee for president in 2004 and served as US Secretary of State under President Obama.

JOHN KERRY

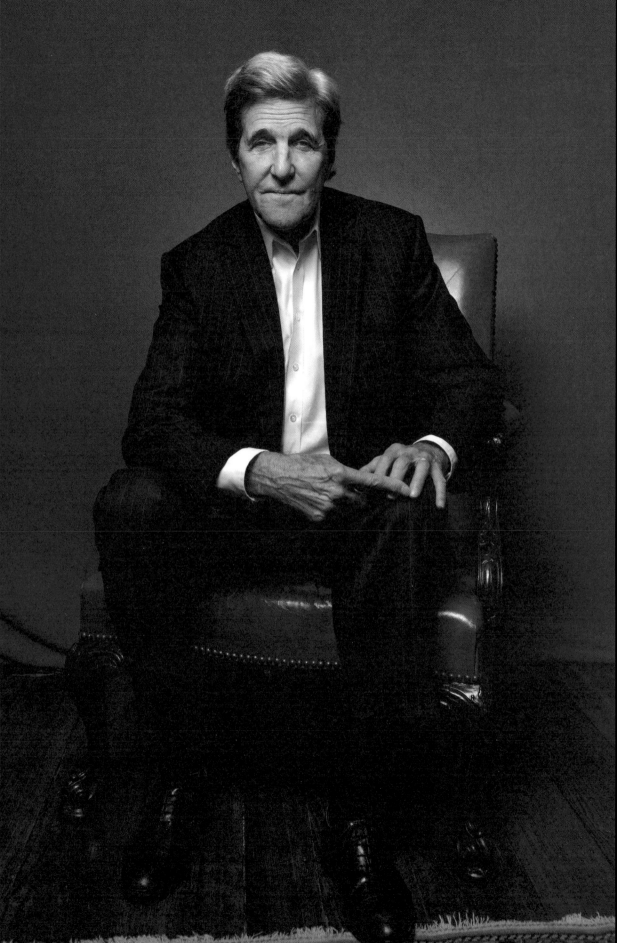

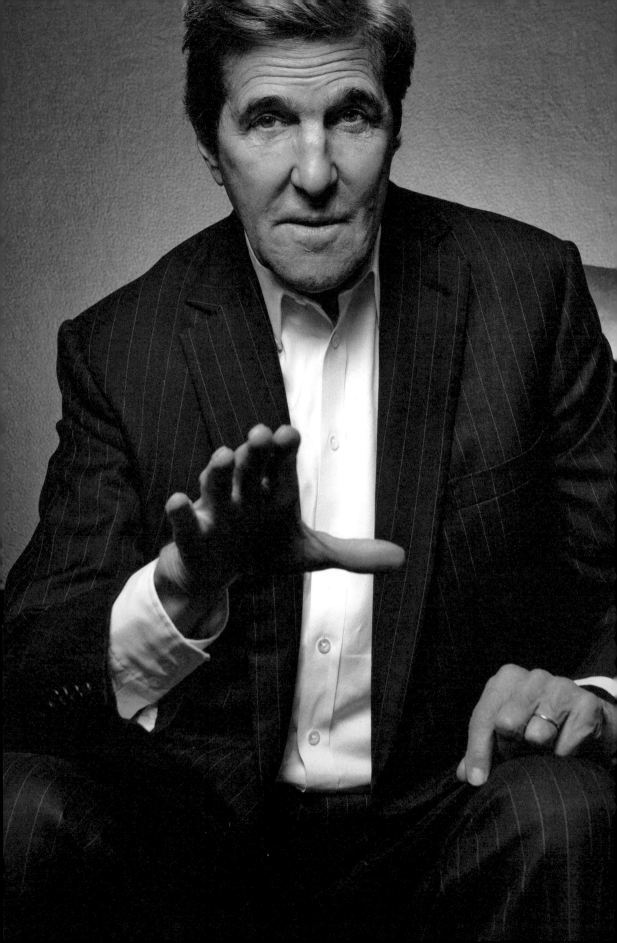

I was raised with a sense of responsibility to community and citizenship. Just a sense of, you know: You're a lucky guy. You go to nice schools. You've got a good life. You owe back. It was a pretty simple theory. So I did volunteer to go to Vietnam. It's just that, when I got there, I learned that what we were being told was a lie. And I don't believe in killing for a lie.

It was a hard thing for me to accept. The longer I was in country, the more skeptical I became about why we were there and the tactics we were using and whether it could ever work. It hit me that we were there because we were there, and that's not a reason to stay somewhere forever when Americans are getting killed and wounded. The blind repetition of missions, which by design couldn't accomplish much and which were inadequately conceived and supported, was symbolic of our whole failing commitment to a war that I was now convinced was wrong.

It made me question things I had not questioned before. I went into the war idealistic about government itself. I was a believer in institutions and particularly in [Kennedy's] "New Frontier." It never occurred to me that people like [then-Secretary of Defense Robert] McNamara, who were this "best and brightest," were saying one thing publicly while privately fervently believing the war couldn't be won. That changes your whole outlook. And when I received my friend Skip's letter about [our good friend] Don's death and the circumstances, it hit home in a very powerful way. I thought that those of us who had been lucky enough to survive had a responsibility to speak up if we thought the war was wrong.

When I spoke out, it was still a minority position. It was tough. It was speaking out against the sitting president of the United States, against all the weight of Congress that was still supportive. It wasn't easy for any of those vets, any of the guys who came to the demonstration we did in Washington (DC). They were raised to believe in their leaders. We all were. You know: God and country. We believed in it. Still believe in it. But, you have to be thoughtful. It's a democracy, and you have to win the support of the American people for sending their kids to war. And that eventually just got sucked away. Of course, with Vietnam, that was a tragedy. It was really a tragedy.

When Senator Fulbright invited me to testify before the Senate Foreign Relations Committee, I felt a huge sense of responsibility. I had to speak for the [Vietnam Veterans Against the War] organization, not just for myself, but I also wanted to speak for people who couldn't be there because they had been killed. I was up all night. I just wrote and wrote. Parts poured out of me; other parts came from what I knew other veterans in the movement felt compelled to share.

I showed up to a committee room jam-packed with veterans, television cameras, reporters, members and their staffs. When I sat down at the witness stand, a long-haired kid with a pronounced Massachusetts kind of drawl, I realized how small I felt compared to the panel staring back at me.

Chairman Fulbright struck the gavel three times and called the hearing to order, and then it was adrenaline driving me forward.

It was hard at times to hold on to my emotions. I never imagined I'd be fighting my own government. I never imagined I'd be screamed at, spied on, followed. Never imagined I'd worry about my government arresting its own veterans. But here we were. I talked about all those people in positions of political authority who had let someone else's son get killed or maimed because they refused to say publicly what they were recording privately. Their actions broke faith with a generation that served. Damn right I was mad about it. Shouldn't we all be mad about it? I spoke of the determination of veterans to undertake one last mission so that in thirty years, when our brothers went down the street without a leg or an arm and people asked why, we'd be able to say "Vietnam" and not mean a bitter memory, but mean instead the place where America turned, and where we helped it in the turning—trying not just to end the war but to really heal from it.

People have talked about my testimony in 1971. Some people still hate me for it and that's fine. But [it's] profoundly wrong to think that fighting for your country overseas, and fighting for your country's ideals at home, are contradictory or even separate duties. They're two sides of the very same patriotic coin. I didn't think anyone should be sent to die for an illusion privately abandoned by the very men in Washington who kept sending them there.

Look, I'm not a pacifist. I'm completely prepared to go to war on behalf of my country, providing we've made the decision as a country this is what we have to do. And we've done it after exhausting the remedies of diplomacy. But you don't rush to war. That's one of the great lessons. And people who haven't been to war tend to be the quickest to rush to war.

Until this moment, that was clearly the most divisive moment the country had experienced since the Civil War. Remember, Nixon had an enemies list. They would use the FBI and others to intimidate the Justice Department. He was attacking the investigation. He fired the special prosecutor. He lied to the country, broke the law. We had pipe bombs going off in the streets of the country. We had people with machine guns raiding people's homes— kidnapping Patty Hearst. Detroit burning. I mean, we had plenty of upset in our country. We had families divided against each other—brothers and fathers with different views on the war and what your duty was and so forth. It was a very difficult, tortured time in the country.

We're in a tough moment now. Very, very tough moment for the country. But I believe we get through this because I inherently believe in the power of our democracy and in the goodness of Americans—the majority—who are ready to come out and do something.

"I inherently believe in the power of our democracy and in the goodness of Americans—the majority—who are ready to come out and do something."

—John Kerry

Avram Finkelstein is an artist and writer, and was a founding member of ACT UP (AIDS Coalition to Unleash Power), and the Silence=Death and Gran Fury collectives, which produced many of the political posters that focused attention on the AIDS crisis. His work is part of numerous museum collections including the Museum of Modern Art (MoMA), the Whitney, and the Smithsonian. His latest book is *After Silence: A History of AIDS Through Its Images*.

AVRAM FINKELSTEIN

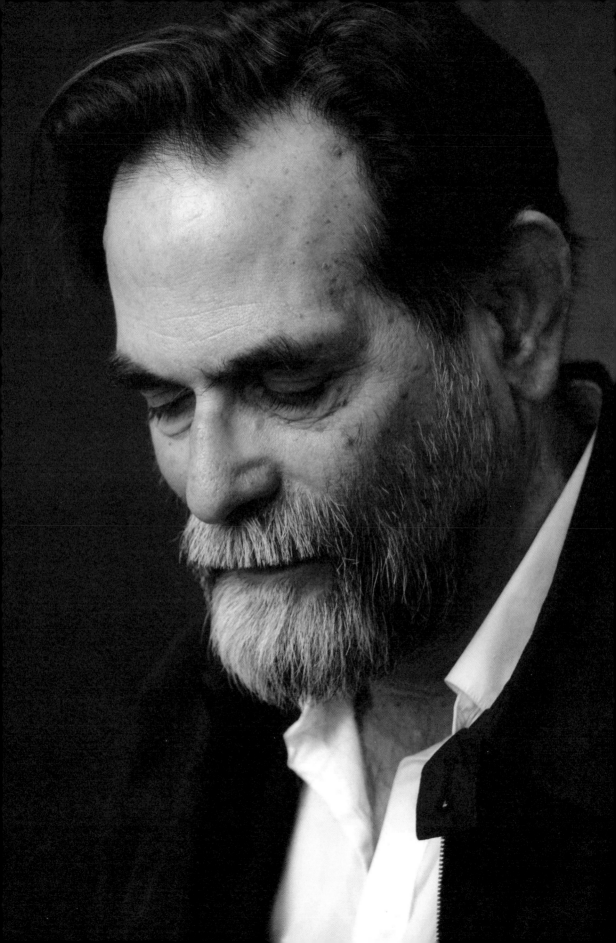

The last fight I ever had with my father, was [after] a friend of mine had just taken his life in the early days of the AIDS crisis. And I was out at the beach staying with a friend. My dad lived on the North Shore (Long Island, New York) and he came down to console me. And we were talking about ACT UP and the work I was doing. And he gave me this, like, old lefty thing—he was a Bolshevik—and he said, "You know, I really love what you're doing, Av, but there will never be a revolution in America so long as there's television."

I said, *Listen, this is the last time we're having this conversation. I have two choices: I can do nothing—and I know what happens if I do nothing. People continue to die. Or I can try something. Maybe it will work, and maybe it won't. And if it doesn't work, I'll try something else. And maybe less people will die. So, we're never having this conversation again. It doesn't matter whether there will be a revolution. People are dying. There really isn't a choice.* If you look at it that way, there is no choice.

The thing that really kick-started our thinking about the content for the Silence=Death poster was William F. Buckley Jr.'s op-ed piece calling for the tattooing of the HIV-positive people. Half of our collective was Jewish, and we were horrified by that. So [that] was going to be the first subject of the poster. But, as we began to explore what the image would be, we realized, *Okay, so what gender is the body that tattoo is on? What race?* We knew that questions of race and gender were very much a part of where we were heading, although no one was really talking about it yet. So we decided to choose a pictographic image to avoid the questions of representation. And that's how we ended up with the pink triangle.

There was something extremely performative about this poster. This kind of trickster, yippie idea of forcing people to confront political questions without their maybe even realizing that that's what's happening. The design problem posed to the collective was, I felt it needed to function on two different levels. One was to imply to everyone outside of the communities who needed to organize that we already were completely organized and well-funded. And to everyone within the communities, we needed to create some Socratic space for people to begin to think politically about the issue—not just in terms of caregiving.

So the slogan "Silence=Death" was in very big font. And we chose that font— Gill Sans Serif Extra Condensed—because it could be read from a car or a cab or a bus for people who were passing through New York, as a way to imply there were more of us and we were better-organized than we were. And all of the questions we were trying to get people within the gay community, and in particular in lower Manhattan, to think about were in a much smaller point size. So, you're forced to step up to it. This is what I mean by performative. In the choice of the point size, we are already making you, making the audience, create a physical gesture: Move their body toward the [posters]. But it's the first action that you're taking. You didn't know it. We made you do it. But you're here, reading a political poster now.

The poster was meant to be the first in a series of three, that would eventually call for riots. But ACT UP happened within weeks of the poster going up in New York. The only person in New York talking about the politics of AIDS was Larry Kramer; he was the catalyst. And we had begun to articulate something that people were thinking. Social movements are delivered on our doorstep, they're described to us, and then they become a part of our history. It seems like a flash fire. But it wasn't. It was a slow-motion train wreck. So Silence=Death didn't make ACT UP. ACT UP didn't make Silence=Death. AIDS activism wasn't made by Larry Kramer. It was made by five years of endless suffering. I think it's really important to remember that because, if you look at this moment, and you think, "Why aren't people in the streets?" Well, you don't know what's happening tomorrow.

We were invited into the art world. And I didn't want to participate. I was sort of hellish about it in the context of the collective, and tormented them and was very doctrinaire about it. But I felt it would be politically retrograde to discuss my own relationship to the AIDS crisis and my own relationship to loss when people were fighting for their lives. Why would I talk about people I had already lost? Even though it was completely motivated by personal loss. I fell in love with somebody who was diagnosed very early and started showing signs of immunosuppression. We had been together about six years when he died. And I was so distraught by that loss that I formed the collective. We met every week, and did, like, a lesbian potluck dinner, and talked and cried and fought and argued; talking about politics, putting one foot in front of the other.

But I felt that if people were talking too much about us as a collective and our political motivations for making our work, rather than what we were saying, that people would do that thing, like, "Oh, thank God somebody's doing something about that. They've got that covered." And maybe put their feet up a little. So I never went on any installations. I never accepted any of the awards that we were given. I never did any overseas travel. I knew that them flying one more person over, that money wasn't going to go into AIDS research. But, I didn't feel ethically that I wanted to participate in it while people were literally dying in hospital corridors and being thrown out of their houses and being put in body bags because their parents wouldn't take their remains. It just—it was a terrible moment. And I didn't want to participate in anything that would begin that part of the story arc: Something's being done about it. I was just thinking about the next poster.

I think we make this mistake about political agency and efficacy. We're so trained to think that if it's not a million-person march, you feel like you're a failure. There's something very male about that set of constructions. But what about the invisible thing that may impact one person? That, without your even knowing it, fifty years from now, will do something that changes the world, right? Why isn't that enough?

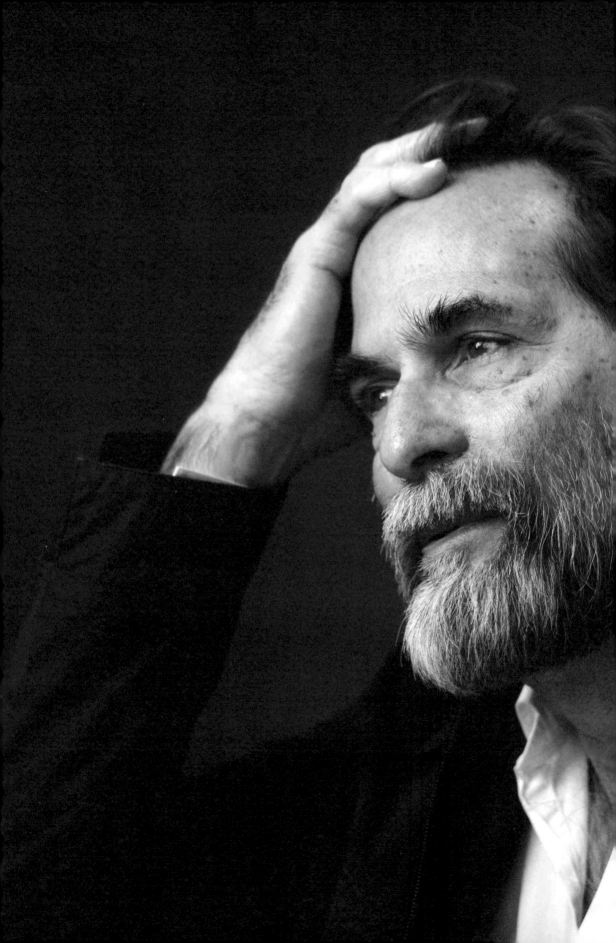

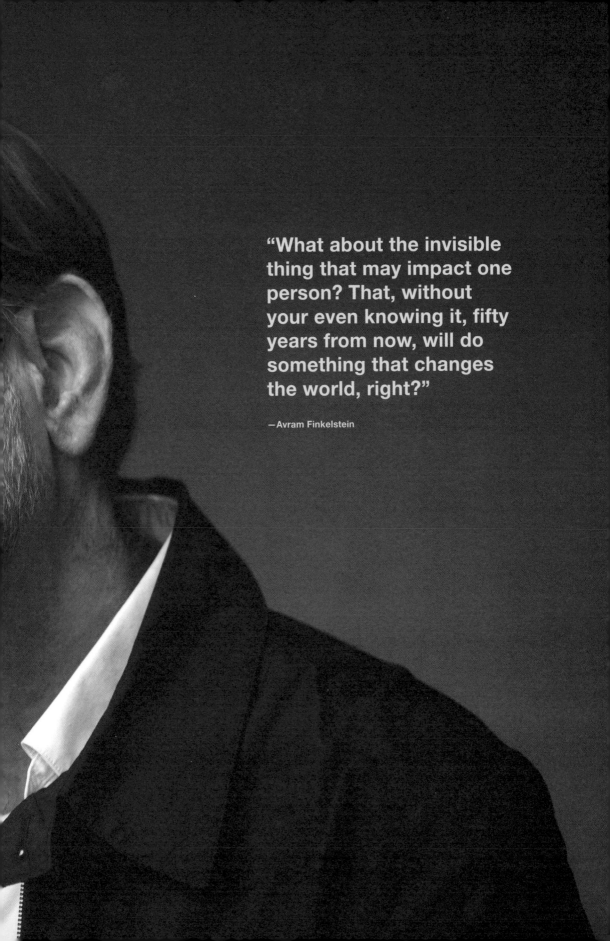

"What about the invisible thing that may impact one person? That, without your even knowing it, fifty years from now, will do something that changes the world, right?"

—Avram Finkelstein

Harry Edwards is a scholar and civil rights activist, and professor emeritus of sociology at the University of California, Berkeley, where he is focused on the connections between race, sport, and society. While a professor at San Jose State University, Edwards launched the Olympic Project for Human Rights (OPHR), the organization behind the famous raised-fist podium protests of Tommie Smith and John Carlos at the 1968 Olympics in Mexico. Edwards has worked with the San Francisco 49ers for three decades. He is the author of several books, including *The Revolt of the Black Athlete.*

HARRY EDWARDS

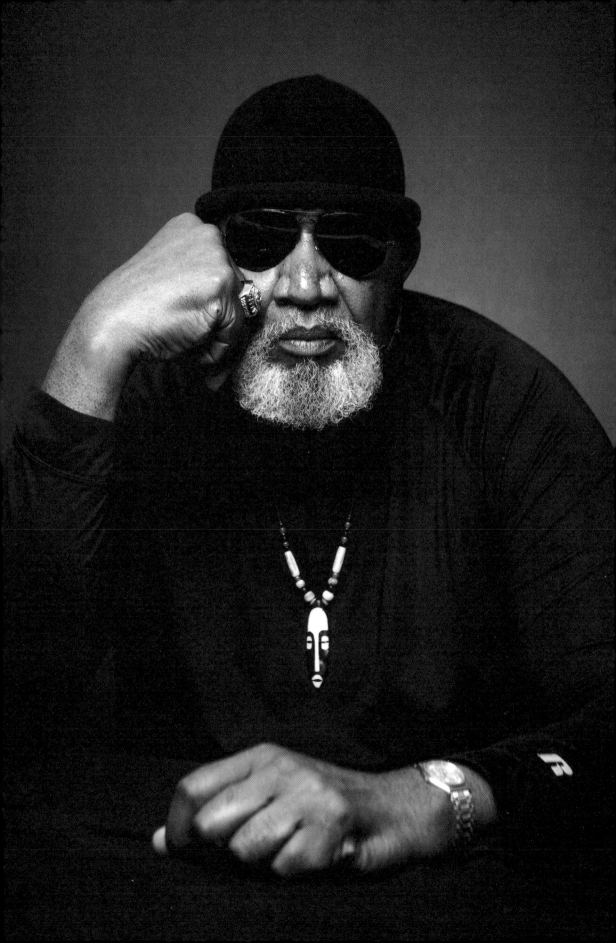

My father wanted me to be an athlete. Because he was a devotee of Joe Louis and Jackie Robinson and Jesse Owens. And that was the area for him in which you could get on your feet, become somebody, become everything that you could be. One of the first things that he did was to buy me a pair of boxing gloves. He bought me a basketball. He would buy me a bat because he knew the kid down the street had got a baseball for Christmas. And he drilled into me, "It's not the color of your skin, but only how well you play the game." But as I got along, I thought it wasn't true. That sport was like the rest of the society. It wasn't how well you played the game. It was what color you are.

My awakening took place beginning in high school. I was among that first mass group who integrated high school in East St. Louis in 1957. But when we got there, it was crystal clear: They had absolutely no idea what to do with us. And so, we played football in the fall. We played basketball in the winter. We played track and field in the spring. And the rest of the time, we moved around from class to class to make sure that the eligibility was in place. I went through school, got scholarship offers to play sports, but they never laid a glove on me in the classroom. I left high school utterly unscathed by education.

When I came out to California, the first thing I was told was, "You haven't taken a college admissions test." My dad had an eighth-grade level education that he got mostly at Joliet State Prison doing ten years for burglary. My mother read at about a third-grade level because she dropped out just before she went into junior high school. They didn't know a thing about college, I didn't know anything, and the school I went to, newly integrated, didn't tell us anything about college admissions; they never pointed us toward college. We were going to be janitors and doormen and, if we were lucky, get a Pullman porter job.

I had a scholarship to San Jose State in basketball and track. And as my sociology melded with my athletic experience, I became more and more of a student and a scholar. Which really, at the end of the day, alienated my father. For three years, he didn't speak to me. Because, when I graduated with high honors from San Jose State, and had a Woodrow Wilson Fellowship, I could go anywhere in the country I wanted to go. And I was looking at Harvard and Cornell and Michigan and University of Chicago.

And so my father flew out here from East St. Louis. And this was a man who was scared to get on planes. He flew from East St. Louis. He said, "I see them letters that you got from the Minnesota Vikings and the San Diego Chargers. And the coach told me that the scout from the LA Lakers was down here, that he was interested in you." But, he said, "You're telling me that you're going to go to school?" I said, *I'm going to graduate school because I want to be a sociologist.* He said, "Well, you've been in school four years and now you want to go to school some more?" My old man wanted to be able to go to the bar in East St. Louis and point up on the screen at me up there with Carl Eller and Alan Page and them guys and say, "Yeah, as soon as one of them other boys get hurt, he's going in. My boy, that's him sitting right there on the bench."

Harry Edwards

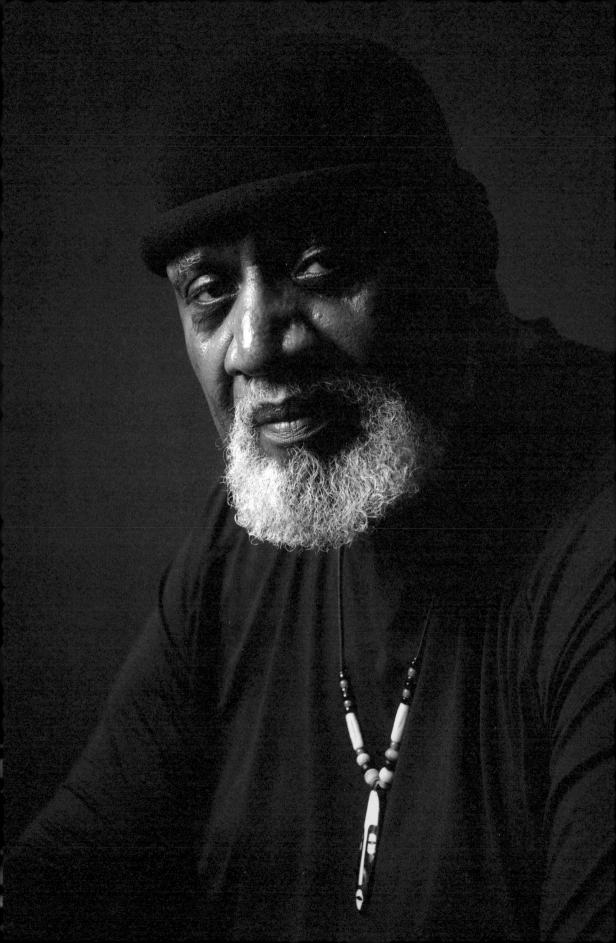

"What all these movements say to those who would govern is that you need to pay attention. Because without the abolitionist movement, there's no end to slavery. Without the labor movement, there's no eight-hour day. Without the women's movement, there's no women's vote. Without the civil rights movement, there's no Voting Act or no Civil Rights Act. Without the #MeToo movement, there are not a hundred women in Congress today."

—Harry Edwards

At Cornell University, I wrote my master's thesis on the black Muslim family, which is how I hooked up with Malcolm X and his organization. As soon as I got through that, I came to California and taught [at San Jose State] while [continuing] my Ph.D at Cornell. That's when I joined the Black Panther Party and began organizing. A lot of that was the influence of Malcolm X. Some of it was the deepening of my dissertation research on issues that interface with sport, race, and society. My position was that sport was a social institution at the same level as the military, education, the family, religion, and so forth. And that sport inevitably recapitulates society. In terms of its dynamics, its structure, its human and institutional relationships, but most importantly, in terms of the ideological rationalizations for those dynamics, for those human and institutional relationships. And that given that that was the case, that there was some evidence that you could impact people's perspectives by challenging their perceptions and understandings of the games they play.

So, you could leverage sport for social change. In the fall of 1967, we shut San Jose State down over a lack of black faculty. So there would be no football. We're not going to go to practice, we're not going to play the game— that was the only leverage we had. And, as a consequence, we desegregated the housing, desegregated the fraternities and sororities, began to recruit faculty, brought the first black individual into the athletic department.

What we saw in the colleges and universities, led us to really look at the Olympic movement [which] had never had an African American member. And with the exception of perhaps boxing, because boxers tended to bring their own trainers, there was not any decision-making position held by an African American in either the NCAA (National Collegiate Athletic Association), the AAU (Amateur Athletic Union), or the United States Olympic Committee. So, I announced the Olympic Project for Human Rights. We felt that it was a human rights issue because of the broad scale, almost coordinated system of exclusion, the systematic denigration of black human dignity, and a lack of respect for blacks as equals. So we pressed for the boycott. US Olympic Committee President [Avery] Brundage came out and said, "Anyone planning to demonstrate is making a serious mistake if they think that they can do that and continue their career as an Olympic athlete."

Well, you know, there's never been a protest where the American mainstream authoritative interests have stood up and clapped and said, "Amen, we understand what you're doing and great, here are some roses and, by the way, let me give you this job." No. I was fired immediately from San Jose State. [John] Carlos and [Tommie] Smith struggled to get jobs. They were declared persona non grata in amateur track and field. I mean, if you're black and radical in America, expect the worst, for you shall not be disappointed. That's why they call it a struggle rather than a picnic.

Somebody asked me at a press conference, after the demonstrations in Mexico City, "Dr. Edwards, what does this achieve? Jackie Robinson came through. Now you're protesting. What has been gained?" My word to that reporter was that our

circumstances in this country are and have always been diverse and dynamic, changing. Our struggle, therefore, must be multifaceted in every arena—including sport—and perpetual. There are no final victories. So don't be surprised if we have to go back and struggle again on terrain that we thought we had gained. Today, you have women, again, fighting for medical services and the maintenance of *Roe v. Wade* and Planned Parenthood. We have voter suppression despite the Voting Rights Act. We have struggles against murder under cover of the badge. It's not lynching, as occurred in Mississippi during Freedom Summer, but to the person that's the victim, they're just as dead. We're fighting that struggle. Again.

The athletes are the canaries in the mine shaft. Taking a knee by [Colin] Kaepernick and [Eric] Reid was not something that emerged in the locker room. It had nothing to do with football. Didn't have anything to do with the anthem. It's something that came over the stadium wall as a consequence of injustices experienced by black people more generally in the broader society.

So, this diverse, dynamic quality of our circumstances, this absolute mandate that struggle be multifaceted and perpetual, it's right there on the field with us. Jesse Owens was not a final victory. Joe Louis was not a final victory. Paul Robeson was not a final victory. Jackie Robinson was not a final victory. Muhammad Ali was not a final victory. Smith and Carlos were not a final victory. Colin Kaepernick will not be a final victory. We need to simply understand that the obligation is not to win the war. It's an impossibility. But to make our contribution in terms of winning the battles that we're confronted with. Because that keeps the next generation from having not only to fight their battles, but the ones we should have fought.

So, what difference does it make [that] Colin Kaepernick takes a knee? One guy out there on the field. Two guys on the field. It's like the little boy on the shore after a storm, throwing back all these starfish that had blown up on shore. And this old guy, wondering, "What are you wasting your time throwing these starfish back, there are thousands of them, what difference does it make?" "Makes a difference to this one." And it makes a difference to that one person that looks at Kaepernick and says, "You know, I think he's got something there." So that's the obligation. That's the obligation.

Because Americans take seriously this mandate from the Constitution that says not, "We the presidents." Doesn't say, "We the Congress." Doesn't say, "We the senators" or "We the courts" or "We the mayors" or "We the legislators" or "We the police." It says, "We the people, in order to form a more perfect union." Americans take that seriously. What all these movements say to those who would govern is that you need to pay attention. Because without the abolitionist movement, there's no end to slavery. Without the labor movement, there's no eight-hour day. Without the women's movement, there's no women's vote. Without the civil rights movement, there's no Voting Act or no Civil Rights Act. Without the #MeToo movement, there are not a hundred women in Congress today. So, through all of this, there's that deep-seated, thoroughly American optimism that we're going to be just fine. Why? Because this is what we the people do.

"Our circumstances in this country are and have always been diverse and dynamic, changing. Our struggle, therefore, must be multifaceted in every arena."

—Harry Edwards

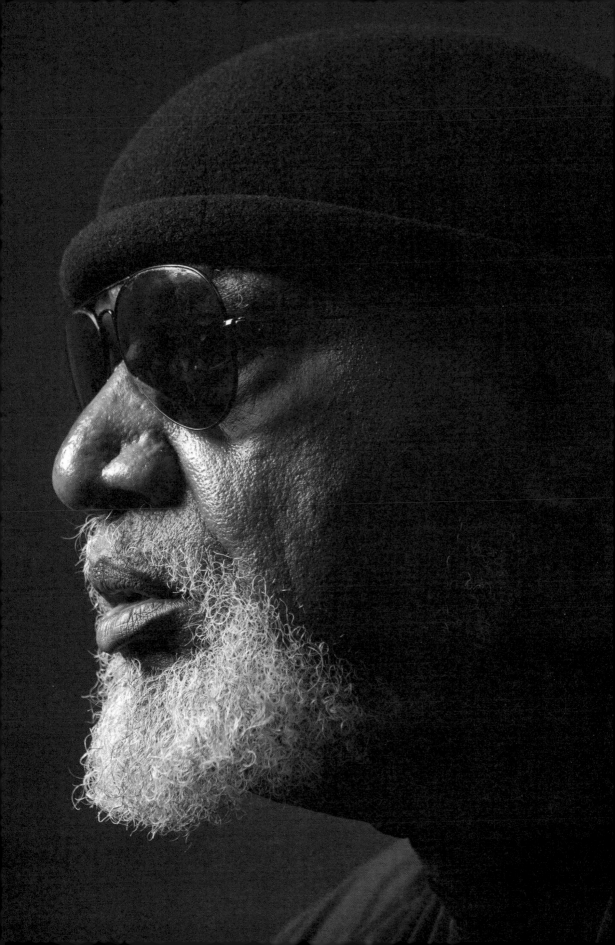

Angela Davis is a political activist, scholar, author, and speaker, and has been active in struggles at the intersection of race, gender, and class, and the movement for prison reform. Davis was named on the FBI's Ten Most Wanted list in 1970 for her alleged involvement in a killing during the attempted prison escape of the Soledad Brothers, sparking international Free Angela protests. She spent eighteen months in jail before being acquitted of the charges. She is a distinguished professor emerita at the University of California, Santa Cruz, and is the author of numerous books including *Women, Race & Class* and, most recently, *Freedom is a Constant Struggle*.

ANGELA DAVIS

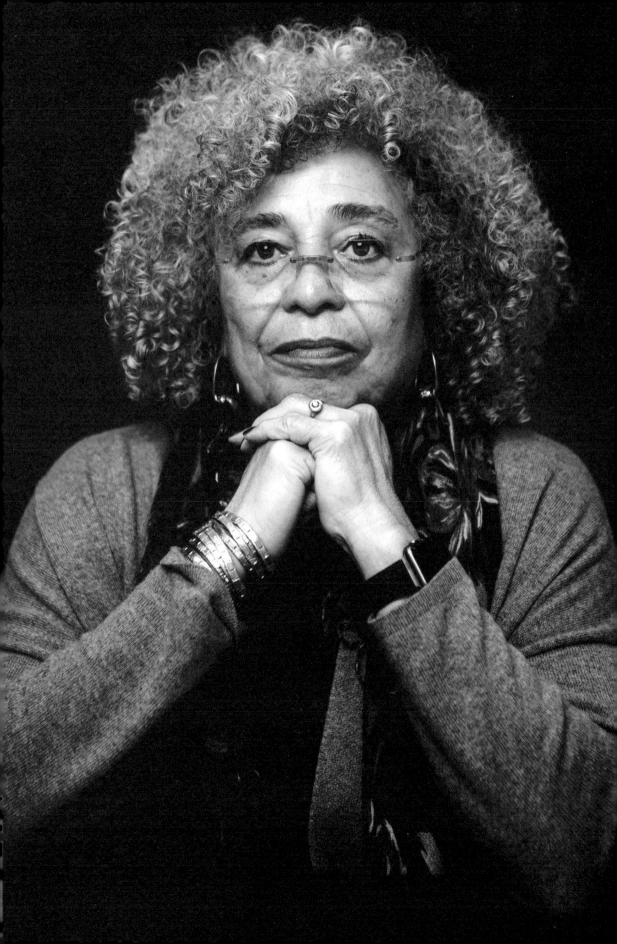

When I was very young, I was a member of an interracial discussion group that brought black and white young people together at the church I attended. That church was burned by the Ku Klux Klan because it sponsored those conversations. The Ku Klux Klan was very much active in Birmingham (Alabama) and whenever black people challenged the status quo, there would be repercussions. Violence was omnipresent, actually. Houses would be burned or bombed. Churches would be bombed. Synagogues would be bombed. So we were aware of that. But, at the same time, it didn't prevent us from living lives that were also fulfilling lives, and lives that allowed us to experience joy and pleasure.

My mother was always very careful to make sure that we did not believe the ideological concepts that surrounded us and that we could recognize the possibility of change. We would often ask her: *Why is it that we can't go to the amusement park? Why is that only the white children are allowed to go?* She would always say, "This is not the way it's supposed to be. This is not the natural order of things." So, I grew up not only living in that [segregated] world—but also imagining what it could be. I learned how to look at a set of circumstances and imagine them in a transformed state. That's critical thinking, critical engagement. And I will be forever thankful to her for giving me that critical perspective toward the world.

Although I wasn't conscious of the specifics when I was growing up, I think there was an atmosphere in our home that valued activism. My mother became active when she was in college, in an organization called the Southern Negro Youth Congress. She got involved in a number of campaigns when she was young. And I know that her friends, Dorothy and Lewis Burnham, were black members of the Communist Party who were very active organizers of the Southern Negro Youth Congress. These were the people we grew up with. So, I think I absorbed a great deal without necessarily reflecting on it, analytically.

It was only later that I began to think of "activism" as a concept; I don't think we used that term in those days. For us, it was more a question of, how do you live with integrity? How do you inhabit the space that is thoroughly determined by racism and segregation—and, at the same time, imagine the possibility of a very different kind of world? So it wasn't, in my memory, a kind of activism that was separate from everyday life. It was a way of living in the world and imagining one's future.

The things that I did do seemed to flow directly from that principle. And always in the context of recognizing that collective movements could overturn existing circumstances—because the individual could do very little by herself or himself. And I think that that sense led me to always want to be linked to others. And so, from the time I was in high school, I was always in an organization, I was always in some kind of a collective. This has been the case all of my life.

I left Birmingham to complete my high school education in New York in 1959. Fortunately, I went to a high school where many of the students in the school expressed solidarity with the struggles that were unfolding in the South, with the Cuban Revolution, and with a range of other issues. But, I felt as if

Angela Davis

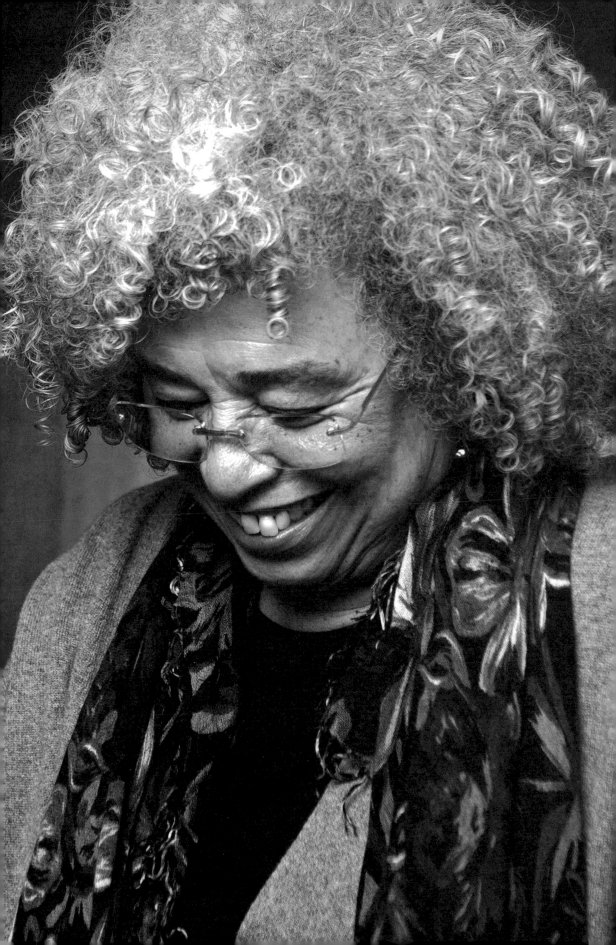

"For us, it was r
of, how do you
integrity? How
the space that
determined by
segregation—a
time, imagine t
a very different

ore a question
ve with
do you inhabit
s thoroughly
acism and
d, at the same
e possibility of
kind of world?"

—Angela Davis

I had left Birmingham precisely at the wrong time. Because as soon as I left, the sit-ins began to happen. And I can remember talking to my parents and telling them I wanted to come back because I wanted to be a part of that emerging movement. But in New York I did get involved with a youth organization called Advance, which was loosely affiliated with the Communist Party. And we picketed Woolworth's every Saturday because Woolworth's was targeted by the students who were involved in the sit-ins. So I sort of got over that urgency of going back to the South because I felt I could also play a role where I was.

This was also the period of the rise of the peace movement. And so my first really major demonstration was a march across the George Washington Bridge calling for an end to the A-bomb—I think the slogan was "ban the bomb." We referred to it as the atom bomb in those days. It was actually really exciting to be a part of demonstrations that involved so many people. Very exciting. And I later came to realize how important these moments are. Because even though they may not accomplish the immediate goal, you get a sense that you're a part of something so much larger than yourself. And that you share a vision with those who are demonstrating. I often refer to John Berger, who wrote that, "Demonstrations are rehearsals for revolution." You get that sense during a concentrated period of time about the real possibility of radical change. So, I experienced that first in New York.

Later, I went to France. Of course, I was studying French literature, and was totally seduced by the notions of liberty and equality and fraternity—*liberté, égalité, fraternité*. And I expected that France would be very different from the United States, much less racist. But I happened to make my first trip to France at the height of the Algerian Revolution. I attended some demonstrations and witnessed some police attacks on people. I was warned by some women who were living in the same building where I lived—I think they were from Martinique—that I had to be very careful because I might be mistaken by the police and by the conservative forces there for an Algerian. It made me want to find out more about the Algerian Revolution. So, I studied the Algerian Revolution. I learned more about the impact of colonialism—Africa and Asia. And that expanded my vision of what might be the arena of activist struggle: It wasn't just in a particular place in a particular country, but it was really about imagining a transformed world. I was introduced to Frantz Fanon. I read him in French before he was published in English. So, I was able to acquire a sense of the absolute importance of international solidarity. And I think I've always been influenced by this sense of internationalism.

Then study[ing] in Germany for a couple of years, I was very involved with a socialist student organization at the time of the Vietnam War. And, of course, by 1966, the Black Panther Party was founded. I can remember seeing images of the Black Panthers standing outside of the state building in Sacramento (California) and strongly feeling the need to return. Because it seemed to me that some very earthshaking developments were about to take place in relation to the black struggle. And I wanted to be a part of that. So I made my way back to California where I became both a graduate student and a member of a number of organizations—the Black Panther Political Party, Los Angeles SNCC (Student Nonviolent Coordinating Committee), the Black Panther Party, and then the Communist Party.

SNCC, unfortunately, fell apart as a result of internal struggles around gender and politics. I was definitely a part of that. Within the organization and also at the national level, some of the male leaders felt that the women were playing too prominent a role. But none of us had ever asked to take a leadership position. We were simply doing the work.

It's usually the case that the women are the ones who do all of the work. But we were also demanding that we be recognized for doing that work. That was the difference. I think it's important to point out that it wasn't a case of the men versus the women. There were men who believed that the women should be able to assume acknowledged leadership positions and there were women who felt that women should be in a subordinate position.

I never have felt that a particular organization entirely reflected everything that I believe. And I think that's fine. I don't know whether the relationship between the individual and the collective can ever be so entirely seamless that there's never anything left to challenge or discuss. But I do think that I've always felt most comfortable in formations that reflected a broader international perspective, in multiracial movements, and within an environment that is produced by making connections across the borders that often keep people divided. I mean, I still struggle with that today, particularly with the emergence of identity politics.

When, for example, some civil rights activists at one point argued that there was no connection between civil rights for black people and civil rights for LGBTQ communities. To me, that revealed an utter incapacity to understand the nature of justice. I like to rely on what Martin Luther King said about justice being indivisible. You never get to decide who is deserving of justice and who isn't.

Some years ago, I was teaching a course in the women's studies department at San Francisco State University on incarcerated women. At the same time, I was also teaching in the San Francisco County Jail. I would take a number of the SFSU students into the jail to give them firsthand experience. One of these students was a really brilliant young woman who was also one of the leading activists on the campus. I had told the students that they would help the inmates around a range of issues. But the first thing I did during that first session was to ask the prisoners

to teach the students about the system—about the jail and the justice system more broadly.

This young woman did not show up again for a while. I was very disturbed and couldn't understand why she had seemingly dropped out of the class. So, I tracked her down, and asked her what was going on. She said that she had been so disgusted with herself, and her ideas about who prisoners were, that that first session in which the prisoners assumed the role of teachers completely shattered her sense of herself. She eventually understood what had happened and became a really powerful advocate. But I never forgot that experience. Because she was responding to the fact that her ideological notions of who offenders are, who prisoners are, was shattered when she was forced to sit down and listen to the prisoners teach the students.

I've had many quiet moments of enlightenment. For me, being in the limelight is not the most important aspect of my life. That is not what I was seeking, not what I wanted. It was a historical accident that my political contributions were shaped in this way. But, at the same time, I realize that the role I can play is to remind people that I'm basically standing in for huge numbers of people who came together around the demand for my freedom. People only recognize me today because of what millions of people did for me in the past. In many ways, they're projecting collective power onto me as an individual. So, I try to demystify this process of projection and tell them that we need the same forceful movement today as the one that led to my freedom in the past. The one that effectively challenged Nixon and Reagan and J. Edgar Hoover. Because there are still people in prison who need the same kinds of movement solidarity. And so, I continue to be active in the campaign to free political prisoners, the campaign against the prison-industrial complex. This will be with me for the rest of my life. We all need to stand together. That is the only way we're going to change the world.

"We all need to stand
together. That is the
only way we're going
to change the world."

—Angela Davis

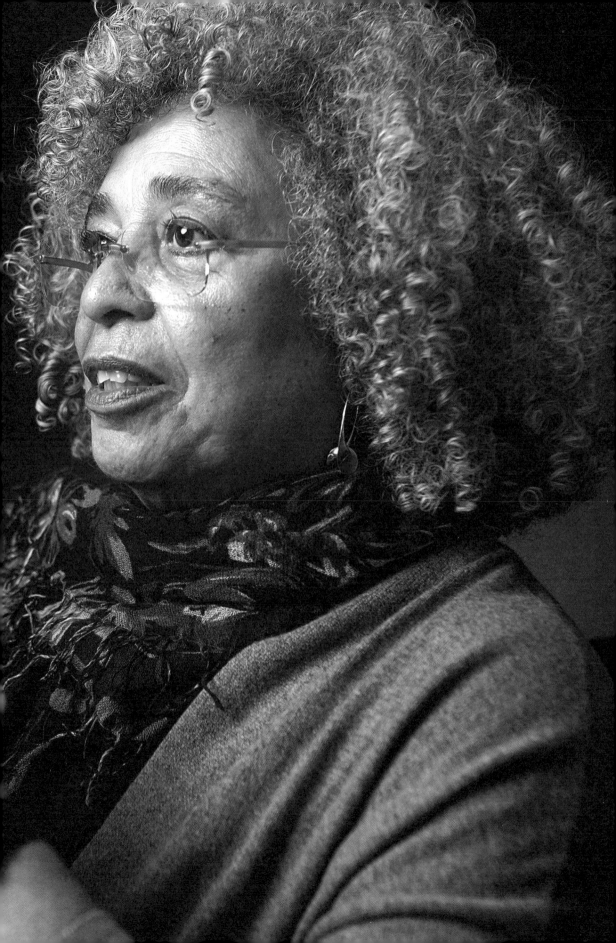

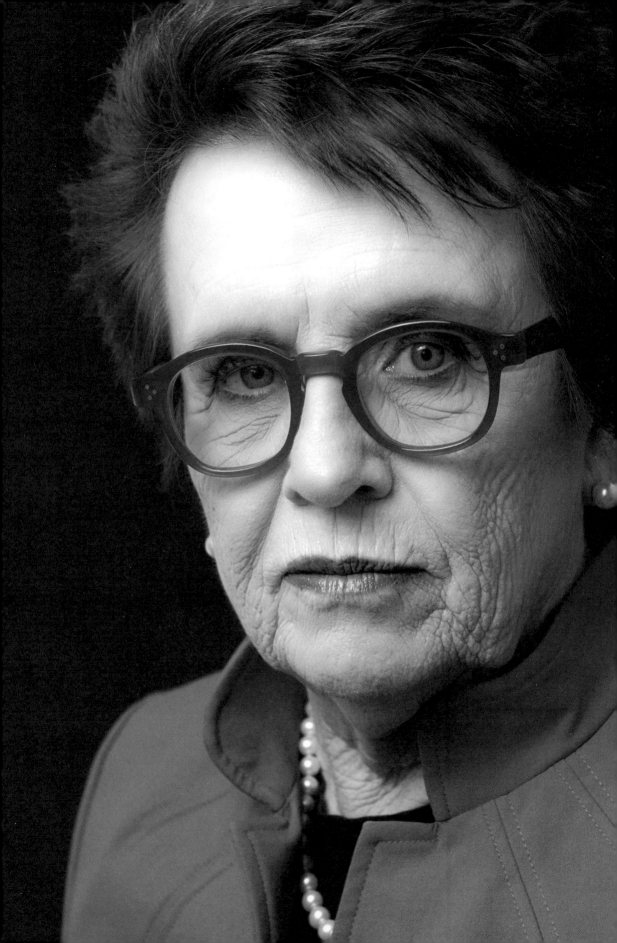

Billie Jean King is a former world number
one tennis player. She won thirty-nine
Grand Slam titles, and was a pioneer for
equal opportunities and pay for women in
tennis and beyond, and for LGBTQ rights.
King won the highly publicized "Battle of
the Sexes" against former men's champion
Bobby Riggs. She continues her work for
women's equality and leadership through
her eponymous foundation.

BILLIE JEAN KING

My dad was a firefighter, a union guy. Blue collar. And my mom was a homemaker. Typical lower middle class. Tract home in Long Beach. My brother Randy and I, if we didn't have that free access through the park and rec system in Long Beach, California, we would never have achieved what we achieved.

By thirteen, I had started to play tournaments to get a ranking—you have to play these sanctioned tournaments. And I started thinking about how everyone who played wore white shoes, white socks, white clothes. Everybody who played was white. So I asked myself, *Where is everybody else?* And that's my epiphany. I knew I was very, very lucky to have tennis. And I promised myself I would fight for equity for everyone. But I knew that I had to be number one. Because I knew that people didn't listen to girls as much. They didn't call on us as much in the classroom. It's always about the boys. Especially in sports. I didn't like it. You know: *I don't want to be a second-class citizen.*

I think every person should have the same opportunities and I'm big on equal pay for equal work. Money matters. Money talks. Money gives you opportunity. First, we fought for fourteen dollars a day in amateur tennis. Then, I fought for open tennis, which is men and women. And just kept speaking out, talking to the officials behind the scenes, trying to get pro tennis. Finally, we got it in '68. So we got paid, but at the first Wimbledon tournament, Rod Laver and I both won in our events. When I got my check, I looked down and went, *Oh, criminy.* He got 2,000 pounds, and I got 750 pounds. I went, *Now we're going to have to fight for something else.*

Nine of us signed a one-dollar contract with Gladys Heldman, and that's the birth of women's professional tennis. We started the Virginia Slims tour in 1971. We had no infrastructure. We had no money. We were giving up everything. We could have never played at Wimbledon again. Never played a tournament again. We didn't care. Our goal was that any girl born in the world, if she's good enough, will have a place to play; would be appreciated for her accomplishments, not just her looks; and be able to make a living, because we had known what it was not to make a living. I got all of us organized and we spread out, talking it up, trying to influence others. Finally, we formed the Women's Tennis Association (WTA). So we had our union.

In 1973, I played against former men's champion Bobby Riggs [in what the media dubbed "The Battle of the Sexes"]. Bobby Riggs had followed me around and asked me for this match. And I said no. But then Margaret Court—it was a lot of money—said she was going to do it. I told her, *Margaret, you have to win. It's not just a tennis match. It goes way beyond.* But she lost. So, I didn't feel like I had a choice: Now I [had] to play him. This is just after Title IX. We just started the Women's Tennis Association, we're playing this Virginia Slims tour. We're only in our infancy. I knew it was pivotal. It would help tennis. Women's sports. Oh, it was huge. I wanted to win that match so much.

Ninety million people saw it. And it wasn't just the US. It was the world. The media were all excited because I'm playing against a guy. If you actually listen to what Howard Cosell said when I was being brought out, he talked only about my looks. But when Bobby Riggs came out, he only talked about his achievements.

So winning was such a relief. Oh god. [Riggs] jumps over the net, and he whispers in my ear, "I underestimated you." It's really amazing what came out of that match. Women gained a lot more self-confidence. I just had a woman today come up to me and tell me that it changed her life. And that happens quite often. Men come up to me. Sometimes they have tears in their eyes. Actually, President Obama, when I met him, he said he watched it when he was twelve. That it changed him. It made him really think. And it helped him raise his daughters. Dads are really important to their daughters. My dad played catch with me. He believed in me as much as [he believed in] my brother.

We didn't make any money, my generation. But I had finally gotten some unbelievable deals for the first time. Finally had endorsements that, even after I quit, I was still going to get. And I would be more secure. But I lost everything overnight [after I was outed]. I lost my endorsements. In those days, the '70s, you couldn't come out like you come out now. There was so much stigma. I was going through hell. My lawyer and my publicist said, "Don't do it. No one's ever done it." I said, *I don't care about everybody else. We're doing it*. Because I think you need to tell the truth. So it was over for a long time. I mean, you have to rebuild. And I went back to play a little bit to pay for the lawyers. But, you know, I was over the hill.

Today, you wouldn't lose your endorsements. You get a call from the president, a job with the NBA. And I'm very proud of [paving the way]. It's exhausting, but you just keep going, you keep looking at the goal and remember to think big. You're going to have setbacks. You've got to bounce back. You have to have fire in the belly every day and just keep thinking how [you] want the world to look.

I have this saying: Pressure is a privilege. Usually, if you have tremendous pressure, it's because an opportunity comes along. I remember thinking about this, actually, when I was at center court at Wimbledon. And I said, *All right. You've been dreaming about this moment. Is it a lot of pressure? Yeah. But guess what? It's a privilege to be standing here*. Most of the time, in work or play or anything, if you really think about it, usually it's a privilege. That I-want-the-ball feeling. Not, please double fault. Give me the ball. Give me the problem to solve. Let's figure this out. Let's go.

"You're going to have setbacks. You've got to bounce back. You have to have fire in the belly every day and just keep thinking how you want the world to look."

—Billie Jean King

Billie Jean King

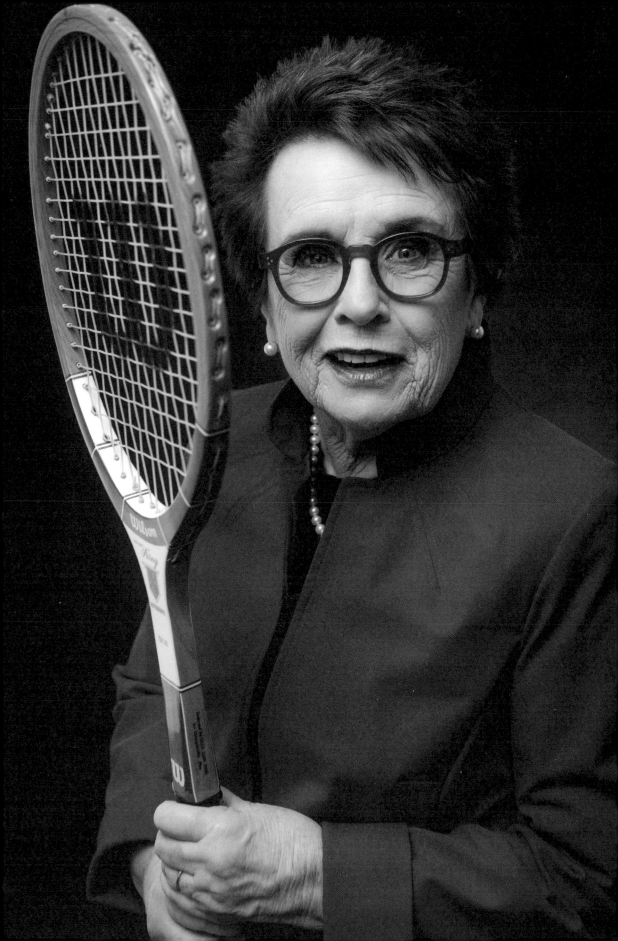

Rose Marcario is the CEO of Patagonia,
an outdoor retail company with a long
track record of social and environmental
responsibility and engagement. Now calling
itself an "activist company," Patagonia
pursues new environmentally friendly ways
to do business, including regenerative
agriculture and using recycled and reclaimed
materials; supports employee activism and
political involvement in campaigns around
environmental issues; and gives away
1 percent of annual sales to environmental
organizations around the world. In 2017,
Patagonia sued the Trump administration for
unlawfully shrinking Bears Ears and Grand
Staircase-Escalante National Monuments.
In addition to Patagonia's increased activism
at the company under Macario's leadership,
profits have also tripled during her tenure.

ROSE MARCARIO

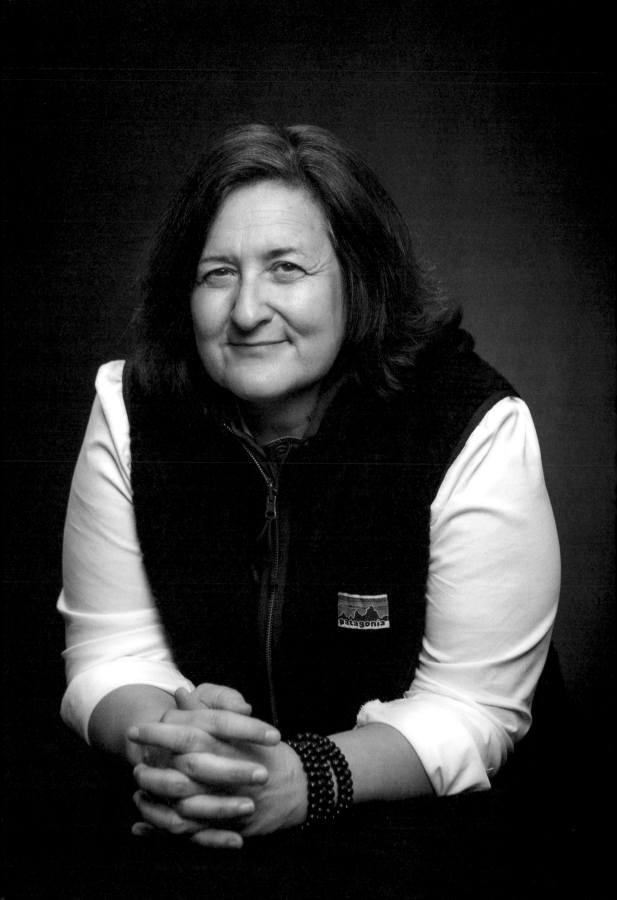

I grew up in this very immigrant sort of ethos that the US is the greatest country in the world, the land of opportunity. And that was true for my Italian immigrant family, for the most part.

And then the AIDS crisis happened. I was seventeen, eighteen years old and working in the theater because I was really interested in acting. And I started seeing my friends dying of AIDS. Jerry Falwell was on TV saying they deserved to die because they're gay. And Ronald Reagan wouldn't say the word "AIDS," you know, and this terrible health crisis was going on. It was the first time I was like, *This is not a country that I recognize*. It seemed so cruel. And so, I was really involved with protesting and ACT UP/LA and stuff like that. That was my first experience of seeing a huge injustice and going, *This just doesn't feel right.*

In my mid-twenties, I started to get interested in Buddhism because I had sort of left Catholicism behind. My partner at the time introduced it to me. We were meditating together and going to Buddhist lectures and stuff like that. And it's a funny thing, because once you start down some spiritual path it starts to transform you. And when you start to get transformed from the inside, you start to wonder: Is my life really consistent with my values? I found myself in a really successful role. I was the CFO of General Magic, which is a public company—a spin-out of Apple Computer. I was in my thirties, a young woman CFO, which was kind of unusual in Silicon Valley. It was, like, *Wow, by every measure that my Italian immigrant grandparents would have, I should be really, really happy. But I'm not, you know, and why not?* And I started going through that exploration.

I felt that the model of quarterly results and companies buying and selling each other really was not good for people or the planet. If you really just boil it down, it doesn't create value. It basically makes the same investors rich over and over again. It's like this picking at a carcass kind of thing. So in my late thirties,

I kind of took a break. I produced some theater. I did some things I hadn't done in a while. And went to India on a retreat. I just knew I needed to make a change. I could get more into my spiritual practice, and maybe get ordained [as a Buddhist nun]. But I felt that wasn't really my wheelhouse. That really wasn't what I was good at, you know—I was good at making money for companies and being a leader and putting together a strategic plan and all that. And then, just randomly, I got a call from a recruiter friend that said, "I think you should check out Patagonia. There's this CFO job there. You and [Patagonia founder] Yvon Chouinard would really hit it off."

I was three to four years into it [the job at Patagonia] when Trump was elected. And he immediately slashed two national monuments. After all the public comments were to keep the monuments, they did the exact opposite. I mean, it was so crazy. In that moment, it was really clear to me that we have to stand up. As a company, we've always been committed to protecting wilderness. We've been giving to grassroots activism for over thirty years; it's part of who we are. But, I think our response to the current government has been a lot more action-oriented because we see a lot of really bad things for the planet and for people happening. And it's ultimately going to be bad for business. And I think that that drove us to do some things we'd never done. It stretched us. We blacked out our commerce site for the day, [filed] the lawsuit. We did things that a lot of companies would be pretty nervous to do. But there's something about pushing for progress or protecting ground; you're energized by that. And, as that force gets more powerful, you have to muster more strength. And that's the way it felt to us. Our responses felt proportional to what Trump was doing. And we weren't going to back down or be worried if there was a negative tweet or something like that.

HuffPost or something did an interview of me and what [Patagonia was] doing on public lands. And they titled the article "The CEO who's leading the corporate resistance against Trump." Something like that. And there was just this flood of death threats. It was really negative. It made me really sad for the country, sad that we were at this point. That someone would threaten to kill you over something you said in expressing your free will or opinion. It made me realize how much all this social media manipulation that went on really aggravated things. That was probably my worst moment around it all. But at the end of the day, you just sort of dust yourself off and get back at it, you know?

Because if the government isn't addressing something as fundamental as climate change, if they're ignoring it and continuing to double down on coal and fossil fuel, I do think businesses have a responsibility to take a stand on behalf of their business long-term, on behalf of the health and lives of their employees long-term. To me, it's not a big leap, really. And you can do it in a joyful fashion, with a certain amount of humor and edge; you don't have to do it in a way that's a total bummer.

I think that leading by example is powerful. You know, it doesn't mean everybody's going to jump on the bandwagon. But there's this feeling that, as the company became more successful by traditional measures, that we had a lot more influence. We weren't just this quirky little company. We were a proof point that it was possible. And to kind of give the world an answer to capitalism as it exists right now.

Like, a lot of people are struggling with the gender equity thing. We've had onsite childcare for thirty years now. And we have total gender parity in management, board, and employees. And I believe it's because of childcare. Because women who would normally have left the workforce, stay in it, and they're in a supportive environment. And I think companies that are willing to take a stand or are willing

to take action, will be rewarded. Because the next generation is a lot smarter, a lot more researched. They want to work in an environment where they can have a positive impact on what they know is a troubled world right now.

I think we're definitely in challenging times, and we need more activism, we need more commitment. And we need people to take their risks and have courage. Something that Maya Angelou said is something that I kind of live by, that if you're going to concentrate on one virtue to develop, it should be courage. Because it's the virtue you need in order to activate all the other virtues. And I think that's true. So if you end up in a situation, you're kind of wondering, you know, should I take this leap or not, I've always sort of gone for taking the leap and letting the chips fall where they may.

I've always been a risk-taker. Maybe that's a way that Yvon and I are alike, even though I'm not a physical risk-taker like he is. And not being a straight woman has, in some ways, been really a benefit. I mean, you sort of give up on boxes at that point, and just sort of make your own way. I guess a lot of that also comes from practicing Buddhism. It develops your inner confidence in your own voice, in your own choices. And if you have inner confidence, then you're better about taking risks, more accustomed to taking risks. You're not afraid to be a warrior when you need to be a warrior.

"You're not afraid to be a warrior when you need to be a warrior."

—Rose Marcario

Whistle-blower Edward Snowden helped
expose the secret mass-surveillance
programs and capabilities of the National
Security Agency (NSA) in 2013, while working
there as a contractor. Snowden has worked
in a number of capacities within the US
intelligence community, including at the
CIA. Charged with theft of government
property and other charges under the 1917
Espionage Act, Snowden has been granted
temporary residence in Russia while the
US government pursues his extradition.
He serves as president of the Freedom of
the Press Foundation, and lives in Moscow.

EDWARD SNOWDEN

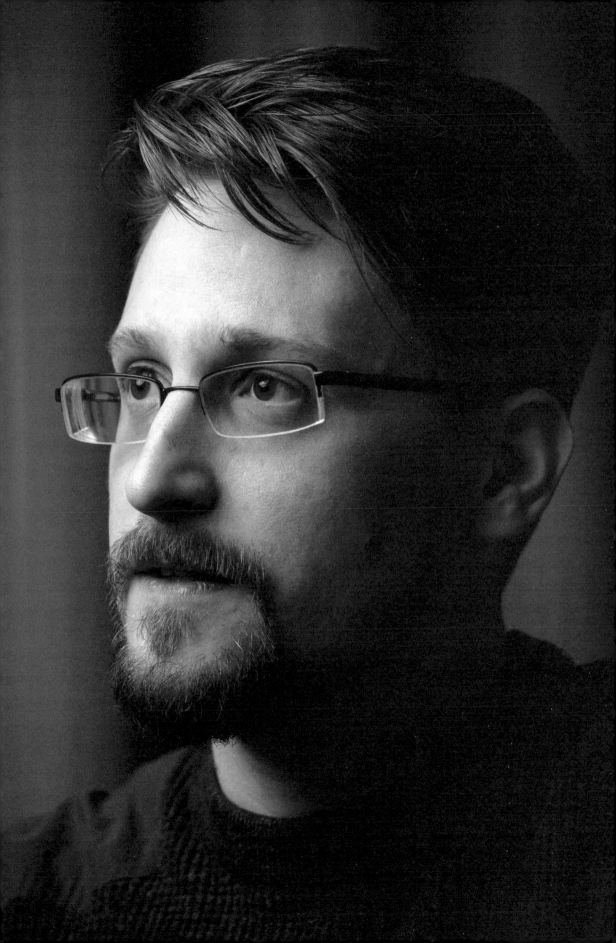

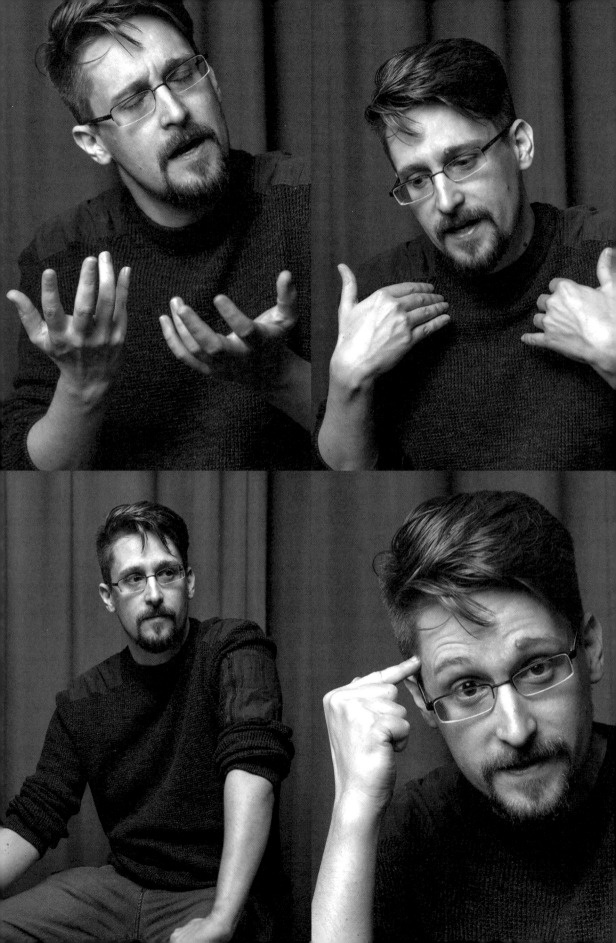

The US government worked really hard to trap me here, which is not what you would expect. They were, like, "This guy's dangerous. He knows all these things. He could be talking to our enemies. He could be endangering national security." If that was the case, why would they want me in Russia?

I was working as a contractor for the NSA in the Office of Information Sharing—they had no idea how good I'd be at that job! One of those ironies. I was overqualified, and basically automated the job as soon as I got in, and I started looking for extra projects. My boss and I had this idea that I would create this system that basically aggregated—like, Reddit on the internet, the equivalent for the top-secret space. Where people would visit this site and it would have all of the new classified reporting happening all over the NSA, CIA, FBI, and all this stuff. And based on your clearance, your need-to-know, your position, it would display what's most relevant to you.

In the process of doing this, I was reading everything all of these agencies were doing. And this was where I suddenly was struck with the big picture. In an intelligence community, it's based on need-to-know; you're only supposed to be doing your job. But then, looking at the big picture, you are struck with that moment of horror where you realize almost everything that they're doing here is founded on an illegal purpose or principle or an unconstitutional interpretation. It came to a head when I came across the Stellar Wind report. I had never seen a document with this particular classification stamp on it. I was, like, *What the hell is STLW?* It is something they call ECI, exceptionally controlled information. Which is sort of a level above top secret.

So I read the document. And it's the secret story that had never been published of how the US government, in the Bush administration, had knowingly violated the Constitution [with mass-surveillance programs]. The scale of it was so vast, it would take your breath away. And when eventually they got to the point where they were called on it by the Department of Justice (DOJ), they went to the director of the NSA and said, "Look, the DOJ won't authorize this because it's unconstitutional. But the president wants to do this on his own authority. If the president asks you directly, gives you a memo saying we want you to do this on his say-so alone, will you do it?" And he—knowing this is unconstitutional—says yes. This is not my interpretation of the events. This is what the inspector general's report says. The classified version, no less. And I was, like, *Whoa. This is not how the system is supposed to work.*

I was, like, *Holy shit. This is crazy*. And it was not even the fact that they did it. Or that they agreed with it. But that these programs—the government will never use the word "mass surveillance"; they use "bulk collection"—even [after] they were revealed in the press, didn't end. All the advocates and activists who thought they had won, had just been screwed. Things had actually gotten worse. The program hadn't narrowed. It had expanded. And Obama, who had campaigned on ending warrantless wiretapping and who I had thought—who everybody had thought—was going to end these

Bush-era abuses, had actually embraced them. And nobody knew about it. I don't think he knew all the details. But he knew these things were happening secretly. So, it wasn't so much that the intelligence agency was lying to the government. It was that the government was lying to the public.

As a compromise, they went, "We'll control how it's applied. We'll control what we use it for. Yes, we could read the emails of any judge. But we won't." Right? "Yes, we could track the location of any journalist to identify their sources. But we won't. We'll only use it for these specific enumerated purposes." And, by and large, they did do this. But that didn't change the fact that it was violating the Constitution. And it didn't change the fact that these programs were getting worse every year. And nobody knew about it, so nobody could actually protest, nobody could try to push for change. How do you organize against something that no one knows exists? In 2013, if you talked about this, it was a conspiracy theory. You were the weird uncle at the Thanksgiving table wearing a tinfoil hat.

That is the whole reason of having a broader distribution of power—a system of checks and balances. Because we're not supposed to substitute the judgment of one person for the judgment of three branches, for the judgment of 330 million Americans. And [in this case], we had three checks and balances in our government, all of which comprehensively failed.

One of the last things that moved me forward was *Amnesty v. Clapper*, which was a case that was litigated by the ACLU (American Civil Liberties Union). I think it went all the way up to the Supreme Court. And they were talking about these kind of surveillance programs. They were like, "Look, we know this is going on. There's a well-established public record. We want you to rule on whether this is constitutional or not." The Supreme Court looked at it and said, "Look, you guys raise great points. And this is the kind of thing that we need to be able to look at and would like to. But you don't have standing. You have to establish standing to bring a case, and in order to establish standing, you have to prove that it's going on. And you can't do that." The government says, "We're not going to give you the documents to prove it, because they're classified."

This happened [February] of 2013. I was already reaching out to journalists. Glenn Greenwald with the US *Guardian*, Laura Poitras, an independent documentary filmmaker, and Barton Gellman with the *Washington Post*. I was saying, *You guys need to look into this. There's something going on. It's really serious. Can we talk privately?* But I hadn't given them anything. I hadn't sort of crossed that point of no return. And then [James] Clapper, the most senior official in the IC (intelligence community) testifies in front of Congress and says the NSA is not collecting any of these records. And I'm sitting there in the office, right, talking to my buddies about this. Like, they're laughing at this. And this is where I go, *It's time to do something*. Three or four days after that, I sent the very first documents to Laura Poitras.

So, I'm working with the journalists to try to meet in Hong Kong. I get there. And it takes them a while to get there. This was a stressful thing that people don't really know from the public record. But their newspapers got cold feet. They know it's real, they know this is going on. But their lawyers are like, "We haven't had a case like this since the Pentagon Papers." And the Pentagon Papers actually were not cleanly resolved. So, they didn't know if the government could go after the individual reporters as a conspiracy or accessory. Their lawyers were just crossing every t, dotting every i, and they just delayed, delayed, delayed, delayed. The main thing I was worried about— like, the journalists didn't even know my name until the last minute, right? Until they were coming to meet me. And the whole reason was, if anybody made a mistake, even if I trusted them, there was just that possibility. If they made a mistake, it would instantly be caught. And then the public would never know. Because I'd go to jail. No one would have any documents. My priority was getting the story out. There was no day-after plan. I don't think any of us expected to get that far.

And [meanwhile] I'm missing at the office. It's an empty chair. And so, yeah, it was a stressful period. That was—that was tough. And [my girlfriend] Lindsay didn't know. She had no idea. I couldn't tell her because, if I did, she'd be charged as an accessory. So, she found out about it when I was on TV, like everybody else. Which made me probably the world's worst boyfriend. But somehow, we're still together. I mean, we had, like, a six-month break, while the FBI was dragging her through the glass. That was the thing. When you tell a partner something like this, you take away their agency. You've made the choice for them. And to me, that just felt wrong. I wanted her to be able to make her own decisions, you know. And, she did. We're probably coming on fourteen years now. Yeah. She's more than I deserve, for sure.

I didn't publish a single document on my own. Instead, I gathered material that I thought either showed criminal or unconstitutional behavior or information that was necessary context for journalists to have a more nuanced conversation with the government and serve the public interest to a better and fairer degree.

The idea was that the journalists would check my biases. Because what if I'm crazy? Right? I believed very strongly in what I was doing, but what if I got it wrong? So they would check me. And then, as a condition of access to this material, I required the journalists to go to the government in advance of publication for every story, and tell them, "Here's what we're going to run, right?" They don't have to give them the draft text or anything like that, but tell them, "We're going to be talking about these programs, and this is what our understanding of it is, this is why it matters, this is why we're telling the public." Like, "Do you have a problem with this story? Is this going to get somebody killed?" And, in every instance that I'm aware of, this process was followed. The government always said, "Yes, we have a problem with this story." But never showed any sort of evidence of harm that spiked a story.

"These programs were getting worse every year. And nobody knew about it . . . How do you organize against something that no one knows exists?"

—Edward Snowden

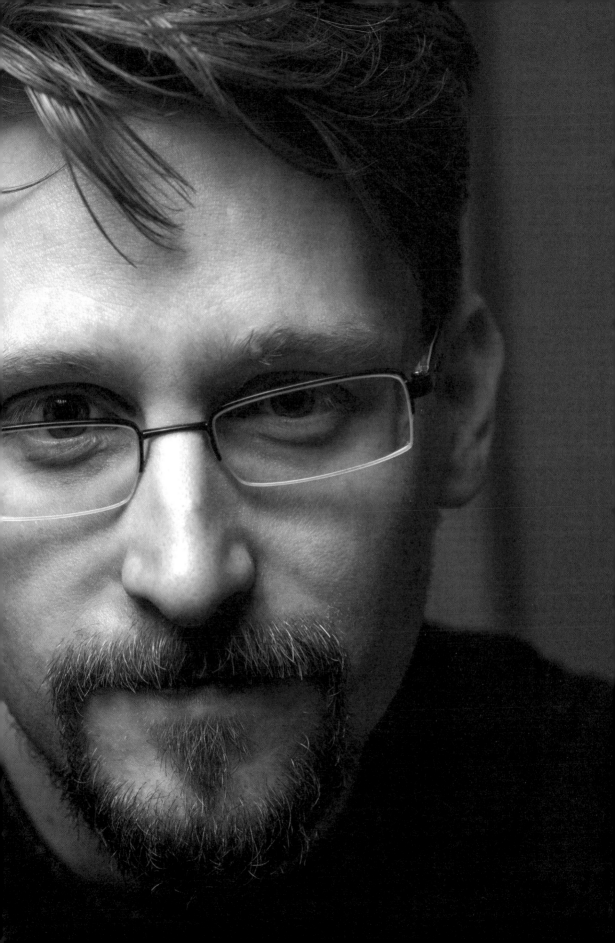

The journalists did, in some cases, you know, remove a sentence or a name or a location or something like that. But the stories still got run.

One of the criticisms is, "Oh, this guy, he didn't go through proper channels." But, the proper channels in the IC are a trap, right? There is [a] no win condition for the public when you go through that. And, "Oh, who elected you?" Nobody elected me. Whistle-blowers are elected by circumstance. It's about what you see. It's about what you witness. It's what you can prove. Not about who you are. It's that you happened to be in that place. Like, imagine walking past the door of a murder scene. You could just keep on walking and be like, "I don't want any part of that." But if you keep walking, the person's not going to get caught.

I think it comes down to caring enough to say something, right? If I don't do it, who will? Not everybody cares. And if you do, that's your power. Right? Care is what motivates you. Care is what enables you to do things other people won't do, what people are afraid to do. If you care enough, you can take risks. And risks are what change things.

I didn't want to leave Lindsay, right? I didn't want to leave my country. Who would want to do that? You're lighting a match and, you know, sticking it to your face. It's terrible. But I was willing to risk prison because I saw how dark the future was. And people look at what's happening today, and they're like, "It's not great." And they're not wrong. But it's better than it could be. And it's going to get better with every single person who makes one of these decisions to stand up and care about something, right? It's not enough to believe in something. You have to stand for something. Because that's the only way things change.

And the question is: what's going to happen if you do nothing?

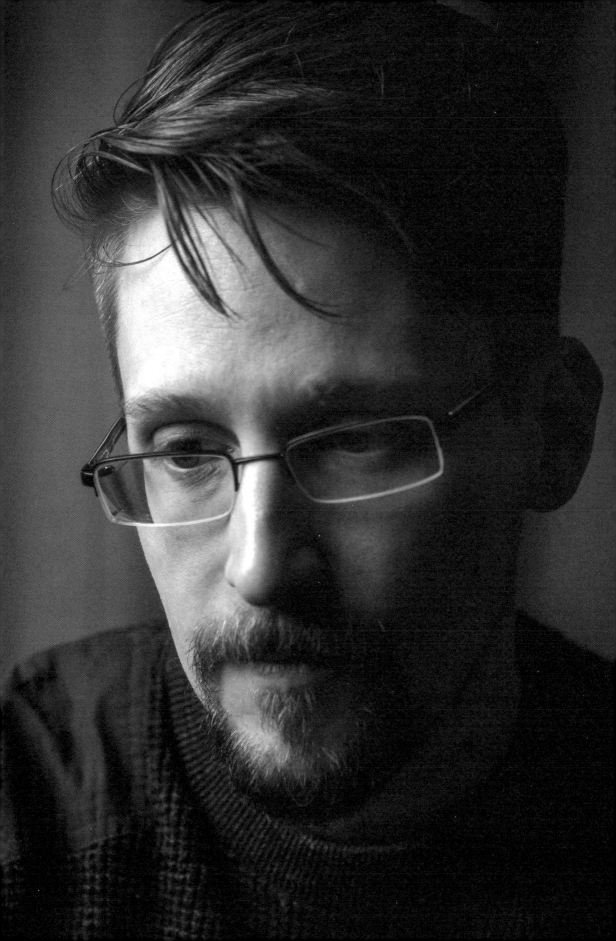

"It's not enou
in somethin
to stand for
Because tha
way things c

gh to believe

. You have

omething.

's the only

hange."

—Edward Snowden

List of Organizations

The following list includes the acronym and website information, where relevant, for the organizations that appear in this book.

ACLU American Civil Liberties Union
aclu.org

ACT UP AIDS Coalition to Unleash Power
actupny.org

ADAPT Americans Disabled for Attendant
Programs Today
adapt.org

AIM American Indian Movement
aimovement.org

ATR Americans for Tax Reform
atr.org

BLM Black Lives Matter
blacklivesmatter.com

CASA (formerly Central American Solidarity Association)
wearecasa.org

CDF Children's Defense Fund
childrensdefense.org

CORE Congress of Racial Equality
congressofracialequality.org

CSO Community Service Organization

DOB Daughters of Bilitis

IIYC International Indigenous Youth Council
indigenousyouth.org

NAACP National Association for the
Advancement of Colored People
naacp.org

NAN National Action Network
nationalactionnetwork.net

NCIC National Capital Immigration Coalition
ncicofdc.blogspot.com

NDWA National Domestic Workers Alliance
domesticworkers.org

OPHR Olympic Project for Human Rights

OWS Occupy Wall Street
occupywallst.org

SNCC Student Nonviolent Coordinating Committee

TPP Tea Party Patriots
teapartypatriots.org

UFW United Farm Workers
ufw.org

UN United Nations
un.org

WTA Women's Tennis Association
wtatennis.com

YPSL Young People's Socialist League

Index of Contributors

Acknowledgments

Working on this book has been an incredible privilege and I am forever grateful for the help of so many people who have made it possible.

First and foremost, my enormous gratitude to the extraordinary individuals in this book who took the time to sit down with me and share their stories. Thank you for welcoming me into your homes and offices and for your encouragement along the way. Above all, thank you for imagining a better world and for doing the hard work to move us all in that direction. Your examples have forever shaped how I see the world, its possibilities, and the potential in each of us.

And to my home team—my family, and family of friends—whose support means the world to me: Thank you. Especially to Matthew for your unfailing belief in me and for the zillions of ways you make everything seem possible—and better. Your help has been critical to the work at every stage, and without it there would be no book. Period. To Nadia and Donovan, for inspiring me, whether with "bring-its," notes and drawings tucked stealthily here and there, snuggles, thoughtful questions, tolerance for the demands of deadlines (and the occasional missed pick-up), and always, always your encouragement—thank you, my sweet chillies.

Special thanks to Mom for always offering a critical and patient ear with the editing, and for the many ways you support the whole crew, stepping in whenever needed. Without you, the wheels would surely have come off the cart long ago! And, of course, to ALL the grandparents for supporting this work—and the family—so that I could have the space to do this. And to the whole family for the love and support that keep us all going.

I am so grateful, also, to the many friends who have stepped forward to help with ideas and connections—Erin, Jon, Lisa, Rennie, Kai, Jamie, Andy, Susan, Lynn. And the good friends who helped us keep afloat in this busy time, with carpools, kid-watching, dinners, and so on—Roopa and Kanak in particular. To David for years of insightful editing and friendship, and to Annie, for masterful transcribing and a willingness to get the job done, even in tight turnarounds.

Finally, to the unbelievable crew at Blackwell & Ruth, especially Geoff, Ruth, Cameron and Nikki, my new colleagues across the world. How very fortunate I feel to have found you! It has been a joy working together, and you have made this work immeasurably more powerful.

First published in the United States of America in 2019 by
Chronicle Books LLC.

Produced and originated by
Blackwell and Ruth Limited
Suite 405, IronBank
150 Karangahape Road
Auckland 1010, New Zealand
www.blackwellandruth.com

Publisher: Geoff Blackwell
Editor in Chief: Ruth Hobday
Design Director: Cameron Gibb
Designer & Production Coordinator: Olivia van Velthooven
Publishing Manager: Nikki Addison
Additional editorial: David Clarke, Claire Davis

Images and text copyright © 2019 KK Ottesen.
Layout and design copyright © 2019 Blackwell and Ruth Limited.
Cover design by Cameron Gibb.
Quote on page 5 and page 9 by Martin Luther King, Jr., reprinted
by arrangement with The Heirs to the Estate of Martin Luther King
Jr., c/o Writers House as agent for the proprietor New York, NY.
Copyright: © 1967 Dr. Martin Luther King, Jr. © renewed 1995
Coretta Scott King.

All rights reserved. No part of this publication may be
reproduced, stored in a retrieval system, or transmitted in any
form or by any means, electronic, mechanical, photocopying,
recording, or otherwise, without prior consent
of the publisher.

Library of Congress Cataloging-in-Publication Data available.

ISBN 978-1-4521-8277-3

Chronicle Books LLC
680 Second Street
San Francisco, CA 94107
www.chroniclebooks.com

10 9 8 7 6 5 4 3 2 1

Printed and bound in China.

This book is made with FSC®-certified paper and
other controlled material and is printed with soy
vegetable inks. The Forest Stewardship Council®
(FSC®) is a global, not-for-profit organization
dedicated to the promotion of responsible forest
management worldwide to meet the social,
ecological, and economic rights and needs of the
present generation without compromising those
of future generations.

Images on page 2 (left–right, top–bottom): Nicole Maines,
Tanya Selvaratnam, Avram Finkelstein, Ai-jen Poo, Marian Wright
Edelman, Edward Snowden, Micah White, Harry Edwards,
John Lewis, Bernie Sanders, Angela Davis, Reverend Al Sharpton,
Shepard Fairey, Tarana Burke, Cecile Richards, Linda Sarsour
Images on case: John Lewis (front), Linda Sarsour (back)